M000104980

Betel Cutters

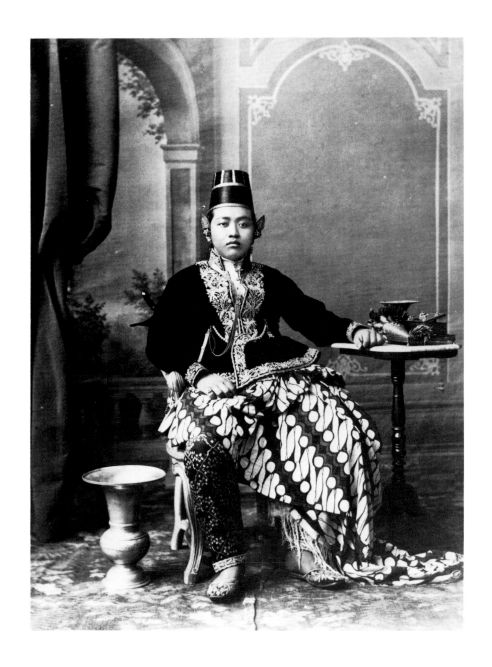

A Javanese prince, with his betel set and large vase-shaped spittoon

Henry Brownrigg

BETEL CUTTERS

from the Samuel Eilenberg Collection

Thames and Hudson

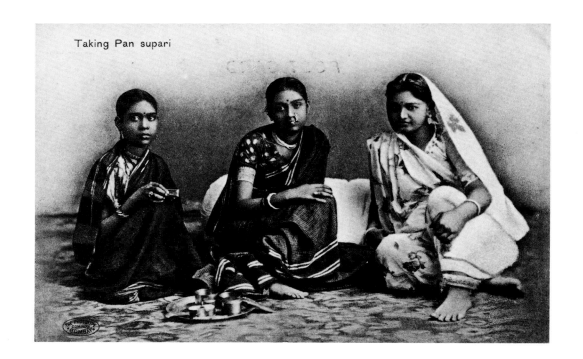

Taking Pan supari

First published in Great Britain in 1992 by Thames and Hudson Ltd, London

First published in the United States of America in 1992 by Thames and Hudson Inc.,
500 Fifth Avenue, New York. New York 10110

By arrangement with Edition Hansjörg Mayer, Stuttgart/London

Copyright © 1992 by H. Brownrigg, S. Eilenberg

Library of Congress Catalog Card Number: 89-50633

All Rights Reserved. No part of this publication may be reproduced or transmitted in
any form or by any means, electronic or mechanical, including photocopy,
recording or any other information storage and retrieval system, without prior
permission in writing from the publisher

Printed and bound by Staib+Mayer, Stuttgart, Germany

Contents

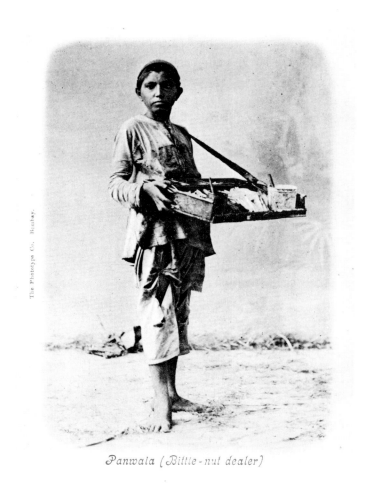

Panwala (Bittle-nut dealer)

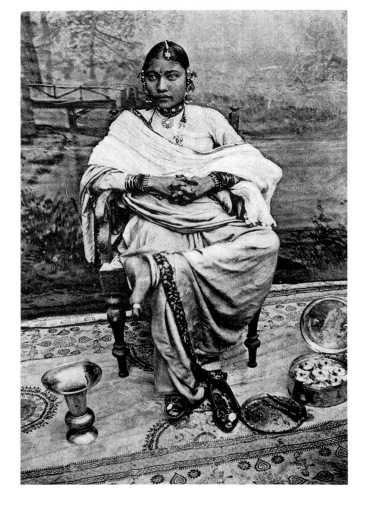

An itinerant betel vendor and an Indian lady with betel set and spittoon

Preface

The custom of betel-chewing, which goes back to Neolithic times, was – and to a large extent still is – endemic throughout the Indian Subcontinent, South East Asia and large parts of the Western Pacific. It thus constituted the most important single cultural phenomenon common to a large body of peoples who differ widely in race, language and religion.

The chew, or "quid" as it is usually called, has three main ingredients: the betel leaf which is used as a wrapper, the nut of the areca palm sliced thinly, and a lime paste obtained by grinding seashells. Other ingredients such as tobacco and various spices are frequently added, depending on individual taste and local custom. The quid is placed between the gums and the cheek and kept there for hours (often even when sleeping). It produces an abundance of red saliva which discolours the lips of the user as well as the sidewalks of many South Asian cities.

There are various conflicting opinions concerning the medicinal value of this addictive habit. Unlike tobacco smoking or snuff taking, which are a personal matter, betel has an official role in ceremonies and plays an integral part in many social activities.

Betel culture required a wide range of implements and, next to textiles and jewellery, these make up a substantial part of the secular material culture of the peoples concerned. As such it provided a rich field for artisanal and artistic activity.

This book is devoted to one such type of implement: the cutter used for slicing the areca nut. Some other implements are also shown at the end. The cutters are commonly known as "betel nut cutters", which is a misnomer since there is no such thing as a "betel nut". The correct term should be "areca nut slicers or cutters" but to avoid controversy we shall simply call them "betel cutters".

Geographically the area in which cutters were used is substantially smaller than the total area in which betel-chewing was practised. In some parts special knives or ordinary knives were used instead.

My own involvement with betel cutters dates back to 1953, when at a charity bazaar in Singapore I came across a curious object which looked a little like a nut-cracker, except that one of the arms had an iron blade so that it could not be used for cracking nuts. It was a handsome object and I bought it. Later that year I discovered that it came from Bali and that it was a betel cutter.

Little did I know at the time that this accidental purchase (no. 178 in this book) was to be the beginning of a long romance, indeed of an addiction. Over the years, on the margin of my more serious collecting of bronzes and sculptures from the area, I have accumulated around eight hundred betel cutters ranging from the very simple to the highly elaborate. This publication contains a selection of the best, and I have also tried to include typical examples of the chief styles prevalent in each area. My aim is to give the reader an idea of the beauty and sophistication of the design and workmanship of these objects.

For a collector the pleasures of the hunt are at least as great as those of ownership. In the field of Asian art the hunt is often complex and protracted. Bargaining is of course a must, particularly when objects of no established value are concerned. Paying the asking price does not command respect and often leaves the seller worried that he did not ask enough. Bargaining is needed to give both the buyer and the seller the feeling that a fair price has been established. It is a game with rules, and when these are observed the game can be quite pleasurable. One strict rule is that when the bargain is concluded both parties should be happy and show it.

You never know when you are going to come across a fine object. One afternoon in Klungkung (Bali) in a vacant lot in front of a temple I was approached by an elderly woman who pulled out a cutter from her bag and handed it to me. It was a very old and charming cutter resembling Donald Duck (in fact it was the clown Sangut from the Balinese shadow play). The price she asked was modest, so I bought it without bargaining – a rare exception to the rule – and it is now no. 165 in this book.

The size of the full collection became a problem when time came to find a permanent home for it. This book is part of the solution. The selection of cutters illustrated here will be shown in museums on both sides of the Atlantic until they come to a permanent rest in one of them. The remaining 600 cutters will be distributed among the participating institutions.

I take this opportunity to express my gratitude to my old friend Henry Brownrigg for undertaking to write the text, and my publisher and friend Hansjörg Mayer for his enthusiastic support and expert handling of the project. Finally my thanks are due to a whole host of suppliers across the globe.

Samuel Eilenberg, May 1991

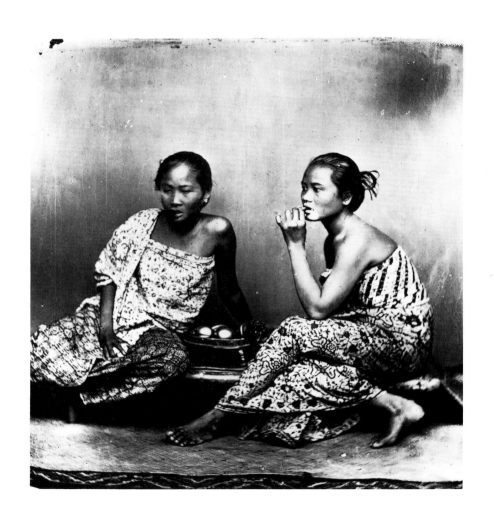

Javanese betel chewers

Introduction

This book is a study of betel cutters, the hinged one-bladed instrument used in the preparation of the Asian stimulant known as betel. More specifically it is a study of a particular collection which was put together over a period of almost forty years by Professor Samuel Eilenberg of Columbia University. Sammy Eilenberg is one of those rare people who has achieved great distinction in two quite unrelated fields. He is an eminent mathematician: a University Professor Emeritus at Columbia, a member of the National Academy of Science (U.S.A.) and the holder of many academic honours. But he is equally well known as a connoisseur and collector of Indian and Indonesian art. The bulk of his collection has now been donated to the Metropolitan Museum of Art in New York.

For Sammy Eilenberg the assembling of his betel cutter collection has been a sort of hobby within a hobby. He is not the sort of collector who merely accumulates, still less the sort who waits for the objects to come to him. On the contrary, his energy in tracking down rare and unusual cutters has been legendary. The result is a collection which is unrivalled in its comprehensiveness. Since good quality cutters are becoming increasingly rare at any price, the collection would be impossible to assemble today regardless of the effort and expenditure the collector was prepared to devote to it.

To put betel cutters into their proper context the book is divided into four sections. The first deals with the betel habit in Asia society; the second is concerned with the various utensils and implements used in betel chewing; the third with betel cutters themselves; while the last is a catalogue of the collection.

Many people have contributed to the book in a variety of ways. In particular I would like to thank Anne Buddle, Simon Digby, Ian Glover, Angela Hobart, Noel Singer and Susan Stronge for their comments and suggestions and Martin Northrop for drawing the maps. Photographs of items in the following collections are reproduced with the generous permission of the owners: Trustees of the Victoria and Albert Museum (p. 30, 31, 34), Tropenmuseum Amsterdam (p. 2, 8, 21, 24, 33, 36), Sven Gahlin (p. 4, 6), Jerry Solomon (p. 40), and the Asian Art Museum of San Francisco (p. 41). I would also like to thank Harper and Collins Publishers Ltd. and Fakhir Hussain for permission to quote from Abdul Halim Sharar's "Lucknow: Last Phase of an Oriental Culture", and Marg Publications for permission to quote from "Treasures of Everyday Art". Errors, whether of commission or omission, are all my own.

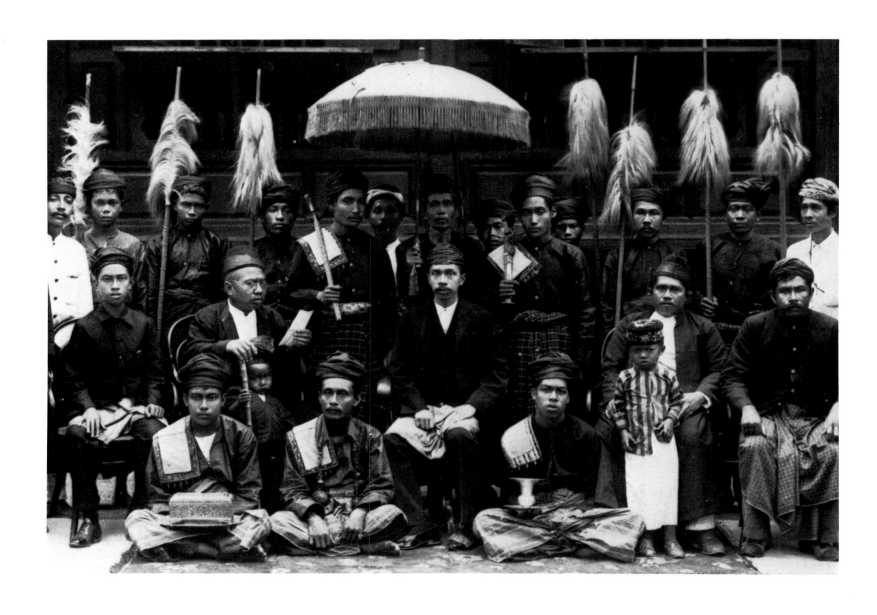

The Sultan of Selangor and his entourage at a federal conference in Kuala Lumpur in 1903.
Seated in front are the bearers of the royal betel box, areca and tobacco receptacles (suspended from a cloth round the neck)
and spittoon. The bearers' office is denoted by rectangular cloths worn over the right shoulder

The Betel Habit in Asia

Notice from Ajmer in north India

The Spitting Image

Betel chewing is, as Sir George Scott observed, an unlovely practice. Western visitors have made a point of complaining about the continual spitting, the blood-coloured blotches on the pavements and the floors of public buildings, and the hawking noise made by the spitters which someone dubbed the Song of India. Those who penetrated to remoter regions were liable to complain of black betel-stained teeth grinning alarmingly from blood-red mouths, while the smell of the addicts' breath was often as unattractive as their appearance.

This was the impression brought back by early European travellers. Yet it did not prevent many Europeans from themselves adopting the habit. As early as 1513 the Portuguese governor Albuquerque derided those of his countrymen who had gone native and were, in his words, *"cheos de betel e de negras"* (literally, "full of betel and black women"). Perhaps it was the women who had introduced their men to betel, since, as the Dutchman Jan van Linschoten reported: "The Portingale women have the like custome of eating these Bettele leaves, so that if they were but one day without eating their Bettele they perswade themselves they could not live... In the day time wherever they doe sit, goe or stand, they are continually chawing thereof, like Oxen or Kine chawing their cud".

The womenfolk were also blamed for the situation in the Dutch Indies where betel was chewed from morning to evening by both Asians and Europeans. Westerners newly arrived in the settlements who were unable to master the practice were mocked with the contemptuous title *Orang-bara* or Newcomer whereas afficionados were known as *Orang-lamma* or Old Hands.

The European ambivalence towards betel was of course completely incomprehensible as far as Asiatics were concerned. In India betel had long been regarded as one of the eight *bhogas* or cardinal pleasures of life, along with unguents, incense, women, music, bed, food and flowers. Poets sang of it, scholars argued over it, but, most of all, everyone from the Emperor to the humblest agricultural labourer was chewing it. The Europeans therefore had to come to terms with a practice which was deeply embedded in social convention. In particular they found that it was central to the etiquette of the royal courts.

Van Linschoten notes: "When any Ambassadour cometh to speake with the King..., the King lyeth on a bed or else sitteth on the ground, uppon a Carpet, and his servant standeth by,

readie with the Bettele which he continually chaweth, and spitteth out the Iuyce, and the remainder thereof, into a Silver Basin standing by him, or else holden by some one of his slaves or wives, & this is a great honour to the Ambassadour, specially if he profereth him of the same Bettele that he himselfe doth eate."

This was echoed a century later by G. E. Rumphius writing about the Indonesian sultanates:

"The Kings of the Indies... have the contributions of the Ambassadors introduced by their translator, and while listening eat *Pinang* the while (the which is immediately presented to them by a whole procession of serving women in costly *pinang* bowls) and they taking for themselves a folded *Siri-Pinang*, have one from the same bowl presented to the envoy, (who) is thereby greatly honoured: but should a foreigner refuse to accept this *pinang*, then the king would consider himself highly insulted and the whole business of the embassy would run into peril".

As well as complying with this convention when visiting native rulers the Dutch employed the same etiquette when receiving envoys or official visitors. Accordingly permission was given by the Council of the Indies for the purchase of an official betel set for use by the Governor-General.

Travellers stressed the honour done to a courtier or ambassador if the ruler offered them betel from his own betel box. However, in parts of South-East Asia matters were taken a stage further in that the greatest honour was to be offered a partly chewed betel quid from the royal mouth. In the words of Sir Richard Winstedt, it was 'the highest favour that could be bestowed upon a subject from a prince's hand, or rather mouth'. This must have tested the sang-froid of even the most experienced of diplomats.

There is one further story of an embassy. In 1792 the British government appointed Lord Macartney to head a large and impressive mission to the great emperor Ch'ien Lung of China. China was closed to foreigners, and little was known about it. However, The Ming emperors in previous centuries were known to have been fascinated by scientific instruments and mechanical gadgets, a field in which the eighteenth century English prided themselves. Macartney's gifts for the emperor therefore included a working planetarium, an orrery, globes terrestial and celestial, a barometer, clocks, two enamelled watches, a pair of air-guns and a horse-drawn carriage.

This selection was not altogether a success. The carriage proved unsuitable because it was unthinkable for the Son of Heaven to be seated at a lower level than his own coachman. In fact the Ch'ing emperors were conservative and inward-looking and had little of the Ming's enthusiasm for scientific instruments. Ch'ien Lung scarcely looked at the gifts, but instead enquired whether any member of the embassy had learned to speak Chinese. It so happened that one of them had: George Staunton, Macartney's twelve year-old page, a precocious boy whose father's boast was that he had never been exposed to childish influences. Pushed to the front, George spoke Chinese with the emperor, who for the first time showed signs of animation, and, taking out a small yellow silk purse for holding areca nuts – the nuts used in betel chewing, he presented it to the boy. The British were unimpressed, and indeed a bag of nuts seemed a poor exchange for the finest products of Birmingham. But, as van Linschoten and Rumphius would have appreciated, the boy had in fact been accorded a singular honour. Nor was the emperor's judgement at fault, for in the next century George Staunton was to become a leading sinologist and one of the founders of the Royal Asiatic Society.

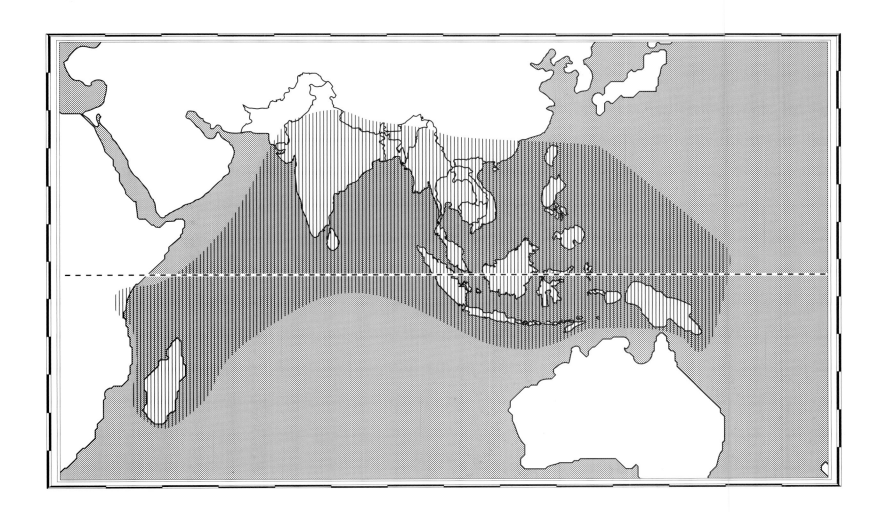

Map showing the main area of betel habituation

A Tenth of Mankind

According to Encyclopaedia Brittanica the practice of betel chewing impinges on the daily lives of roughly a tenth of the human race. Such an estimate is far from impossible. The countries where betel is chewed, even if one excludes those areas of China and Pakistan where betel is also popular, have a population currently around 1200 million, well over a fifth of the global population. Of course much of this is composed of small children and others who, for a variety of reasons, are unlikely to be betel addicts. But historically betel was such a pervasive custom that there seems no particular reason to doubt that it touched the lives of a good half of those living in this region. Today the estimate needs to be readjusted downwards since in many areas the younger generation has turned to alternative habituations such as tobacco, so that betel has come to be seen as rather dated and old-fashioned. It remains the passion of a still numerous but rapidly diminishing generation of elders.

The area of betel cultivation and use stretches some 11,000 kms from west to east and 6,000 kms. from north to south. Its heartland is the wet hot region of southern Asia and the western pacific which is climatically suited to cultivation of the betel vine. This includes the Indian subcontinent, Sri Lanka, the whole of mainland South-east Asia, Indonesia, the Philippines, Papua-New Guinea, Micronesia as far east as the Caroline Islands, and Melanesia as far as Tikopia in the Santa Cruz Islands.

Of course there are places within this area where, for one reason or another, betel and areca do not occur. Coversely enclaves of betel use are found outside the area: for instance in Zanzibar, the Tanka province of Tanzania, the Malagasy Republic and the island of Reunion. Betel is used in Fiji, though it has to be imported. In Melanesia the other popular habituation is *kava*-drinking, and most islands use one or the other but not both. An entire theory of Melanesian settlement is based on the existence of two different waves of migration known as *Kava*-people and Betel-people.

In the early period of Islamic civilisation betel was well known in Persia and Arabia, and was used by physicians such as Avicenna. Masudi, in the tenth century, states that betel was highly regarded by the inhabitants of Mecca and the Yemen. However, Ibn al-Baitar, writing around 1225 AD, states an obvious problem when he says: "Betel is seldom brought to us from India now because the leaves once dried go to dust for lack of moisture". To this practical difficulty was in due course added a moral sanction. Betel chewing was held to contravene Islamic teaching, along with alcohol and other stimulants (though not the narcotic qat which is widely used in South Arabia). At one time users of betel were even threatened with the death penalty. Betel use is still banned in much of the Arabian peninsular.

Indian and Pakistani Muslims have not followed their Arab co-religionists in this attitude. Indian Muslims are no less devoted to betel than other communities. In Pakistan it is somewhat less popular and has its strongest following among the *mojahirs*, people who immigrated from other parts of the sub-continent at the time of Partition in 1947. But the explanation for this is climatic rather than theological: Pakistan is too dry to sustain cultivation of the humidity-loving *piper betle*, and, though the leaf can of course be imported, the betel habit is not as strongly engrained as it is elsewhere in the sub-continent.

One area where betel is not as popular as it once was is south China. Betel and areca are mentioned in a number of Chinese literary sources dating from the seventh century onwards, but are mostly described as things of foreign origin which were imported from Annam (modern Vietnam) or Burma. Significantly, the Chinese word for areca, *pin-lang*, seems derived from the Malay word *pinang* with the same meaning. However, areca is also grown in parts of south China and Taiwan, and on the island of Hainan in the far south it is described as 'extraordinarily plentiful'. Betel cannot be cultivated in the north, and was therefore regarded as a rare luxury. However, its popularity throughout China declined in the nineteenth century, possibly due to the rapid spread of opium as an alternative habituation.

The area where betel cutters are used is considerably smaller than the whole area of betel consumption. This is because areca can be eaten in two forms, either when the nut is fresh and is soft enough to cut with a reasonably sharp knife, or when it is dry and hard and can only be cut with the added leverage of a pair of hinged cutters. The cutter zone roughly corresponds to the part of Asia which has historically came under Indian cultural influence. This comprises the Indian subcontinent, Burma, part of Thailand, Malaysia, and Indonesia as far east as the island of Lombok. Further east in the 'tribal' areas of the Pacific and further north in the area of predominantly Chinese influence, cutting knives are generally preferred. But, of course, like most generalisations, this is replete with exceptions. Thus in Thailand – an Indianised culture *par excellence* where the kings are called Rama and the

arts are permeated with stories drawn from Hindu epics – the royal regalia contains gold-mounted cutting knives. Knives are also used in Assam and other parts of north-east India as well as in Cambodia, Laos and Vietnam. Conversely, China has produced some remarkable examples of hinged cutters (including nos. 98–100 in this collection).

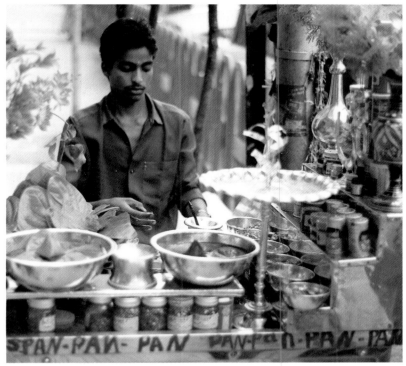

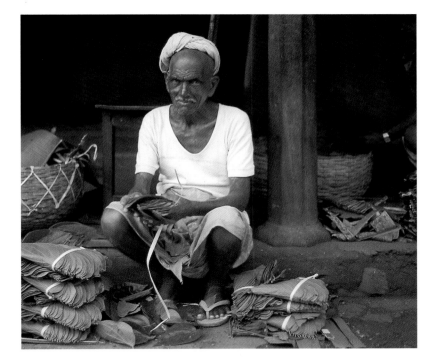

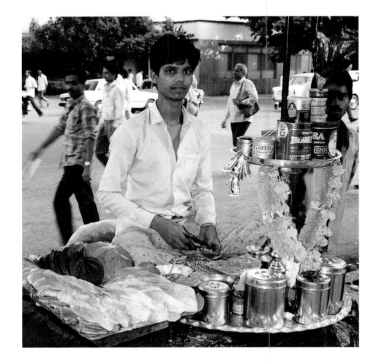

Betel vendors in Bombay

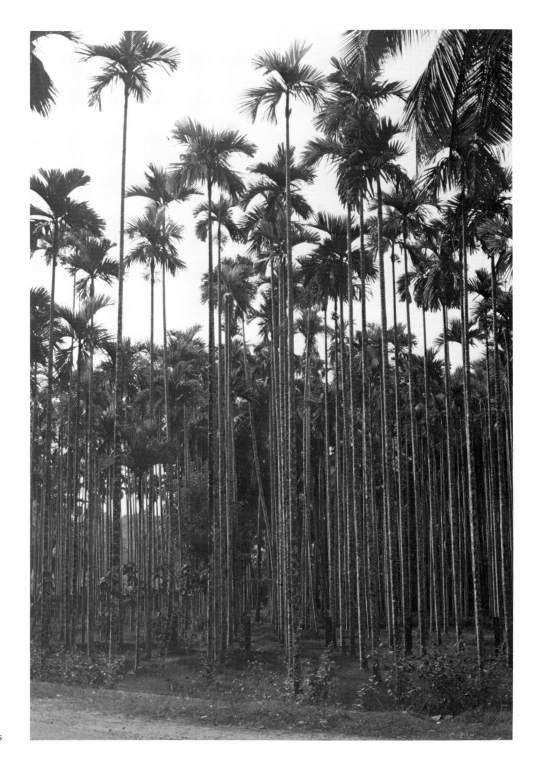

A grove of areca palms

Composition of the Quid

Betel is traditionally served in the form of a 'quid' or 'chew', a small package consisting of the various ingredients folded inside a betel leaf. Although one talks about 'betel chewing', the quid is not necessarily chewed outright but may be retained in the mouth for hours on end and pressed gently between the teeth so that the aromatic juices permeate the saliva flow.

The quid is based around a trinity of essential ingredients and a varying array of optional ones. The three chief ingredients are areca nut, betel leaf and lime paste. (Areca nut is often misleadingly referred to as 'betel nut', an error which crept into the English language in the seventeenth century). To make the quid, the leaf is smeared with lime paste, shavings of the nut are placed in the middle along with the other ingredients, and the leaf is then wrapped around them and sometimes fastened with a clove.

Preparation of betel was once one of the courtly accomplishments of Asia, essential for any woman of breeding or with social ambitions. As we have seen, royal courtesans and female servants stood by the throne preparing quids for the ruler and holding the various receptacles. At other levels of society girls sought to impress husbands and lovers and – no less important – these young men's relatives, with the subtlety and refinement of their blend of ingredients and the elegance of their presentation. Today this tradition only survives in patches. Betel is still widely used, but it is not prepared at home with the former attention to detail, and may – as likely as not – be bought ready-to-eat from the street vendor's stall. In India some exotic mixtures, known as *mukwas*, are served in restaurants as the postprandial equivalent of an after-eight mint, but they are eaten by the pinch without the formality of being made into a quid. Worse, there is a trend towards betel fast foods such as areca fragments churned out by a milling machine, mentholated, silvered to enhance their appearance, and sold in tins or in airtight metal-foil packets like peanuts in a cinema. But for traditionalists the home-made quid remains the proper and dignified way in which betel should be served.

Areca

Areca nut is really the seed of the areca palm (*areca catechu*) which grows semi-wild in the coastal areas of the Indian sub-continent and South-East Asia. In appearance the palm is distinctively straight and slender, and is very attractive whether growing singly or in groves. The nuts grow in clusters at the top of the trunk like dates, and are green in colour ripening to orange. They consist of a thick almost impenetrable fibrous husk containing the actual nut which is about the size of a nutmeg. They are harvested before they are fully ripe and are then sold fresh or dried according to taste.

Areca can be served in a variety of ways including exotic ones such as being boiled in milk, steeped in syrup, or dyed different colours. Since this book is about areca cutters, let us consider the sheer complexity involved in the act of cutting it. This description comes from the refined ambience of turn-of-the-century Lucknow:

"To cut (areca) was a very ordinary operation but in Lucknow it was made into an art by the ladies who cut the pieces as small as a millet seed with each one exactly alike. Care is also taken to use the whole nut and not to lose the kernel... The kernel is delicate and fine in taste, but the portion near the rind is a little astringent and the bottom insipid in flavour. In order to avoid the bad taste of these parts, special ways were devised in Lucknow of cutting the nuts. One way of doing this is called *do rukhi*. In this a good deal of the top and bottom and a little of the sides of the nut are cut, leaving a bowl-shaped residue which contains the soft and delicate kernel. Another way, called *ek rukhi* (rounding) is to scrape the nut all round but leaving the bits of the defective portions either at the top or bottom. A third variety takes the form of octagonal lumps cut entirely from the kernel... All the scrapings are divided into various categories, the scrapings from the kernel being at the top, followed by those resulting from *do rukhi* and *ek rukhi*. They all differ very much in delicacy and taste, and there is a corresponding difference in cost."
(Abdul Halim Sharar – 'Lucknow: Last Phase of an Oriental Culture')

Today the subtleties of old Lucknow have given ways to the more workaday practice of using the betel cutter to slice the nut into eight pieces. As far as the areca fast foods are concerned, the nut is chopped mechanically, and the betel cutter is as anachronistic as the palanquin.

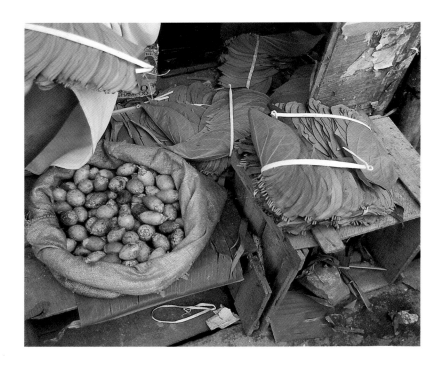

Betel leaves and unhusked areca nuts (top);
folded and unfolded betel quids (bottom right);
A Vietnamese woman preparing betel, Hanoi district, 1916 (bottom left)

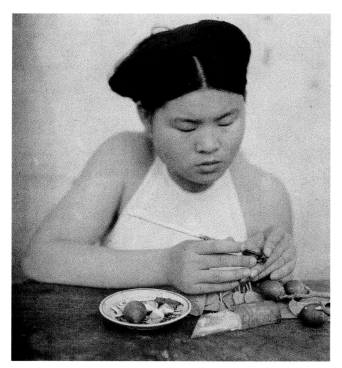

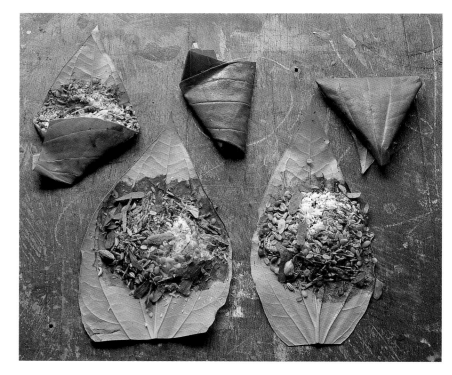

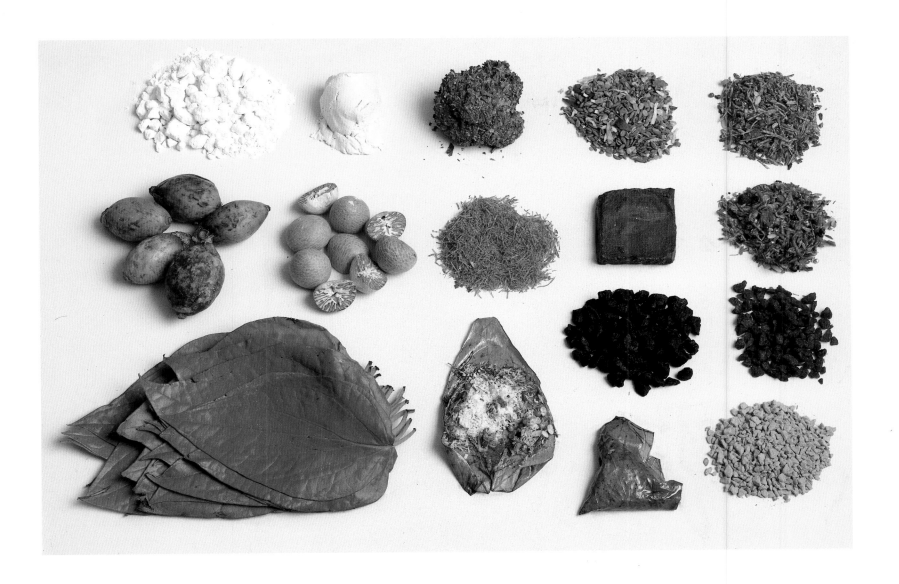

Betel ingredients and mixtures from Bombay: (Top row) powdered lime, lime paste, tobacco, two types of *mukwas* mixture. (Middle row) unusked areca, husked areca, shredded areca steeped in syrup, catechu, *mukwas* mixture. (Bottom) betel leaves, open and folded quids, three types of processed areca "fast foods"

Betel

Betel is the leaf of the *piper betle*, a creeper of the pepper family. Unlike areca it needs careful cultivation and irrigation and is often grown in sheltered and shaded gardens. The vine is supported on a bamboo frame or climbs a tree, and there is a popular belief that the type of tree affects the flavour of the leaf (kapok and coconut palm being the trees which are preferred). In India betel cultivation is the speciality of certain castes such as the Barai and the Toreya, while others such as the Tamboli are betel vendors.

Superstitions and rituals surround the Indian betel garden (*bara*). The Barai wash themselves before entering, and animals and menstruating women are kept out. The *bara* is seen as the haunt of cobras, and for the Barai betel cultivation is closely associated with the cult of cobras and of Basukih the *naga*-queen who created betel from the severed top joint of her little finger. In the 1670's the Englishman John Fryer chose to see betel gardens as satanic cathedrals:

"These plants set in a Row, make a Grove that might delude the Fanatic Multitude into an Opinion of their being sacred; and were not the Mouth of that Grand Imposter Hermetically sealed up where Christianity is spread, these would still continue, as it is my fancy they were of old, and may still be the Laboratories of his Fallacious Oracles: For they, masquing the face of Day, beget a solemn reverence and melancholy habit in them that resort to them; by representing the more enticing Place of Zeal, a Cathedral, with all its Pillars and Pillasters, Walks and Choirs; and so contrived, that whatever way you turn, you have an even Prospect."
(John Fryer – 'A New Account of East India and Persia' (ed. Croke, Hakluyt Society, London, 1909)

Betel leaves are normally bright green in colour, and around 12 to 15 cms. in length. They are arranged in sheaves, and sometimes have ceremonial, magical or decorative functions in their own right irrespective of their role as part of the betel quid.

There is even more connoisseurship about betel than about areca. The leaf comes in numerous varieties, and experts are able to distinguish differences resulting from the type of vine and the way it was cultivated as well as from the preparation of the leaf itself. The veins of the leaf are sometimes removed, and so too is the tip. (The latter practice is sometimes explained by a legend – part of the cobra cult – in which a curative betel leaf was proffered to the hero by a snake which held it in its mouth by the tip). Betel has to be prevented from drying out and is therefore often kept in water or wrapped in a damp cloth.

Nowhere is betel connoisseurship taken to greater lengths than in India, where every variety of leaf has its own devotees. In the north the three main types are *Calcutti* which is delicately flavoured, *Desi* which is regarded as cooling, and *Banarsi* which is sometimes matured by being covered with rice stalks or buried in the ground until it turns yellow, softens and loses all trace of rawness. In this state it is thought to have incomparable taste and savour and becomes a prized luxury. In the south the main types include *Chigarlayele* which has a small fragile leaf, *Ambadi* which is thicker, and *Kariyele* which literally means black leaf and is chewed with tobacco. Where the leaves are small two will be needed to make a quid. Indian quids are most commonly triangular, though conical ones are popular in the north and cylindrical ones (looking not unlike Greek *dolmades*) in the south.

Lime paste

Lime, the third member of the betel trinity, is made from chalk, coral or sea shells which are baked in a kiln at a temperatures of upto 1000–1100 degrees, causing dissociation of calcium carbonate into unslaked lime (CaO) and carbon dioxide:

$$CaCO_3 \rightarrow CaO + CO_2.$$

The lime is then slaked with water, giving the reaction:

$$CaO + H_2O \rightarrow Ca(OH)_2.$$

This produces slaked lime, which is pounded to powder and made into an edible paste which is smeared onto the betel leaf with a small spatula. Coconut oil is sometimes added to stop the lime drying out. In India other additives may include cream, whey and sugar sweets (*batasas*). In Sri Lanka and South-East Asia the lime is often tinted pink or yellow with turmeric water.

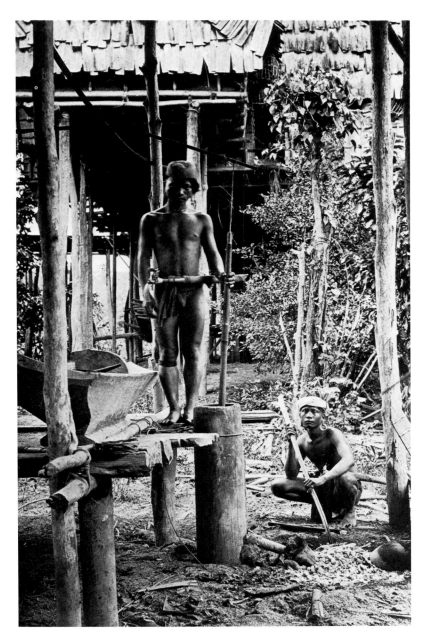

Burning chalk to form lime in Borneo, Indonesia.
The vertical wooden cylinder acts as the bellows

Other ingredients

Among other ingredients the most common is *catechu*, which
is the residue of a concoction of barks, acacia pods (especially
those of *acacia catechu*) and sub-quality areca. It is wholesaled
as balls or solid blocks but is normally served as a red-brown
paste which, like the lime, is spread onto the leaf. It is
particularly popular in India where its Hindi name is *katha*.
Catechu has very high concentrations of tannin – to the extent
that it also plays an important part in the tanning and dying
industries. It therefore gives astringency to a betel *masala*
(mixture) which might otherwise be too bland or too sweet.
Gambir is a similar substance, somewhat paler in colour, and
is made from the leaves and young shoots of *uncaria gambir*. It
is mainly used in Indonesia and Malaysia where it fills much
the same role as catechu.

 Tobacco is another frequent component of the betel quid.
In many places it is used raw, and its strong taste tends to
predominate over the other flavours. In India roasted tobacco
leaves are finely chopped or powdered and then scented.
Sometimes leaves and stalk are boiled, and the residue made
into pills or paste scented with perfume and rosewater.

 Historically betel mixtures often contained exotic and
expensive substances intended to confer prestige on the person
who served them. The seventeenth century French traveller
Tavernier records that the king of Bantam in Java was
attended by an old black woman who crushed *seed pearls* with
the other ingredients, though the effect was rather spoiled by
her having to put the mixture into his mouth with her fingers
as he was toothless. *Camphor* was a popular though expensive
item, and was thought to be an aphrodisiac and to induce
euphoria. Other exotic substances included *musk* from the musk
deer and *ambergris* from the intestines of the sperm whale.

 Indian *masalas* contain a particularly wide range of spices
including *fennel, turmeric, saffron, cumin, coriander, nutmeg* and
ginger. Cardamom pods are included whole and are sometimes
silvered for decorative effect. *Cinnamon* is served in powdered
form in India but as flakes of the dried bark in South-East
Asia. *Cloves* are often used as pins to fasten the quid. *Melon*
and *cucumber seeds* contribute a nuttiness to the texture.
Crystalline *menthol* is a recent popular addition with an over-
powering aroma. Those with a sweet tooth are catered for with
syrup (gulab) and tiny *sugar balls. Rosewater* and *mint essences*
add fragrance. Finally, in south India the finished quid may be
dusted with grated *coconut*, while in the north it is sometimes
adorned with a decorative covering of edible *silver leaf (vark)*.

Physical Effects of Chewing

In an age which has devoted so much attention to stimulants ranging from *cannabis indica* to *ginseng*, it is perhaps surprising that betel has been almost totally ignored. Those few modern westerners who have tried it have found the thrill rather overrated. At the same time there has been a certain confusion as to what betel actually does. Is it a narcotic? It is addictive? What are its side-effects? Does it, like opiates, induce torpor and moral degeneracy, or are its ill-effects confined to tooth-rot and bad breath?

To the ancients betel was an unalloyed good. Arab physicians like Avicenna credited it with theraputic virtues and also used it as a styptic. Sushruta, the first century AD 'father of Indian medicine', wrote that: "It tends to cleanse the mouth, impart a sweet aroma to it, enhance its beauty, and cleanse and strengthen the voice, tongue and teeth, the jaws and the sense organs, and acts as a general safeguard against disease". Other Sanskrit texts were rather more poetic: "Betel possesses thirteen qualities hardly to be found in the region of heaven. It is pungent, bitter, spicy, sweet, salty and astringent; it expels wind, kills worms, removes phlegm, subdues bad odours, beautifies the mouth, induces purification and [last but not least] kindles passion". Even Tiger Balm, the panacea ointment made in Singapore, cannot claim so many beneficial effects.

In the 1920's betel was one of a number of substances examined by the German pharmacologist Louis Lewin in his work 'Phantastica: Narcotic and Stimulating Drugs, their Use and Abuse'. Lewin divides these substances into several categories: Euphorica (e.g. opium, cocaine), Phantastica (cannabis), Inebriantia (alcohol, chloroform), Hypnotica (*kava-kava*), and Excitantia (betel, qat, coffee, tea, cocoa and tobacco). Betel, then, comes right at the bottom of the range, closer to cocoa than to cocaine. Yet Lewin goes on to describe betel habituation in terms which almost suggest the opposite conclusion:

"The craving of the betel-nut chewer for his drug is hardly less strong than that of other drug-addicts for their respective intoxicants. With regard to the daily frequency and persistence with which betel is chewed, it even surpasses all other substances of the same kind. No product of the Far East is craved for with the same ardour as betel. The Siamese and Manilese would rather give up rice, the main support of their lives, than betel, which exercises a more imperative power on its habitués than does tobacco on smokers. To cease to chew betel is for a betel-chewer the same thing as dying. The greatest privations and sufferings of human life, insufficient or bad nourishment, hard work, rough weather and illness lose their disagreeable character before the comforting action of betel."

This may be something of an overstatement. But one thing is clear: far from inducing torpor, betel is what gets you through the day. It creates a feeling of energy, appeases hunger and assuages pain. The British anthropologist Tom Harrisson found that when he was worn out after an hour's hard climbing in Sarawak, a few minutes of betel chewing sent him shooting up again, the stuff sending waves of energy through his body. Betel also calms the chewer and nerves him for pain. It is given to boys before their circumcision. The tenth century Arab traveller Masudi records that it was fed to Indian *suttees* about to throw themselves on their husband's funeral pyre, much as coca leaves were given to human sacrifices in South America. In the nineteenth century Isabella Bird noted that betel was invariably part of the 'auspicious foods' given to Chinese criminals before they were executed.

The immediate effect of betel-chewing is excitation of the salivatory glands and irritation of the mucous membranes of the mouth. The active agent is arecoline, an alkaloid contained in the nut, which is hydrolyzed by reaction with the lime into another alkaloid, arecaidine. These alkaloids, together with the essential oil of the fresh betel leaf, are responsible for the euphoric properties of chewing, and act in much the same way as nicotine. The alkaline nature of the quid also explains its role as a digestive. It neutralises the excess acid decompositon products which form in the stomach as a result of a diet which is excessively uniform. Betel is Nature's Alka-Seltzer.

Betel's most visible characteristic, the fact that it turns saliva red, is the result of interaction of the lime with the other ingredients – areca and catechu to some extent, but mostly with a colour-producing phenol in the essential oil of the leaf. This phenol, known as betel-phenol, is similar to eugenol found in oil of cloves, and may also explain the successful use of betel in folk medicine as an antiseptic and pain-killer.

Chewers usually spit out the first saliva to flow after putting the quid in their mouth, though the more inveterate addicts tend to swallow it. First-time users who swallow it often feel the dizziness which was graphically described by the Italian Niccolao Manucci: "Having taken them my head swam to such an extent that I feared I was dying. It caused me to fall down; I lost my colour, and endured agonies; but (an English lady)

poured into my mouth a little salt and brought me to my senses. The lady assured me that everyone who ate it for the first time felt the same effects."

This initial rection is short-lived, though unripe nuts have a 'heady' effect even on habitués. The dizziness gives way to a general feeling of well-being, conducive to hard work but equally conducive to love or contemplation. According to Dr. B.G. Burton-Bradley: "The net result is parasympatho-mimetic with contracted pupils and increased secretion of tears, sweat and saliva. The suffused appearance, feeling of well-being, good humour and undoubtedly increased capacity for activity provide a typical picture". He concludes that: "Betel chewing mixture is a fairly harmless stimulant and addictive agent and its use certainly no less respectable than the behaviour of its opponents who often indulge in the smoking of tobacco and the consumption of alcohol". Lewin reaches much the same conclusion. Describing betel as 'a mild excitant with narcotic and stimulating properties', he goes on: "Taken as a whole, the ill consequences of betel are relatively so trifling that we might wish that the devotees of other substances of the same kind experienced as little inconvenience".

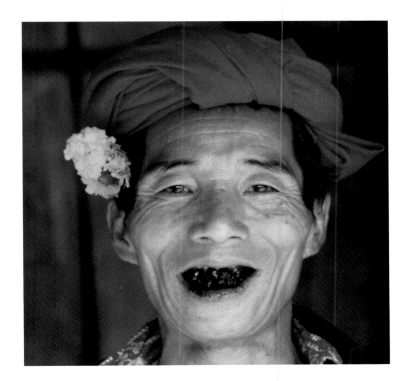

One effect which cannot be regarded as trifling is the suggested link between betel chewing and oral carcinoma (mouth cancer). This is normally attributed to tobacco included in the quid, and is perhaps unsurprising when one considers that some addicts not only chain-chew throughout the day but even sleep with a betel quid in their mouths, However, Burton-Bradley, for one, regards the whole link with mouth cancer as unproven.

It is ironic that two of the attributes almost invariably ascribed to betel by early writers were that it strengthened teeth and gums and gave a pleasant smell to the mouth, whereas modern commentators claim that it has almost exactly the opposite effects. The paradox is perhaps more apparant than real. Betel has no adverse dental effects provided that the teeth are regularly cleaned. Asians are often scrupulous about dental care, the frayed end of a *neem* twig sometimes serving as a very efficient toothbrush. But where the teeth are not regularly cleaned, betel chewing has three consequences.

Firstly, it stains the teeth black. The evidence from prehistoric skeletons shows that this is not new. To some people such as the Shan and Akha of Burma and Thailand the blackness was a cause of pride since 'all animals have white teeth'. Some South-East Asians were in the habit of lacquering their teeth black, just as they used saliva from the quid to

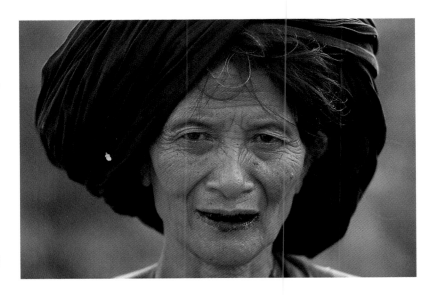

redden their lips. The early missionaries who introduced western dentistry were obliged to make their false teeth out of ebony since they found that white ones were unacceptable. But fashion has changed, and today in the Philippines the term 'black teeth' is a pejorative one meaning illiterates.

The second effect is to encourage the formation of calcium carbonate plaque. This too has its aesthetic admirers: in the Admiralty Islands it is called 'toothstone' and is a source of prestige for chiefs and elders. Unfortunately, as in the West, it is a major contributor to tooth decay.

The third effect is that fragments of the quid get stuck between the teeth, where they decompose, again causing tooth and gum disease. They also produce the unpleasant odour known as 'betel smell', which was immortalised in the character Bloody Mary in the musical 'South Pacific'.

"Bloody Mary's chewing betel nuts,
She's always chewing betel NUTS,
Bloody Mary's chewing betel NUTS,
And she don't use Pepsodent.
Now-ain't-that-too-damn-bad."

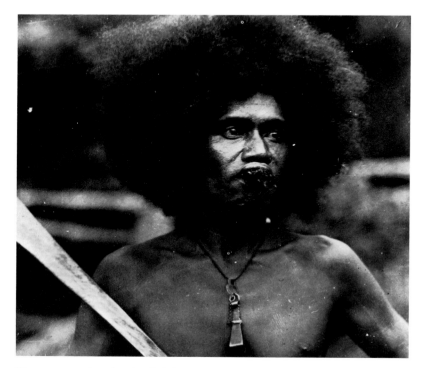

Timorese warrior chewing betel

Origin

Betel can be traced back through literary sources to around the beginning of the Christian era. It is mentioned in Jataka stories and in various other Pali texts, as well as in the medical works of Sushruta who lived in the first century AD. Epigraphic evidence also refers to the office of Bearer of the Betel Bag. However, betel is not mentioned in texts such as the Ramayana and the Mahabharata, and it does not occur in Buddhist or Hindu religious or secular writings until around the fourth century AD. All this led N. M. Penzer to conclude that "Until further evidence is discovered it seems probable that the upper classes of Hindu society did not in general take to betel before the first centuries AD."

And there the matter might have rested were it not for some astonishing evidence from archaeological work on prehistoric sites in South-East Asia. Traces of *piper* seeds (very probably *piper betle*) and of areca have been found in the Spirit Cave in North-West Thailand at levels dateable to between 5500 and 7000 BC, a period possibly pre-dating the invention of systematic agriculture. Similar finds have been made at sites on Timor in Indonesia dating from before 3000 BC. In the Duyong Cave on Palawan in the Philippines a male skeleton dating from 2680 BC was found buried with six bivalve shells bored near the hinge and containing lime. The skeleton had betel-stained teeth.

These remains of the betel ingredients cannot have found their way into the interior of caves by natural means; they have to have been taken there by man. It therefore seems that the ingredients of betel – though not necessarily mixed in their present form – were among the earliest plants gathered by prehistoric man.

So far no equivalent archaeological discoveries have been made in the Indian sub-continent, and this lends support to the belief that betel originated in South-East Asia and then spread westward. There is in any case ample evidence that betel was a flourishing practice for the South-East Asian aristocracy at around the first century AD. A number of highly sophicated limepots and spatulae survive from Java at around that date. Betel therefore appears to have been in common use among the South-East Asian social elite at roughly the same time as it first appears in the literature of India.

Words for Betel and the Betel Cutter

The word 'betel' comes from the Portuguese *betle* which is derived from the Malayalam word *vettila*. This was the first word for betel encountered by the Portuguese when they landed on the Malabar coast (modern Kerala), and has consequently passed into European languages. But in India far more common words are the Hindi *pan* or *paan* and the Sanskrit *tambula*.

All these words refer primarily to the leaf. The commonest word for areca is the Hindi word *supari*, and the combined word *pan-supari* is used to describe the quid. "Areca" itself may be derived from another Malayalam word, *adakka* or *adekka*. The same root provides a number of Deccani and south Indian words for the cutter, such as *adakottu* in Kannada (Karnataka) and *adekitta* in Marathi (Maharastra). However, the most common word is the Hindi *serota*. In Bengali the cutter is known as *yanti*, and in Gujarati *sudi* or *sudo*.

In the Sinhala language of Sri Lanka betel is known as *bulat*, areca as *puvak*, and the cutter as *gire* or *giraya*. In Thai betel and areca are *plu* and *mak* respectively. In Malay and Bahasa Indonesia they are *sirih* and *pinang*, and the cutter is *kacip*. As we have seen, the word *pinang* has been incorporated into Chinese as *pin-lang*. The Balinese word for the cutter is *caket*.

Ceremonial and Social Use

Betel impinges on a person's life even before birth. In Malaysia a sheaf of betel leaves was given to the midwife in the seventh month of pregnancy, and after the delivery she received the full ingredients for the quid. If she doubled as an expert in divination, she might throw some pieces of cut areca on the floor to determine the baby's sex, and after birth she would certainly spit betel juice onto the child as a protection against illness. Children themselves were encouraged to chew betel from an early age. In Burma it was said that a child would not speak Burmese well until he could chew betel.

Thereafter, betel punctuated one's ceremonial progress through life. It was part of initiation ceremonies such as circumcision, tooth-filing, ear-boring and the Brahmin *upanayana* (investiture with the sacred thread). It played a huge part – as we shall describe – in courtship and marriage. It was regularly offered to friends, to guests, to superiors and to supernatural beings. And finally it accompanied one into the grave for use in the after-life. In India its importance can be gauged from the fact that E. Thurston's monumental 'Castes and Tribes of Southern India' has no less than 300 references to betel and areca.

As a gift betel has many advantages. It is intimate, it is popular at all levels of society, and it suffers from relatively few of the social and religious taboos associated with food, alcohol and tobacco. A case in point is the Buddhist clergy. Shway Yoe (a pseudonym of Sir George Scott) notes that in Burma the Buddhist monks, though forbidden to smoke, are among the most persistent chewers of betel which is seen as a great stimulator of the meditative faculties. Sri Lankan Buddhist monks are similarly addicted.

Nonetheless there are people for whom betel chewing is forbidden or discouraged. We have already seen that at one time courts in Arabia forbad it under pain of death and, though the penalty today may be less severe, the ban remains. Among Hindus it is seen by some castes as essentially the prerogative of *grihastas* (those in the married state). It is forbidden to unmarried Brahmins, to *brahmachari* (students), to ascetics and to widows. Fasts and abstinences are encouraged. For instance, when the Zamorin of Calicut died, his successor abstained from betel for a year as a token of mourning.

The giving of betel is often bound up with the all-important question of caste. Thus, in Sri Lanka the highest sub-group of the *goyigama* caste would not offer betel to anyone who was

lower than a *goyigama*. A *goyigama* of intermediate status probably would offer it, but by hand rather than on the plate used for equals or superiors; while a low country village *goyigama* might offer it as an equal to the immediately subordinate caste but for anyone lower would either offer it by hand or not at all. (Bruce Ryan – 'Caste in Modern Ceylon' [1953]). On the other hand betel is frequently offered up the social ladder to caste superiors, bosses and landlords. It is also offered to relatives. Before a wedding the bride's father would take a tray of betel leaves to relatives and those he wished to invite, and they would signify acceptance of the invitation by taking two or three leaves from the tray. For funerals the same procedure was followed but with the leaves turned upside down. Estranged relatives were described with the expression *'Api unta bulat denne naha'* ('We do not offer betel to them').

Offering betel to guests became so established as a social convention that for the host not to offer it or for the guest to refuse it was seen as a serious affront. In the Malaya Code at the start of the century definite fines were laid down for such breaches of etiquette as not offering betel before a wedding or other ceremony. Someone who had not received the customary gift of betel was considered not to have had a proper invitation.

Apart from the outright offence of not offering betel, there were all sorts of nuance of etiquette involved in the exchange, and ample scope for oblique insults. The speed with which the betel box was produced for a visitor might indicate the enthusiasm with which the visit was regarded and the social distance which the host wished to keep. If the box was clearly not the host's best, the guest could draw the obvious conclusion. Among some groups, such as the Hanunoo of the Philippines, conversation could only continue so long as betel continued to be offered; so, if the host produced a small supply which was immediately used up, it was an indication that he did not want the conversation to be a long one. In India, on the other hand, betel was traditionally offered to the guest before departure, and so the sudden appearance of the betel box might indicate that the guest was beginning to outstay his welcome.

There was even an etiquette about spitting. Those of refined sensibilities naturally used a cuspidor or spittoon, which in Mughal north India were small and discreet. In the south and in Sri Lanka they were much larger. So too in Burma. As Shway Yoe puts it (in a deft backhander), "The Burman has none of the delicacy with regard to a spittoon which characterises the American, and these articles require to be of a very considerable size".

Even where the spittoon is unknown, spitting still has its rules. When staying with the Hanunoo, according to Harold Conklin, one should spit only at the edges of the flooring sections, out ot the windows or doors or between the central flooring slats.

Etiquette aside, spitting could also provide the initiated with a positively Holmesian treasure-house of information. For instance in the island of Yap in the Carolines:

"Apparent bloodstains mark all the frequented trails of Yap. Most of these trails are not dirt paths, but stone causeways, upon which any such mark is clearly revealed and easily studied. By the freshness of the stain, the good betel-juice reader can tell you how recently, within a few minutes, someone has passed that way. He can also tell you many other things about the spitter – basing his conclusions upon such considerations as volume, chemical strength, frequency of discharge, relative location, angle of deflection and so on. Knowing the particular betel habits of individuals, he can often tell exactly who has passed – as well as whether he was in a hurry, tired or brisk, calm or excited, travelling light or under a load, in company or alone, talking or silent, where he stopped to rest, where to chat, where he interrupted his betel-chewing to eat, what he ate, as betrayed by the juice of the new quid, and many other considerations more recondite. What the American redskin could tell from a footprint the redmouth can deduce from a betel stain."
(Willard Price – 'Rip Tide in the South Seas' [1936], quoted in Penzer – 'Poison-Damsels').

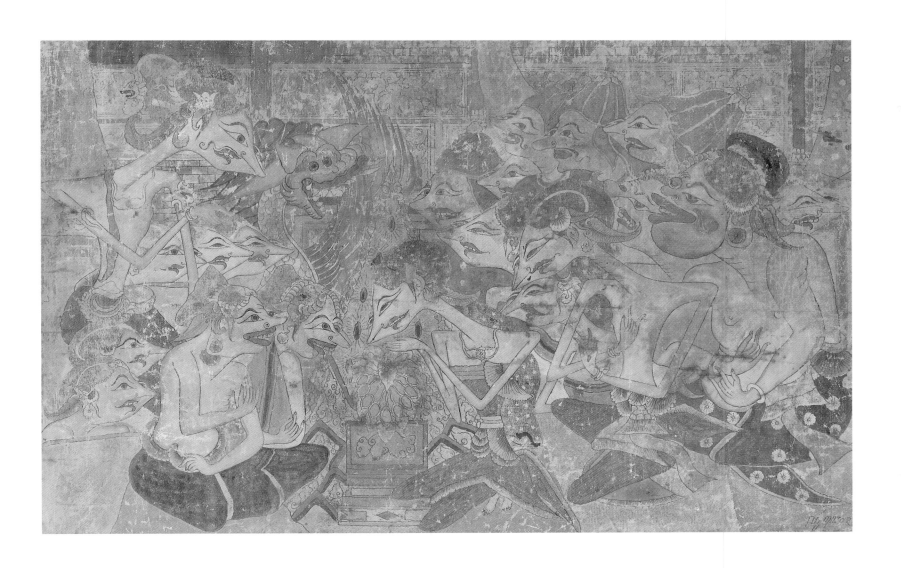

Javanese *wayang beber* panel depicting the marriage of the hero Panji (centre-right)
to Sekar Tadji (centre). The bride extends her hands over an offering of betel and areca.
Betel commonly plays a part in traditional wedding ceremonies throughout India and South-east Asia

Betel at Court

The importance of betel at the courts of Asian rulers has already been described through the eyes of foreign diplomats. Two features are common to these descriptions. Firstly, the ruler himself chews betel throughout the audience. Secondly, he offers it from his own tray, or occasionally from his own mouth, as a token of favour. In India there is a variation of this. The betel quid became a symbol of a particular task or charge. "Who will take this up?" the ruler would ask, and the courtier who accepted the betel quid thereby committed himself to undertake the task in question. This practice still survives in the expression *'Pan ka birha uthana'* ('taking up the betel') which means the acceptance of responsibility.

An even greater honour than being offered betel was to be offered one of the receptacles which contained it. We have already seen young George Staunton being presented with the Chinese emperor's areca bag. Fra Sebastien Manrique, a seventeenth century Portuguese missionary, did even better. In an audience with the King of Arakan to request permission to build a church, he was given a gold betel receptacle. He decided that this was just the thing in which to keep the Holy Sacrament once the church was completed.

It is in South-East Asia that the identification of betel with monarchy is closest. Betel sets form an integral part of the regalia of South-East Asian royalty, and were a favoured item for diplomatic gifts from one ruler to another. The office of Keeper of the King's Betel Receptacle which frequently occurs in early Indian inscriptions and clearly refers to an important functionary (Epigraphica Indica, vol. xi, p. 329 etc.), still exists among the court officers of the Malaysian sultans where the betel box and spittoon are among the heirlooms carried in procession at the time of the ruler's inauguration. The Perak regalia contains two solid gold betel sets said to be the oldest in Malaysia, and another gold set was among the items presented by the then Sultan to the Prince of Wales in 1901. In Kedah betel box and spittoon are among the seven indispensible items of regalia. Similar objects are found among the regalia of the other sultans (p. 10). But when, at the time of independence in 1957, it was decided to commission regalia for the newly created office of Head of State (*Yang di-Pertuan Agong*), the traditional betel box and spittoon were excluded as being too old-fashioned.

Betel receptacles also formed part of the regalia of the Thai kings and of the former kings of Burma. No less than seven betel boxes are included in an illustration showing how the Burmese regalia was formally displayed. This regalia was seized by the British in 1885 but was restored to Burma after independence. In Thailand there are several fine betel sets among the regalia and royal heirlooms. When the present Crown Prince was formally invested he received a regalia of twenty-one items including betel set and spittoon, both of enamelled gold.

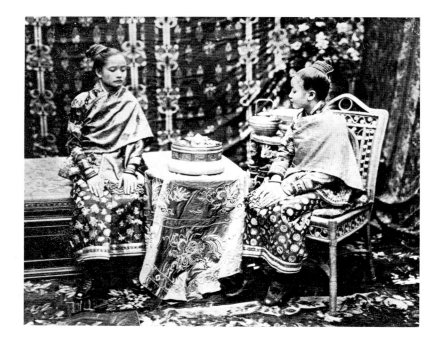

Laotian princesses with a betel set

Magic and Poison

In many parts of Asia, especially in traditional rural communities, people live in perpetual fear of a host of invisible forces – malevolent spirits, astrological influences, natural and supernatural phenomena, and the results of spells, charms and the evil eye. All of these are actually or potentially threatening, and they therefore need to be constantly propitiated, controlled or protected against. Betel ingredients inevitably play a part in this. Betel quids may be left about to distract the spirits and keep them happy. In Sri Lanka betel plays a part in the complex rituals needed to propitiate the *yakku*, malevolent spirits able to inflict illness. In Thailand a boatman about to descend the rapids propitiates the river spirits by throwing a betel quid into the water. And Mubin Sheppard has a story of the Malay spirit-doctor (*bomor*) who, when playing in goal for the local football team, spat betel saliva on the goalposts and so prevented the other side from scoring.

Indeed, it seems that the saliva produced by betel chewing has particular magical power. In Bali, if a child goes outside in the early evening – which is a time when spirits notoriously gather in the lenthening shadows – its mother will first smear the crown of its head and the lobes of its ears with betel spittle. Spirits evidently view the red juice with much the same distaste as do western visitors, and so keep their distance. In Timor betel juice is smeared on the chests of warriors. In many parts of South-East Asia it is massaged into the foreheads or stomachs of sick children. Widows of the Indian Malasar caste spit it over the eyes and neck of their husband's corpse. In Malaysia, in cases of difficult labour an old woman spits pieces of areca nut into the vagina of the expectant mother, apparently in the belief that betel's well-known stimulation of the saliva flow will be equally effective at the other end.

So far we have only discussed 'white' magic; but of course betel is neutral and lends itself just as easily to the other side. Thus, if in Sri Lanka one wishes to put an evil spell (*kodivina*) on someone, the best way may well be to give him an enchanted betel quid prepared with the appropriate rituals, or even to bury it somewhere where he is likely to walk over it. If one suspects that one is oneself the victim of a *kodivina*, one may wish to consult a sooth-sayer (*sastra-kariya*). This gentleman is customarily paid in advance with a sheaf of betel leaves with a gift of money placed on top of it. In examining one's case he will lift the uppermost leaf and study it carefully, tracing the course of the veins like a palmist to see where the trouble lies. If the sooth-sayer recommends the employment of an exorcist (*edura*) the latter will, among other things, wear in a corner of his loincloth a magically charged betel quid with some powdered sandalwood to protect him against the invisible dangers which are inherent in his calling. Of course, in Sri Lanka as elsewhere, betel is only one of several magically powerful plants and substances, but it is nonetheless one of the most common weapons in the magic-man's armoury.

Because of betel's reputed aphrodisiac qualities and its role in courtship and marriage, there can be no surprise that it is the natural medium for those wishing to slip someone a love philtre. This seems as common in Asia as it once was in Europe. More seriously betel can be a vehicle for poison. The offering of betel is of course an act symbolic of hospitality and friendship, and so to offer poisoned betel is a symbol of deep treachery, comparable in Western culture to the Judas kiss or the poisoned chalice.

Stories and legends involving poisoned betel are so common and cover such a wide area that one must assume that there is some basis of truth in them. The poison is normally contained in the lime paste, and for this reason etiquette requires the traveller to accept leaf and nut from those whom he encounters but to carry his own limebox. Certainly the portable limebox is a common feature of betel paraphernalia throughout most of the region. In Sri Lanka the most effective poison is said to come from the oil of the black-and-yellow varan lizard (now an endangered species) or from a python or viper. The victim is said to swell up, hiss like the lizard or serpent, and die in violent convulsions.

The seventeenth century French traveller Francois Bernier has a story (which seems to belong more aptly to the court of the Borgias than of the Mughals) to the effect that Shah Jehan, suspecting that his favourite daughter was carrying on a romantic intrigue with a young courtier, presented the young man in full *diwan* with a betel quid. Needless to say, it was poisoned, and the youth died before he could reach home.

An equally gothic and considerably more original story concerns Mahmud Shah of Gujarat. This potentate was in the habit of taking small regular doses of poison so as to build up his immunity to assassination. This gave him a poisonous breath and skin, so that flies alighting on him immediately dropped dead. His method of executing disgraced noblemen was to chew betel and then spit the juice at them, causing them to die. Unfortunately his breath had the same effect upon his concubines, so that every one that slept with him was

29

found dead in the morning. This story created a big impression among Europeans and gave rise to the stanza in Samuel Butler's satirical poem 'Hudibras':

"The Prince of Cambay's daily food
Is asp and basilisk and toad;
Which makes him have so strong a breath
Each night he stinks a queen to death."

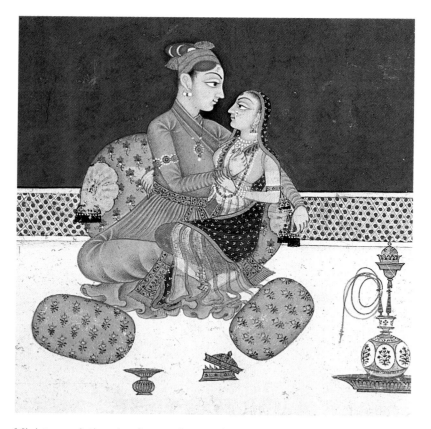

Miniature painting showing two lovers with spittoon, *pandan* (betel box) and *huqqa* (water pipe). [Bilaspur, c. 1730–40. Colln.: V&A]

Betel in Love

Although betel had a role to play in almost all the ceremonies marking the stages of life, nowhere was it more in evidence than at the time of courtship and marriage. Within the betel heartland there seems scarcely a region or social group where betel was not in some way connected with the marriage ceremony. In South-East Asia the two ideas are so inseparable that even the terminology of marriage is derived from the betel cult. The Thai phrase for wedding, *khan mak*, literally means a bowl of areca. In Malay the words *pinangan* (engagement) and *memingan* (to ask in marriage) are both derived from *pinang* (areca). *Pinang muda* is the young nut, the two halves of which symbolise a perfect match. And *sirih kuning* is a dainty morsel, meaning an eligible young girl.

In most of the area the preliminary negotiations before a wedding involved presents of betel, and often the acceptance by the girl's parents of betel offerred by the boy's family had the same force as a marriage contract. In some more emancipated places the girl herself was the recipient of these foliar valentines. In parts of India the suitor knew himself rejected if his leaf was returned with a slit in the middle, whereas an arrow cut in it denoted consuming passion. In Java the girl might take the initiative by sending the boy a quid with the tip of the leaf showing and for this to be refused would be the cause of great offence. Among the Dyak headhunters of Borneo it was at one time common for the young man to include with his gift of betel and areca a fresh human head as proof of his prowess in war; but this practice was suppressed by spoilsports from the government.

Traditional weddings in Malaysia are perhaps the occasion on which betel reached its highest profile. Firstly, there were the delicate negotiations between the families. The young man's relatives went to the house of the girl's family where they were received with a betel bowl, a sheaf of betel leaves, and coffee. Politeness requires that one does not come directly to the point, and so the conversation ranged over unrelated subjects until at last some hint was dropped of the purpose of the visit. If a this stage the receptacle holding the betel leaves was carelessly overturned and left lying on its side, the boy's relatives knew that they should not pursue the matter but should look elsewhere. If the receptacle remained standing they knew they could proceed with a formal proposal.

At Malay engagement ceremonies a sheaf of betel leaves is often made into the shape of a bird and is carried to the house of the bride's family. The engagement ring may be placed in

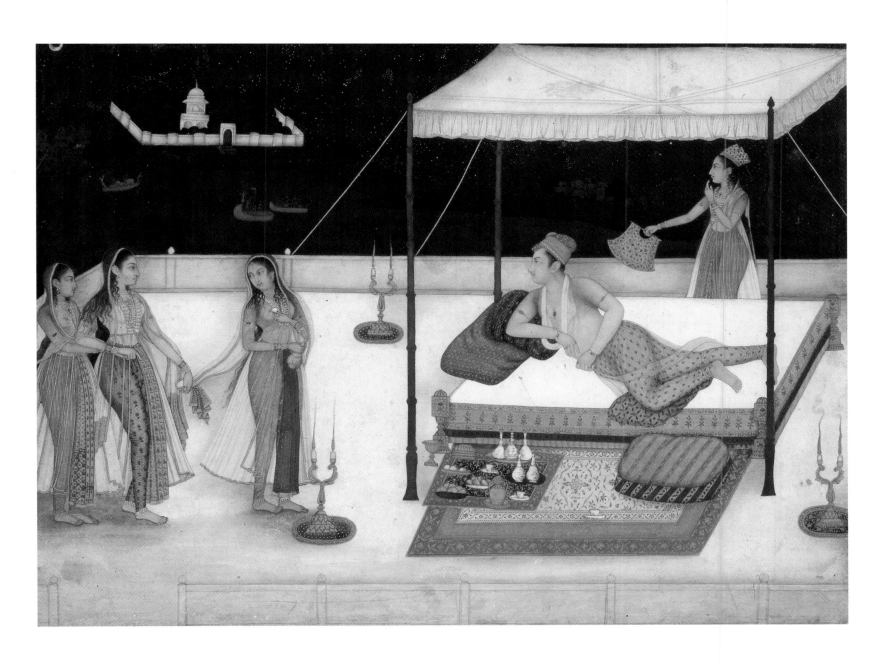

An Indian prince pioneers the idea of the candle-lit dinner.
The receptacles on the cloth include a domed *pandan* (top row, second from left).
[Mughal, second half of the seventeenth century. Colln.: V&A]

a bowl lined with betel leaves, and in Kelantan it would be surrounded with tiny flowers made from the other ingredients of the quid. Another bowl of betel leaves holds the groom's financial contribution to the cost of the wedding.

During the wedding the young couple are supposed to be Raja and Rani for a day, and so, like a real Raja, the bridegroom has a betel box (wrapped in a silk sarong) carried in his procession, and this is prominent on the dais during the couple's formal *bersanding* (sitting in state), along with another tray produced by the bride's relatives containing twenty sheafs each of twenty betel leaves. Finally, it used to be the practice for a betel box to be placed outside the nuptial chamber for the wedding night. If the next day it was overturned, this meant that the husband was questioning his wife's virginity and seeking an annulment.

Just as betel plays a ceremonial role in marriage, so too it sometimes plays a role in divorce. In Arakan a wife seeking a divorce would tear a betel leaf in two and give half to her husband. If he chewed it this meant that he agreed to the separation. In Aceh, the fiercely Muslim area in north Sumatra, the husband pronounced a formal divorce (*taleue*, from the Arabic *talaq*) by taking three pieces of areca and handing them to his wife one by one with the words "One *taleue*, two *taleue*, three *taleue*: thou art to me but a sister in this world and the next". A wife who was angry with her husband might challenge him to give her 'the three pieces of areca'.

It will be recalled that in the much-quoted Sanskrit verse about betel one of the thirteen qualities 'hardly to be found in the region of heaven' was that it kindled passion. There is no modern medical reason for believing this to be true, but it was nonetheless widely believed, and betel was much esteemed in consequence. Thus in 1443 Abdu-r Razzaq, Shah Rukh's ambassador at the court of Vijayanagar, wrote excitedly to his master: "It is impossible to express how strengthening it is and how much it excites to pleasure. It is probable that the properties of this plant may account for the numerous harem of women that the king of this country maintains. If report speaks truly, the number of princesses and concubines amounts to seven hundred." Our old friend van Linschoten was similarly impressed with betel's aphrodisiac quality, and wrote that women consorting secretly with their husbands first eat a little betel "which (they think) maketh them apter to the game".

The presumed aphrodisiac properties of betel of course enhanced its role in the wedding festivities and contributed to a certain playfulness which is evident particularly in Indian weddings. For instance, in Maharastra the ceremony may involve the girl holding a quid in her teeth while the boy bites the other end. Betel became associated not just with the ceremony but with the wedding night.

Consider an aristocratic wedding in north India a hundred years ago. It is of course an arranged marriage, and both families are deeply involved in the preparations. Throughout these preliminaries heavy-handed allusions are made to the physical pleasures which are to come. The bride is bathed with turmeric water or sandalwood paste, her eyes painted with *kohl*, her hands and feet with henna. While this is going on, professional singers (*domnis*) sing songs heavy with innuendo. Meanwhile the cosmetics which the bride applies but rubs off before her bath are sent to the groom's house to titillate his excitement. While being bathed she sits on a stool covered with betel leaves, and these are then taken and made into quids which, with many a nudge and wink, are later fed to him. When the groom arrives, mounted on a horse (as even the most sedentary middle class Indian bridegrooms still do), her relatives are waiting with a bowl containing her bathwater, and this is ceremonially poured at the horse's feet.

Finally, the ceremonies complete, the happy couple are led to the elegantly decorated nuptial chamber, equipped with a bed and, of course with a betel box (*pandan*) and spittoon (*ughal dan*). Here, apart from relays of gossipy relatives listening at the keyhole, they are alone with each other for the first time. Whether, after all this build-up, passion is the sentiment uppermost in their minds or sheer terror, one can only guess. But one can well imagine the girl nervously fiddling with the *pandan* in between bouts of lovemaking (and perhaps shyly glancing at her husband to see if in his deft use of the *ughal dan* he gives any indication of what life will hold in the years to come). And if his performance has not been quite what she expected, there is no opportunity for her to overturn the betel box and demand an annulment. Her only recourse is to feed him some more of that invigorating betel.

Javanese woman with betel set

Betel leaf vendors (top and bottom right) inside the Emperor Akbar's palace at Fathepur Sikri. From an illustrated manuscript of the *Akbar nama* dated c. 1590. [Colln.: V&A.]

An Indian lady chewing prepared betel quids. [Colln.: Doris Weiner, New York]

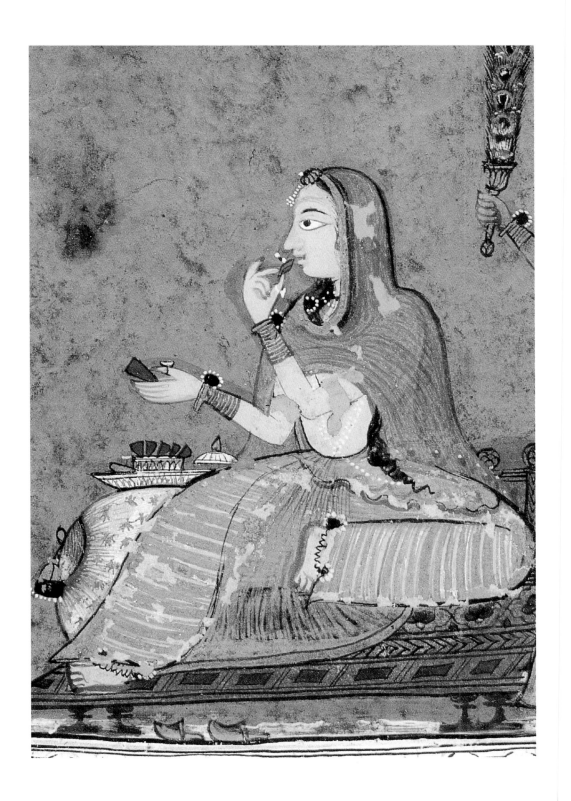

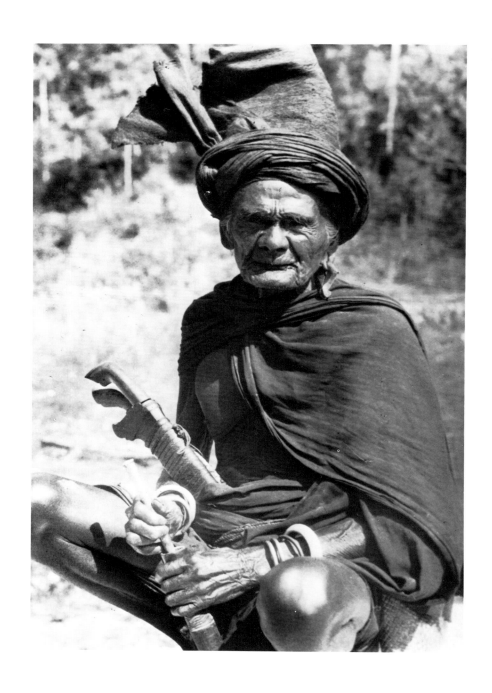

A toothless Indonesian chewer mashes the betel
ingredients in a cylindrical mortar

The Paraphernalia of Betel Chewing.

The essence of betel chewing is that it is a social activity, and it is particularly associated with hospitality to guests. Because of this, people at all levels of society have sought to possess betel utensils which would create a good impression and show the owner to advantage. This has created an enormous variety of vessels, receptacles and implements devoted to the betel cult. They are made of iron and steel, of gold and silver, of bronze, brass, earthenware, porcelain, wood, horn, gourd, lacquer, bamboo and numerous kinds of fabric. All of them are alike in exhibiting to the outside world their owner's wealth and taste, and in this respect they are no different from such western equivalents as the cut-glass decanter, the snuff box and the gold cigarette case.

The main types of utensil may be listed by function, though the categories, like the items themselves, vary greatly from region to region:

1. Betel set or receptacle for holding all the ingredients;
2. Dish for serving prepared betel quids;
3. Container, often portable, for lime paste;
4. Container for betel leaf;
5. Cutter for areca nut;
6. Mortar in which elderly toothless betel users can pound the ingredients;
7. Spittoon to cope with the rapid flow of saliva.

With these categories in mind, some of the most popular types of utensil are discussed below. Some examples belonging to Professor Eilenberg are illustrated towards the end of this book. Though they are not intended in any way to be a representative sample, they do give some idea of the diversity of objects and styles.

India.

The classic betel vessel in India is the betel box (pandan) which is frequently shown in Mughal miniatures along with the huqqa and other items of personal furniture. Many such Mughal pandans survive. They are mainly round, polygonal, or lobed boxes with a domed lid, and are relatively small, typically 12 to 17 cms. in diameter. They may be made of silver, brass, copper or bidri metal (a lead-zinc alloy), and decorated with champlevé enamel, silver overlay, lac inlay or merely with an engraved design. They did not normally contain small inner receptacles for the individual ingredients.

The lineal descendants of the classical Mughal pandan are the repoussé metal boxes which turn up in antique shops described as 'turban boxes' or 'fruit coolers'. These are larger than their Mughal prototypes. Hinges and clasp attach the box to the lid (which was formerly separate) and a loose handle on top of the lid enables the box to be carried. In some examples this handle has been replaced by a pointed finial so that the lid resembles an Indo-Persian dome. Inside the boxes are little metal cups for the lime and catechu, lidded receptacles for different types of sliced nut, and a container for cardamom or cloves. Above these is an interior tray on which are placed betel leaves wrapped in a damp cloth.

Some of the most elaborate of these pandans came from Lucknow, a city which epitomised ostentatious luxury in the decorative arts. Their evolution is wryly described by Abdul Halim Sharar:

"In the course of time the handy betel box also came to serve as a treasure-house and cash box for women. The size began to increase until it came to weigh twenty to forty pounds. At the same time it became necessary for ladies to take it with them wherever they went. Just as 'the larger the turban, the greater the learning', so the larger the betel box the greater was the status and grandeur of the lady. Eventually the betel box took up all the space in the palanquin and there was no room for the lady."

Of course the round Mughal-inspired pandan was by no means the only type. Others were melon-shaped, and there was a wide range of caskets in the European style. These sometimes had interior compartments but not removeable receptacles. In addition to the pandan other utensils were required for serving the prepared quid (gilauri). Muslims tended to favour a tray with a domed cover, known as the khas dan, which somewhat resembled a truncated pandan.

Limeboxes and other small portable containers for betel ingredients come in the usual proliferation of different styles – some shaped like fruit or vegetables, some like birds or fish, some spherical, some cylindrical, some like Greek amphoras and others like American water hydrants. Limeboxes from the south are often spherical, composed of two hemispheres linked by a hinge. The lime is contained in a domed internal compartment with a small hole in the centre. A narrow spatula, attached to the hinge by a chain, is used to get at the lime through the hole. Held by the chain, the limebox is kept shut by its own weight. This shape is essentially that of a bivalve mollusc and is of astonishing antiquity since, as we have seen, mollusc shells containing lime have been found in an archaeological site in the Philippines which is over four thousand years old.

Sri Lanka.

Betel equipment used by the Sinhalese population is highly distinctive. Perhaps the most unusual item is a large embroidered bag *(bulat-payi)*, which is drop-shaped, over a metre in length, and fastened by a cord with a "Turk's head" knot. These are now rare outside museums but were once commonly used to hold the smaller utensils on a journey or on ceremonial occasions when they would be carried by a servant.

In Sri Lanka betel is served on a stepped pedestal-tray *(ilath thattuva)* which is normally of brass but is sometimes of wood lacquered with concentric rings of red, yellow and black. The characteristic Sinhalese limebox *(killota)* is a hinged lenticular box rather like an old pocket watch. Examples of this and of an oval variant are shown on page 129. A spade-shaped spatula is attached by a chain but to the clasp rather than to the hinge as with the Indian bivalve type. *Killota* can be made of silver, brass or copper and are often of copper with brass fittings. Sri Lankan mortars (p. 128) are short metal tubes with a screw top. A spatula passes through a hole in the top: one end is attached to a handle; the spatula can be worked up and down but is too wide to be withdrawn.

Burma.

It is in South-East Asia that betel sets really come into their own. In the Indian *pandan* the splendour is all on the outside: where there are interior receptacles they are functional and unadorned. This is not the case in South-East Asian sets where

the style was for matching receptacles, often of superb workmanship, grouped in their box or tray like eggs in a nest. It was just such a receptacle that the king of Arakan gave to Fra Sebastien Manrique and which the latter used to contain the sacrament in his church.

The nest image is particularly appropriate for Burmese sets since the containing box was sometimes in the form of a *hamsa* or sacred goose. Several such boxes, some of gold studded with emeralds and rubies, formed part of the Burmese royal regalia and are now in the National Museum in Rangoon. One fine example is in the Victoria and Albert Museum in London. Unfortunately none of the small internal receptacles have survived.

Hamsa boxes are exceptional. The more normal Burmese betel containers take the form either of a cylindrical box with interior trays *(kun-it)* or of a pedestal tray *(kalat)*. Both can be made of gold, silver or brass, but are most commonly of the red and black lacquer which is a Burmese speciality. The *kun-it* has a lid coming down the whole length of the box, so that it is in effect composed of two cylinders, each open at one end, the one fitting tightly over the other.

Thailand.

Thailand too is the preserve of the betel set. Exquisite matching receptacles of gold and silver, often with enamelled or niello decoration, have tiered stupiform lids which give them an architectural appearance. These repose on a *paan*, a pedestal tray consisting of a deep bowl supported on a pedestal which is in effect a smaller inverted bowl of the same proportions. There are several such sets in the regalia and royal collection. The Thais are unusual in serving betel leaves rolled into cones or cheroot-like tubes. This necessitates new receptacles: open cups for the cones, and, for the tubes, truncated triangular or vase-shaped containers. These are normally of silver, though a few are of porcelain. In neighbouring Laos they are shaped like a miniature cornucopia.

The tall "pepper-pot" lime receptacle (see p. 132) is a style of considerable antiquity. The gold example comes from Ayutthaya and dates from the 15/16th century. More recent examples are similar though less slender, and the top is sometimes connected to the base by a braided chain.

As we shall see, Thailand produces a style of good (if rather unvaried) cutters in the form of mythical beasts. Interestingly, these do not seem to feature in the betel sets in the royal

collection. Either there is no cutting implement or there is a round tipped knife. This preference for the simple cutting knife requires some explanation since elsewhere in the region it has been found a very inadequate instrument for cutting a substance as hard as dried areca nut. The clue can be found in a comment in the Bangkok calendar for 1864: "The natives of Siam much prefer the nut in a fresh state before it is fully ripe." In this state areca is still quite soft, and a knife would be perfectly suitable.

Cambodia.

Cambodia is well known for betel boxes in the form of animals. Ceramic limepots dating from the 11th–13th centuries were fashioned as rabbits, elephants, cockerels and other animals. These ceramic forms were themselves based on earlier bronze prototypes, and the same subjects were later used for silver betel boxes in the 19th–20th centuries. The earlier of these silver boxes were relatively simple, and a more ornate style dates from the 1920's and 30's. Other subjects include various species of mythical lion, tigers, deer, birds, turtles, blow-fish, pumpkins and mangosteens. Large boxes of upto 25 cms. in length and over 1 kg. in weight were sometimes used to contain the smaller ones.

Malaysia.

Malay betel sets come in three main forms. A round or polygonal open box known as *puan sirih* is related to the Thai *paan* or pedestal tray. Another style, possibly of Sumatran origin, takes the form of a rectangular lidded box tapering inwards towards the top. However, the commonest form is an open rectangular tray *(tempat sirih)* tapering outwards towards the top and resting on small feet. The *tempat sirih* may be of silver, brass, wood, lacquer or even tortoiseshell, and is around 25 cms. long, 12.5 cms. wide and 6 to 12 cms. high. An interior partition creates a rectangular space for the betel cutter *(kacip)* and an L-shaped one for the four silver or other metal receptacles containing the ingredients. Underneath the tray there is a drawer for the leaf. The *tempat sirih* is the first betel set of those so far described which has the betel cutter as an integral part.

As elsewhere, Malays use small portable containers to carry betel ingredients around with them. There are several types of round or polygonal silver boxes, notably the *chimbul* for holding sliced nut and the *chelpa* for tobacco. These can be hung from the belt by chains. A waisted or 'capstan-shaped' box was used for lime. These boxes are decorated with restrained repoussé work in foliar and floral patterns. An unusual silver-gilt leaf-receptacle is shown on page 132.

Indonesia.

Indonesian utensils have a stylistic affinity to those of Malaysia. This is particularly true of Sumatra. The area around Palembang produces the style of covered rectagular box, tapering towards the top, which is also found in Malaysia. Sumatra also has a variety of brass pedestal trays, some tall and deep, others low and shallow.

Java had a rich tradition of metalwork during the Hindu-Javanese period which preceded the Islamic triumphs of the fifteenth century. This included utensils as well as votive images, and the frog limepots (p. 130) dating from the thirteenth century are fine examples. More recent Javanese betel sets are in the tradition of the Thai *paan* and the Malaysian *puan*, though sometimes also influenced by Chinese ceramics. They take the form of baluster-shaped brass vessels, round or polygonal, resting on a low foot. On top of this is a tray with a somewhat stupa-like projection in the middle, by which it may be lifted. On this tray are placed covered or open receptacles, normally of heavy cast brass. A set in this style is shown on page 127.

Bali predictably offers a profuse variety of fine betel utensils, especially silver repoussé bowls of superb workmanship.

Among smaller betel equipment Sumatra and Java use silver boxes similar to the *chelpa* and *chimbul* of Malaysia. They are usually of compressed spherical or lobed form and are frequently linked in pairs: a larger one for tobacco and a smaller one for the lime.

The mortar used for pounding the ingredients by toothless addicts who are unable to chew, which elsewhere is often plain and undecorated, is in Indonesia promoted to rank aesthetically with the other main utensils. The Batak example (p. 128) is made by the lost-wax process, cast from a spiral of wax thread. In Java, Bali and Lombok the long tubes are mostly without interest but the spatula handles are fashioned (like *keris* hilts, with which they are sometimes confused) into elaborate animal, human and non-figurative forms. Some examples are shown on p. 128.

The Philippines.

Although the Philippines does not produce decorative betel cutters it does have a fine tradition of unusual betel receptacles. These come from the Muslim south and are mainly the work of the Maranao and Bogobo peoples. The best-known style is the *lotoan*, a heavy rectagular box inlaid with silver in the formalised motifs generically known as *okir*. The lid is hinged. Inside are four small hinged lids which open like trapdoors to reveal three compartments for nut, leaf and lime.

Instead of inlay the Bogobo preferred boxes with a raised tendril-like decoration made by applying thin threads of wax to the surface before casting by the lost-wax process. Some of these boxes are crescent-shaped so as to fit snugly when worn at the waist. Others are rectangular or octagonal and are sometimes connected in groups by rigid links, so that they resembles a group of tiny buildings. For formal occasions Filipinos had sets consisting of small rectangular, octagonal or lenticular receptacles fitted tightly into a brass casket or tray.

A large wheeled Filipino betel box with removable tray. From the Maranao people of Mindinao. It is of brass with silver inlay, gold plaques and U.S. silver coins. [Length 51.5 cms. Colln.: Jerry Solomon, Los Angeles]

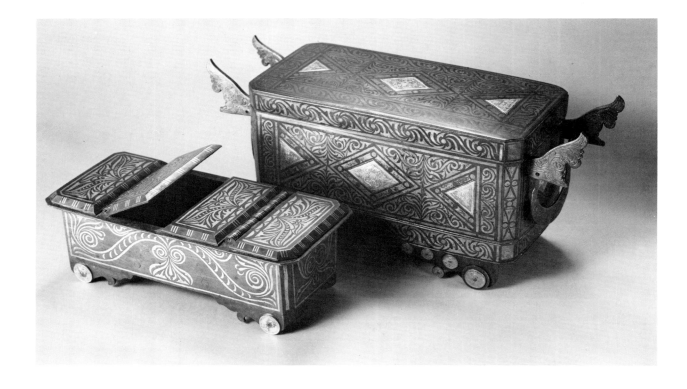

The Cutter

Probably the earliest literary reference to betel cutters is in the Basavapurana of Bhima-Khavi, an Indian work written in 1369. The term used is the Kannada word *adakottu* formed from *adaki* (areca nut) and *ottu* (to press or crack). However, archaeological evidence seems to take the cutter back to a much earlier date. Two examples, now in Sri Lankan museums, are attributed to Anuradhapura, the great Sinhalese capital sacked by the Cholas in 993 AD. The oldest example in the Eilenberg collection is a Thai cutter (no. 121) dating from around 1400 AD. The earliest Indian cutter is the superb iron saluki (no. 57) thought to come from the kingdom of Golkonda (1512–1687).

Although betel cutter is the most common and therefore the most convenient term for the hinged instrument used in betel chewing, strictly speaking it is an areca cutter used to slice and pare shavings from the hard areca nut. Its form is not unlike a single-bladed pair of scissors. There are two arms, one with a blade (which is invariably of iron even if the rest of the cutter is of brass or some other metal), and the other with a butt or flat surface against which the blade falls. These arms pivot on a simple rivet or hinge.

Like the other components of betel paraphernalia cutters were items of social prestige, and so, throughout the region, pieces of the highest quality were commissioned by the wealthier members of the community. Cutters can therefore be seen as a sort of microcosm of Asian metalwork, with the craftsmen of a dozen different cultures producing items which are similar in function and general shape but utterly different in design and workmanship. It is this diversity which gives cutters their particular fascination.

Classification of the different styles is complicated by the fact that, being small and portable, cutters tended to travel far afield. Burmese cutters are found in south India; Gujarati ones turn up in Sumatra. Provenance is therefore an uncertain and often a misleading guide. The classification attempted in this book is based not only on the 187 cutters illustrated but on a further 600 in the Eilenberg collection as well as many more from other public and private collections. Working from such a large sample helps one identify stylistic common denominators and so provides more reliable criteria for classification. However, it provides no guarantee of infallibility. Where attributions were in doubt I have inclined to boldness rather than caution, and if inaccuracies have crept in I apologise in advance.

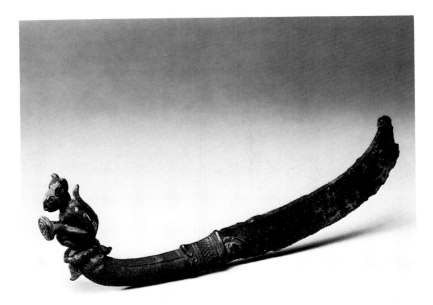

Khmer areca knife dating from the 12th/13th century.
[Colln.: Asian Art Museum of San Francisco]

41

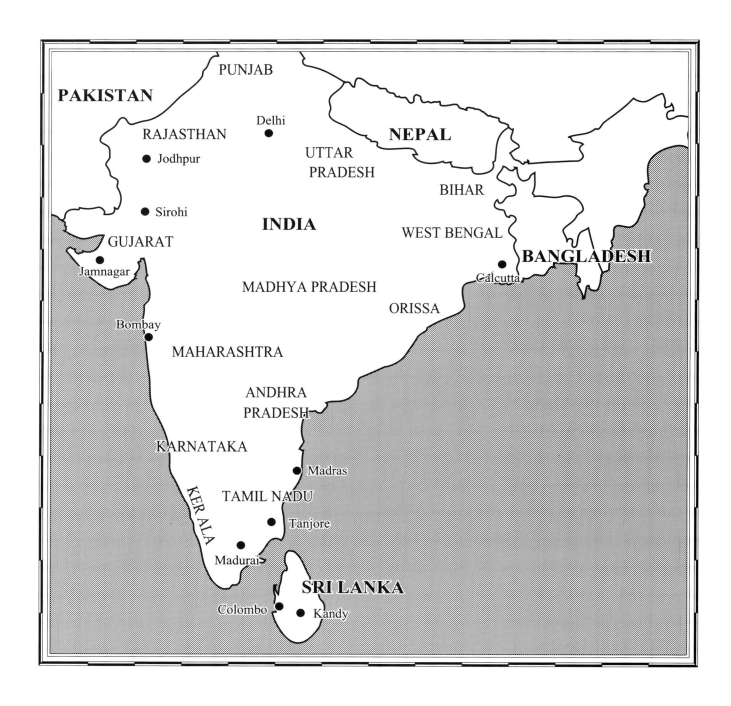

PAKISTAN

PUNJAB

Delhi

RAJASTHAN

NEPAL

UTTAR
PRADESH

Jodhpur

BIHAR

Sirohi

INDIA

WEST BENGAL

BANGLADESH

GUJARAT

Calcutta

Jamnagar

MADHYA PRADESH

ORISSA

Bombay

MAHARASHTRA

ANDHRA
PRADESH

KARNATAKA

Madras

KERALA

TAMIL NADU

Tanjore

Madurai

SRI LANKA

Colombo

Kandy

India.

India is not only the largest but also the most varied producer of cutters. Part of the reason for this is that Indian and Sri Lankan cutters are made equally of brass or iron (or occasionally of silver.) In contrast cutters from South-East Asia are always of iron. Brass and iron call for different techniques and are the work of different types of craftsmen. In north-west India, an area prolific in the production of both types of cutter, the iron ones are normally the work of *lohars*, a caste of blacksmiths, and the brass ones of a caste of metalworkers known as *kaseras*.

The iron cutter often achieves its effect through sheer elegance of form (nos. 18, 65) and is, in Ling Roth's phrase, "blank space adorned by the ornament it does not have". But others are embellished by surface decoration, and this is especially the case in the Mughal-influenced area of north India where there is a fine tradition of damascening in gold and silver.

Damascening consists of inlay and overlay of the surface with precious metals. Inlay, known as *teh-i-nishan*, is achieved by cutting a deep groove in the metal and then hammering into it gold or silver wire which adheres strongly to the iron or steel and is flush with the ground *(teh)*. In most cutters, however, the silver is overlaid rather than inlaid, leaving it proud from the surface. The term *koftgari* work is normally used to describe "false damascening", a technique in which the metal is hatched and the overlay adhered to the surface rather than sunk into it. *Zar-nisha* is a thicker type of overlay, while the best quality work is known as *thetulla*.

These skills were originally developed to meet the limitless demand for decorated armour and edged weapons. However the gradual spread of British rule, which entailed strict control on the bearing of arms in conquered territories like the Punjab, forced armourers and damasceners to seek alternative outlets for their talents. This encouraged the development of decorated objects such as betel cutters (much as in Japan a wide range of new products were developed by armourers put out of work by the suppression of the samurai system after 1868). In the Punjab, especially in the towns of Gujrat and Sialkot near Lahore, a variety of steel ornaments decorated in gold *koftgari* work were made for the European as well as the Indian market. However, the work was often inferior, and, in the words of Lt.-Col. Hendley writing in the 1890's, "Although the Punjab is so prominent in damascening, the most artistic work is done in Rajputana (modern Rajasthan) or wherever the Rajput lives".

In Rajasthan the main centre for swordmaking and damascening was the town of Sirohi near Mount Abu. In his *Annals and Antiquities of Rajasthan* James Tod wrote that the sword blades of Sirohi were as famed among the Rajputs as those of Damascus among the Persians and Turks. Sirohi also became a centre for the production of good quality betel cutters and, along with Kota, may be the place of origin of some of the best damascened examples in the collection (nos. 2, 6). A large number of non-damascened iron cutters were also produced in Rajasthan (nos. 10–13, 18, 23–24), especially in the northern part around Jaiselmer and Bikaner. The other major area of iron cutter production was at the other end of the country in Tamil Nadu. Here figurative subjects were preferred, and cutters of exceptional sophistication and complexity were produced (nos. 61, 70).

Brass cutters are produced in many different parts of the country. Among towns mentioned in nineteenth and twentieth century sources as places where betel cutters were made are Bhuj, Mandvi, Anjar, Jamnagar and Patan in Gujarat; Jhalawar, Jodhpur, Sirohi and Kota in Rajasthan; Karnal in Harayana; Kaimganj, Shajehanpur and Meerut in Uttar Pradesh; Timarni and Lalitpur in Madhya Pradesh; Banpas, Khagra and Dinajpur in Bengal; Chatrapur in Orissa; Pune and Nasik in Maharastra; and Madurai and Tanjore in Tamil Nadu. This list is very far from being exhaustive.

A traditional brass casting process used for manufacturing cutters in the town of Jamnagar is described as follows:
"From the original model (which is either an old nut-cracker or a newly made model for further replicas) a mould is prepared. The original model which is to be copied is in two parts, i. e. the part with the cutting edge and the part acting as butt. From the former part the cutting blade is removed while making a mould. A mixture of alluvial river soil and molasses is prepared and filled in an oval-shaped thick iron frame. When still wet the parts of the original model of the cracker are pressed inside the clay frame. The soft clay obtains in recession the impression of the protruding details of the part. When the part is removed, the recessed negative mould in clay is ready. Then dry molten metal is poured in the mould to obtain the replica. After the parts are thus ready, an iron blade is fixed to the cutting lever and the two parts are joined at the top with a rivet so that the instrument is ready for its function. – (J. Jain in "Treasures of Everyday Art" [Marg Publications]).

Jamnagar is also a notable centre for the manufacture of cutters by rather less traditional processes (no. 25). This work

is carried out in small family-owned workshops equipped with electric grinding, buffing, cutting and drilling machines. According to the District Gazetteer for 1970, some forty to fifty families were engaged in this work.

The state of Gujarat is one of the largest areas of betel cutter production. Cutters from Jamnagar are found all over India. So too are those from Kutch, which faces Jamnagar across the Gulf of Kutch and which specialises in a style in which "blank space adorned by the ornament it does not have" is conspicuously absent (no. 14). Gujarati cutters have a number of different styles and substyles, often featuring parrots and *makara* heads.

Despite the occasional parrot north Indian cutters are mainly non-figurative, a fact which no doubt reflects the influence of Islam on north Indian art. South Indian cutters, by contrast, tend to be highly figurative. The animal or, increasingly, the human figures are no longer mere decorative details but are small sculptures encompassing the entire cutter, the handles often forming the legs (nos. 41, 42, 57, 70, 75). At their best these belong to the same tradition of metal casting as fine south Indian bronzes. Many of the most fanciful come from Tamil Nadu. The *mithuna* (embrace) style involves two lovers whose faces are brought together as the cutter is operated (nos. 42, 73–75). Another similar style involves a parent and child (no. 41).

Cutters from Karnataka and the Deccan often have straight column-shaped handles and, like those of Gujarat, have parrots and other animal forms (nos. 52, 53) Orissa in the east has a distinctive style, often with a crescent-shaped blade and with projecting animals and human heads (nos. 43, 45–49).

Sri Lanka.

Although the population of Sri Lanka is only a tenth that of India, the island boasts a wide and distinctive range of cutters, and can claim, with India and Indonesia, to be one of the "big three" of cutter design.

Sri Lankan cutters tend to be quirky and humorous. They continually surprise with their subtlety and complexity. Faces peep unexpectedly and ambiguously from the oddest angles. An abstract shape becomes a figurative one. The handles may have a bizarre dog-leg form as if the cutters seem about to advance on tiptoe. These handles end in stupa-like finials, and these in turn are being swallowed from the top by voracious monsters. Nothing is what it seems. And in use the cutters become miniature puppets in which the jaws open and close

and the young girl's hands are brought to her forehead in greeting. Even the metal surprises with its rich combinations of silver inlay, brass, copper, steel and blackened iron.

The basic Sri Lankan form consists of a flat blade arm with an elongated triangle forming the handle. The butt arm is rounded and curves down from a high hinge. In the distinctive anthropomorphic style known as *vandun giraya* the hinge is at the shoulder and the triangular handle becomes the thigh and leg (nos. 82–84). The hands are extended so that they are brought to the face in a salute *(anjali)* when the cutter is used. Similar cutters are sometimes found in other areas (nos. 45, 72, 78, 159), but this is predominantly a Sri Lankan form.

Another distinctive style *(andu gire)* has the arms extended beyond the hinge to form a beak which opens and closes in use (nos. 87, 89, 92). The dog-leg handles are also distinctive, although parallels can be found in some south Indian cutters (no. 55). Some examples of this style are abstract (nos. 88, 90); others are transformed into spectacular *serependiyas* or other mythical creatures (nos. 93–97). Blackened iron, a technique rather like gun-blueing, is used to protect the cutter against rust and to highlight the silver inlay decoration (nos. 91, 92).

Many betel cutters come from the area around Kandy, the old Sinhalese capital. It was the practice on occasions such as the Sinhalese New Year for craftsmen to present a fine example of their work as a customary gift *(penuma)* to their landlord or feudal superior. For a smith this would normally be a cutter, and many good quality cutters may have been made for this purpose.

China.

Chinese betel cutters are unlike those of any other country. The blade arm is a triangular piece of steel tapering into a loop which enables the cutter to be manipulated by the thumb. The loop terminates in a swan's head, and the neck of the swan is often bound in rattan The butt arm is usually of buffalo horn, though one example in rhinocerous horn is also known. The horn is usually carved in the form of a lion or a horse.

Cutters in this style are rare. In addition to the three collected by Professor Eilenberg only seven examples are known to exist in museum and private collections. This implies that they were not in general use but were confined to a small social elite. They seem to date from the 17th–18th century.

Burma.

Burmese cutters are of two very distinct styles. The more common comes from Upper Burma, possibly from the town of Pyawbwe which has a long tradition of silver overlay on steel weapons. The cutters are fairly simple and are characterised by flat handles rounded at the tip. The blade is straight. The inner edge of the blade arm forms an acute angle with the blade and has a nose-like projection about a third of the way down. All the decorative interest of the cutter comes from the fact that it is extensively overlaid with silver, brass or copper wire in scrolling meanders or bird designs. Cutters of this sort have been exported to India in such large numbers that some people swear that they originate from Madras. Most date from the twentieth century.

The second style is characterised by the very pronounced saddleback form of the blade arm, with the handle bending back from a high shoulder. The nose-like projection noted above becomes here a hook echoing the curve of the blade. The source of this style is unknown, though it has been suggested that it derives from the coastal area of Arakan. The style adheres closely to its own rules, so that two cutters of apparently very different date (nos. 100 and 102) nonetheless have an almost identical form.

South-East Asia

The cutters of Thailand, Malaysia and Indonesia form a discrete group which have basic differences from those of the countries so far discussed. In the latter a variety of metals are used, and, more importantly, the handles are part of the overall structure. By contrast in Thailand, Malaysia and Indonesia all cutters are made of iron, with other metals appearing solely as decoration. The iron handles are plain and are almost always sheathed in tubes of gold, silver or white metal. These sheaths are often finely worked but they are of different workmanship from the cutters themselves, and the cutter therefore becomes the sum of two parts rather than an integrated whole. This is exacerbated by the fact that the sheaths often get damaged or lost and are replaced with others which are not original.

The difference in sheathed and unsheathed styles is best illustrated by comparing the treatment of the horse in cutters from India and Indonesia. In Indian horse cutters (nos. 67-70) the animal's hind legs form the handles, and the horse is therefore shown in action, leaping or charging with a spear-carrying warrior in the saddle. No such action is to be found in Indonesian cutters. Those of Java and Madura are often attractive but are essentially static and two dimensional (nos. 134, 147-153). They are very stylised, with heads that sometimes seem to owe more to the seahorse than the horse, and with exaggerated manes which dominate the composition. Balinese horses are a lot more sculptural and are so naturalistic that one can almost hear them whinny (nos. 168-173). But only the head and neck are shown, so that they lack the movement of Indian horse cutters. The sculptural impact is diminished rather than enhanced by an excessive use of precious metal inlay. Lastly, there are the incongruous sheaths, which may be of gold when the inlay is silver and of silver when it is gold, and which seldom look as if they form part of the original design.

Thailand and Malaysia

Thai cutters mostly come from the southern part of the country which has long political and cultural links with peninsular Malaysia. Because of this there is a shared style, essentially Thai in origin. Cutters of the Thai/Malaysian type are all of roughly the same form, which is slender, boat-shaped and generally smaller and less robust than cutters from the Indian subcontinent. At the hinge end is the head of a mythical monster, whose jaw and crest move when the cutter is used. In Malaysian examples this head is sometimes stylised into an abstract or semi-abstract form in deference to the Islamic dislike of figurative representation. The animal's tail is shown as a spike jutting forwards from the blade arm near the handle. In Thai/Malaysian cutters this tail is either vestigial or is highly stylised so as to resemble a typical Thai flame motif (nos. 115, 116, 119).

The handles are sheathed in gold, silver or white metal, sometimes with niello decoration. Niellowork, often combined with silver-gilt, was the speciality of the town of Nakhon Si Thammarat in south Thailand, from where the technique spread to the Malaysian state of Kedah. The sheaths end in finials which vary from characterically Thai lotus buds (nos. 111-114) to the round and parasol shapes found in Malaysia and Indonesia (nos. 115, 120).

Indonesia.

Indonesian cutters come almost exclusively from the five most westerly of the chain of islands forming the archipelago's

spine. These are Sumatra, Madura, Java, Bali and Lombok.

Sumatra, an island about the same size as Sweden, has three main styles: that of the artistically prolific Batak people in the north-central part of the island (nos. 122-124); a trapezoidal geometric style from the area around Palembang in the south (nos. 125-127); and a comical style from the Lampung district at the extreme southern tip (nos. 128-130). Cutters said to come from the far northern district of Aceh, an area known for its severe Islamic piety and its strong trading links with India and Arabia, have been found to be either Indian imports from Gujarat or local imitations of Indian styles.

Madura is a narrow island running along the north coast of east Java near the port of Surabaya. Madurese cutters, which unsurprisingly are stylistically related to those of east Java, are of plain iron forged into two-dimensional forms which are intended to be seen in silhouette. The most dramatic of these is a bird with a long curved beak, of which no. 135 is a large and spectacular example. Other subjects include horses and mythical monsters. There is no inlay or complex silver sheathing. Instead the main decoration takes the form of openwork designs, particularly around the animal's crest or mane.

Over two-thirds of Indonesia's 180 million people are crammed into the relatively small island of Java which accounts for only seven percent of the country's landmass. In this situation cutters naturally tend to migrate from one area to another, and styles overlap. Three broad styles can be identified. Cutters from the cultural heartland of central Java around the old royal capitals of Jogjakarta and Surakarta tend to have very small blades and long handles and to depict *nagas* and birds (nos. 136-146). Those from the northern coastal area have silver or white metal sheathing not just on the handles but on large areas of the cutter as well. The subjects include horses, spectacular stags and figures from the *wayang* shadow play (nos. 151-158). Horses, rather crudely modelled with small heads, are also a common subject in the third style which comes from east Java (nos. 147-150).

Bali and Lambok are culturally linked owing to the existence of a strong Balinese component in Lombok's population, and their cutters are so similar as not to be worth treating separately. In general Bali/Lombok cutters are more robust and three-dimensional than those of Java. Subjects include birds (nos. 179-182), *singhas*, elephants, horses (nos. 168-178), and clowns from the *wayang* shadow play (nos. 165-167). Most of the animals have wings, which, in the case of the *singhas* and elephants, are shown naturistically on either side but, in the case of the horses, are shown as a single stylised spike jutting up from the shoulders. Similarly, the *singha* tails are shown as an elegant flame-like curve (nos. 177, 184-185), whereas horse tails take the form of a forward-raked spike not unlike those found in Thailand and Malaysia. (In Java the spike is vestigial and its purpose in representing the tail has been forgotten, so that it appears as freely on cutters depicting humans (nos. 157-161) as on those depicting animals.)

Silver and gold wire inlay is a Balinese speciality. The iron is first covered with resin glue. Grooves are cut into the metal with sharp chisels, and small teeth cut in the sides of the groove. Silver wire is inserted into the groove, and the whole surface then hammered so that the teeth hold the inlay in position. The most popular decorative motif is a pattern *(banji)* of interlocking swastikas. This is a common Balinese motif but is also found as far afield as Tibet and Korea. The inlay work is often combined with rather crude overlay on a cross-hatched surface. A wheel-like solar symbol is sometimes shown near the tail.

Indonesian cutters are, of course, the work of ironsmiths, whose role needs to be seen in the context not only of craft techniques but also of popular superstition. In much of Asia official religion coexists with strongly held animistic beliefs. This is particularly true in Indonesia, and nowhere more so than in Bali where the veneration of spirits (or, more precisely, the propitiation of potentially dangerous supernatural forces) is almost a continual occupation. Many objects and substances have magical attributes, and among these is metal, especially iron. In the words of the Dutch scholar Roelof Goris – ('The Position of the Blacksmiths')

"All metal was and is considered by Indonesians as magically "charged" and anyone who desires to be in daily contact with it must himself have magic power at his disposal since otherwise there are great risks involved. For this reason the smiths constituted a separate geneological group in which not only the techniques of forging was kept secret but certain magical craft usages were retained".

The two words used for smith are *empu*, a title implying special power to cope with the supernatural world, and *pande* meaning expert. Balinese ironsmiths *(pande besi)* lived in communities which worshipped at special temples and claimed the god Brahma (here seen as Lord of Fire) as their progenitor through a mythical ancestral proto-smith known as Empu Pradah. These communites served the royal court, but the

relationship was not entirely one of dependency since even the nobility found it necessary to be on good terms with these dangerously powerful people. The smiths were able to sidestep the authority of the Brahmins, claiming that the Empu Pradah tradition predated the brahminical one.

Part of the prestige of Javanese and Balinese smiths came from their role as makers of *keris*, the magically endowed daggers which played a central role in traditional Indonesian society and were venerated almost like a family deity. The relationship between *keris* and betel cutters is of some interest. Although the cutter is a totally secular object with no magical overtones, many of them were made by the same people who made *keris* for the courts. The same motifs are used, often protective beasts like the *naga* and *singha*, and in some cases (nos. 136, 175) cutters are made of the same material, *pamor*, a combination of wrought and nickel-containing "meteoric" iron which gives *keris* their characteristic watered appearance. Furthermore, some cutters, especially those from Palembang in Sumatra (nos. 125–127), have on the vertical inside edge of the blade a series of indentations and serrations similar to those, known as *greneng*, found near the hilt on a *keris* blade. In the *greneng* each notch has a name – elephant's trunk, elephant's tusk, elephant's lips, thorn, beard, bean sprout, etc. No similar nomenclature exists for the cutter, but it is clear that these indentations conform to rules and are not merely haphazard.

Colour Plates

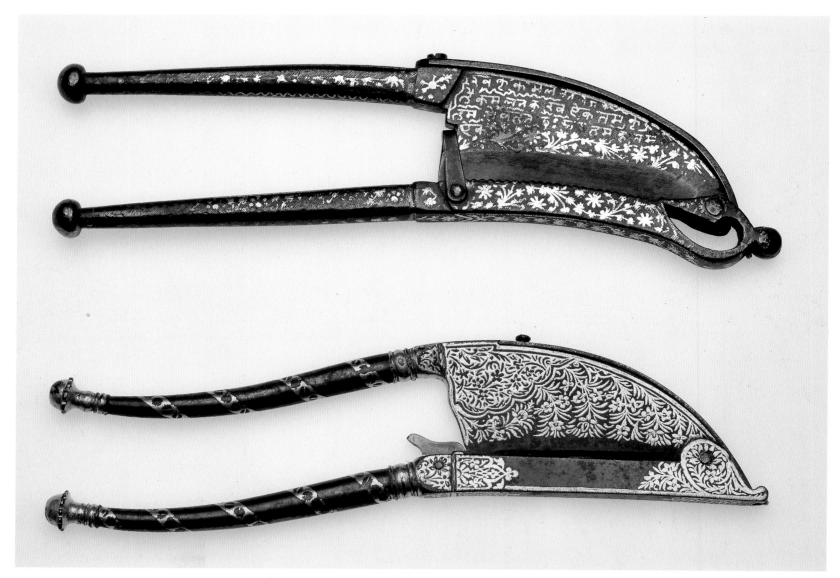

INDIA

Cutters of the "spring-catch" type popular in North-west India. The spring running along the upper rim forces the cutter open unless it is secured with the catch.

1. Steel with silver and gold overlay. 175 mm. Rajasthan.
The overlay on the side illustrated is of gold and silver wire applied to the hatched surface of the metal. A verse inscription is combined with a scrolling pattern. On the other side there is a somewhat different foliar pattern in silver, but no gold and no inscription.

2. Steel with gold overlay. 174 mm. Rajasthan.
Elegantly shaped cutters with extremely fine gold overlay. A sophisticated touch is provided by the cartouche at the top left where the pattern is shown in reverse with steel flowers silhouetted against the gold. This is similar to the style of bidriware known as *aftabi*. A spiral band of gold down the handles is another attractive feature.

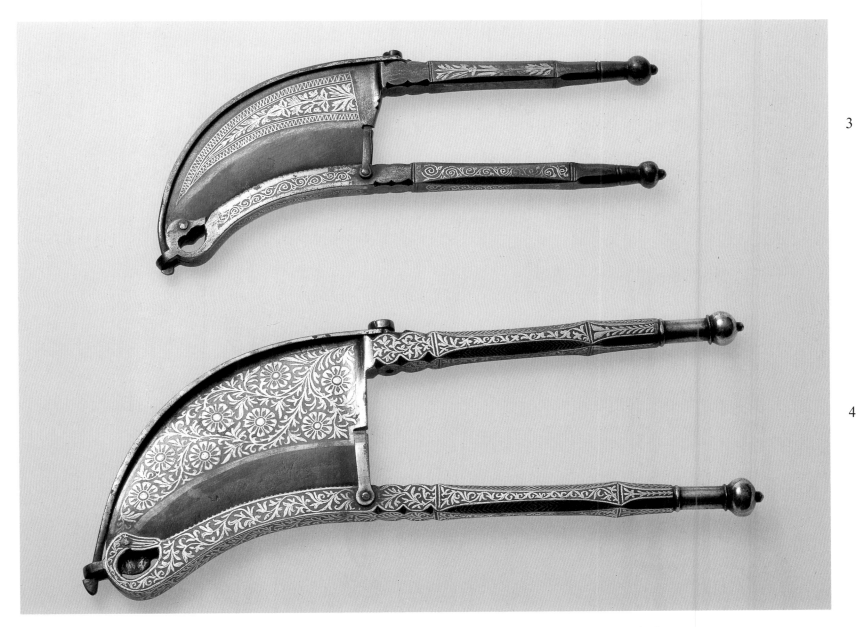

More cutters in the "spring-catch" style.

3. Steel with silver overlay. 175 mm. Rajasthan.
A late cutter with overlay work which is rather weak and debased in comparison to the other examples shown. As with several cutters in this style there is a duck's head and neck motif with the eye formed by the hinge and with a socket to hold the lower end of the spring.

4. Steel with silver overlay. 212 mm. Rajasthan.
The overlay here is very much stronger in design. It consist of a floral and foliar scrolling pattern which extends down the well-shaped handles.

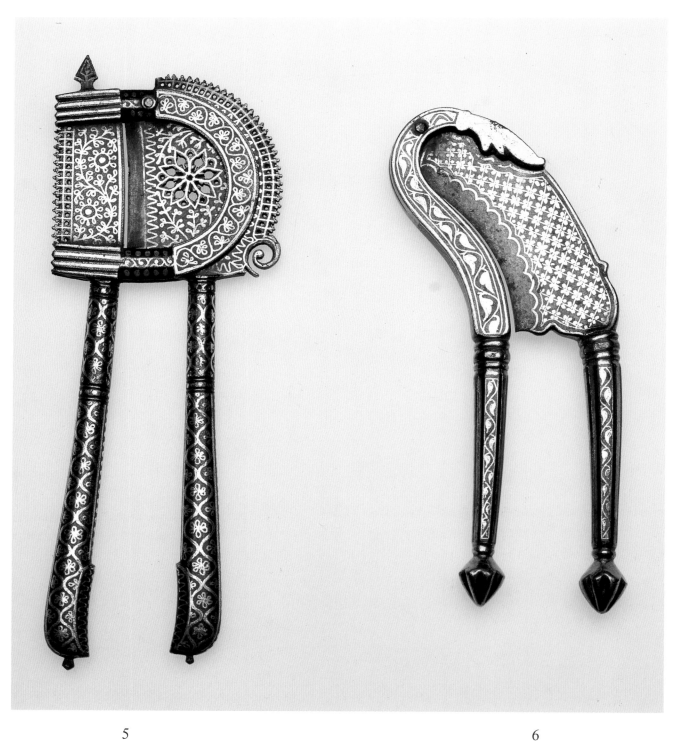

5

6

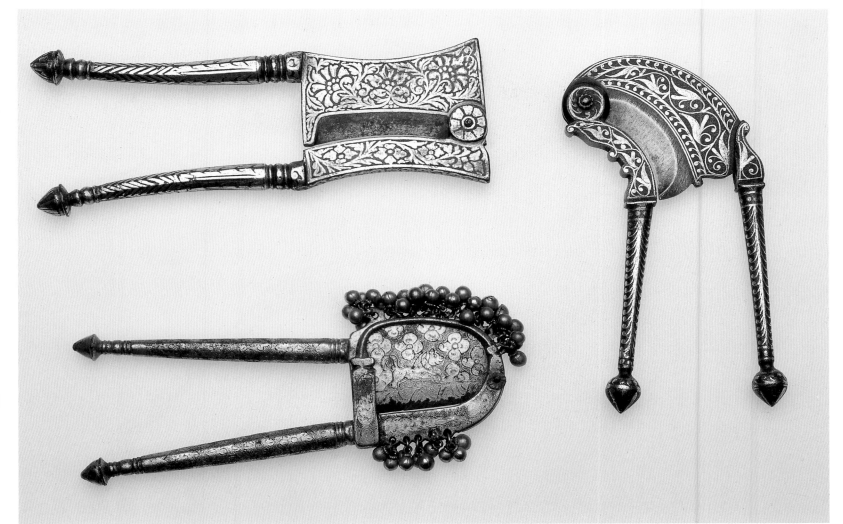

7

9

8

5. Steel with silver overlay. 164 mm. Probably Rajasthan.
An example of the "guillotine" style in which the blade moves inside a D-shaped arch attached to the lower arm. These cutters come mainly from north-west India, especially Rajasthan, and may be of brass or iron. This fine example combines openwork tracery with silver wire overlay in the form of arabesques and trellises. The arms end in "lobster claws" rather than the usual bud finials.

6. Steel with silver overlay. 132 mm. Rajasthan.
The silverwork is of very good quality and is unusual in that the pattern is different on the two sides: miniature florettes on the side illustrated, and a chequerboard design on the reverse. The lower arm projects beyond the hinge in a stylised *naga*, a feature common in Rajasthani cutters.

7. Steel with silver overlay. 152 mm. West India.
Square-topped, with the hinge in the form of a rosette. The metal is overlaid with silver in a floral pattern.

8. Iron with gold wash. 142 mm. Deccan.
The whole surface of the iron has been scored and then partially gilded to form a pattern of rosettes with a lion. Silver jingles are attached to the top and bottom.

9. Steel with silver wire overlay. 132 mm. Rajasthan
Apart from the cutting edge the whole surface has been crosshatched and overlaid with silver wire in a foliar pattern. The work is inferior.

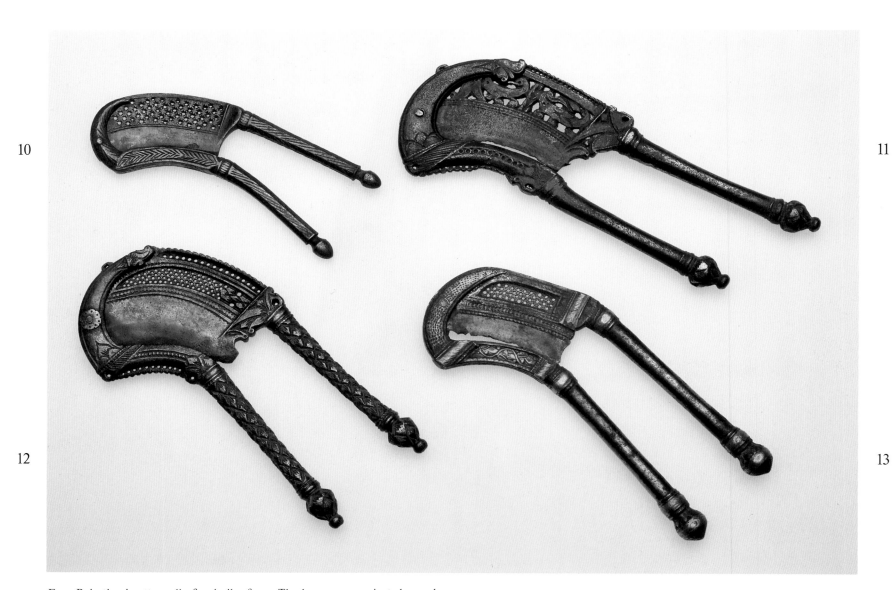

Four Rajasthani cutters all of a similar form. The lower arm projects beyond the hinge to form a beak, snout or *naga* (snake). The hinge forms the eye.

10. Iron 118 mm. Rajasthan
Pierced decoration.

11. Iron. 170 mm. Rajasthan
An openwork pattern of birds.

12. Iron. 146 mm. Rajasthan (probably Jaiselmer).
Pierced decoration. Traces of lac inlay.

13. Iron and brass. 145 mm Rajasthan (probably Jaiselmer)
Pierced decoration.

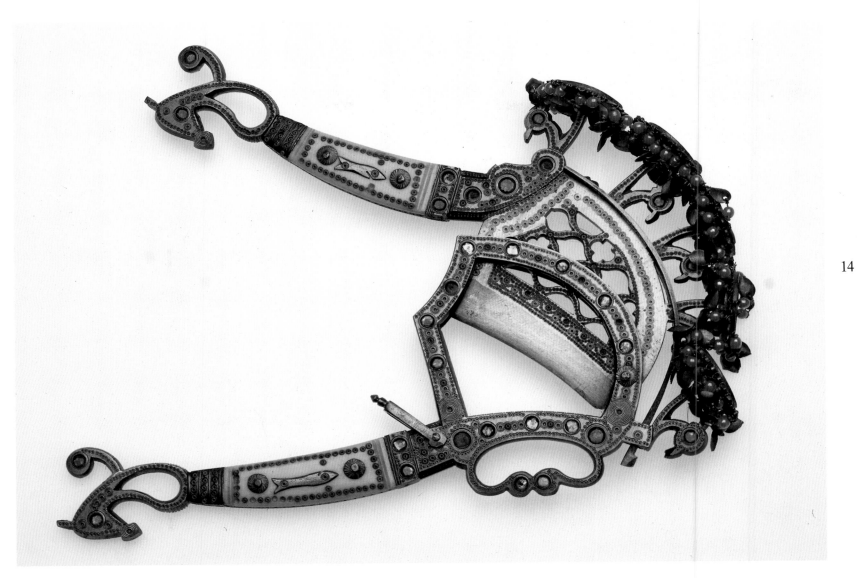

14. Brass with inset bone panels, glass, mirrors and beads. 214 mm. Kutch, Gujarat.

Kitsch from Kutch. This twentieth century cutter is a particularly extravagant example of a relatively well-known type. In essence it is a combination of the "guillotine" and "spring-catch" forms. To this has been added such a wealth of embellishment that the finished item seems almost like a piece of confectionery. The brass is milled with a pattern of tiny roundels, some of which have been set with foil-backed coloured glass. The handles terminate in horses' heads, and each has a bone panel set with a brass fish and tiny blue beads. Peacock heads and mushroom-shaped projections protrude from the back; each mushroom is set with a mirror and decorated with pendant beads and brass peepul leaves.

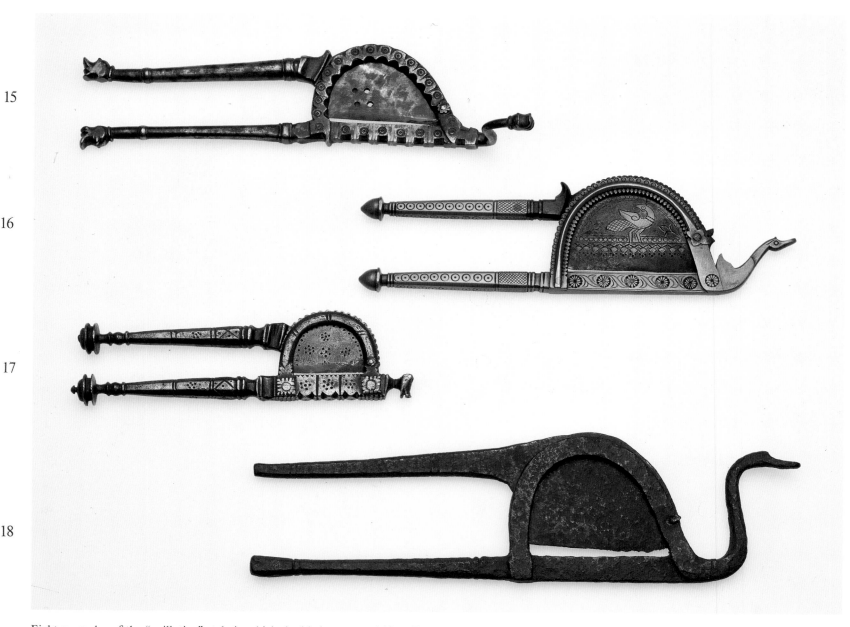

Eight examples of the "guillotine" style in which the blade moves within a D-shaped arch.

15. Steel with brass fittings. 220 mm. Rajasthan
The projection at the end is sideways to the cutter and terminates in a brass makara head.

16. Brass and iron with traces of red lac inlay. 209 mm. Bengal.
There is a swan's neck projection, and a brass bird is set into the blade. the other side is inscribed "H. Ghosh 1887".

17. Iron. 158 mm. Deccan.
A typical Rajasthani cutter with an animal head projection.

18. Iron. 259 mm. Rajasthan
Although similar in shape to no. 16 from Bengal, this iron cutter comes from Rajasthan.

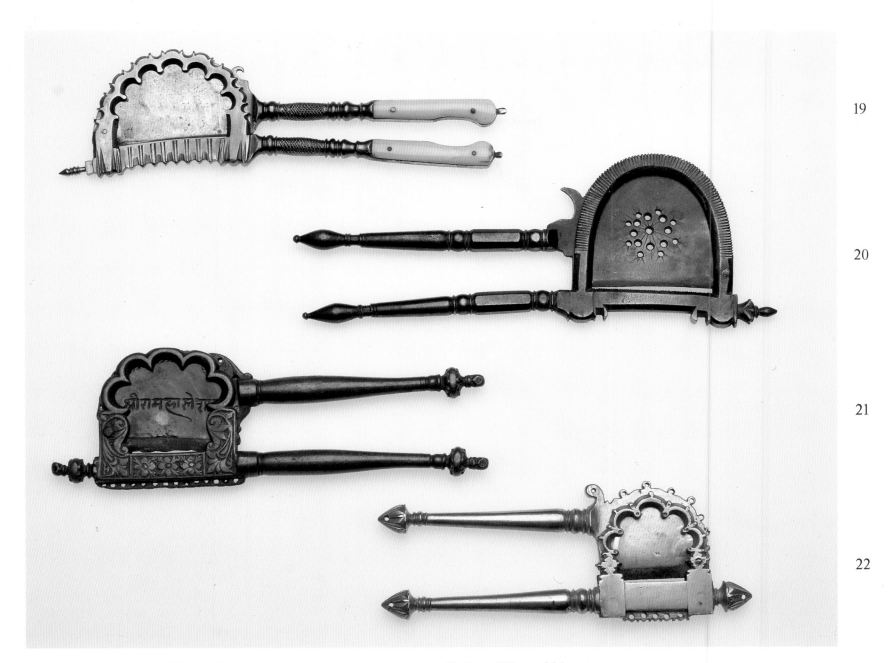

19. Steel with ivory panels. 186 mm. Deccan.
Finely cut steel. The cutter combines a cusped "Mughal" arch with handles influenced by European design.

20. Iron. 199 mm. Rajasthan or Maharastra.
A plain cutter simply decorated with striations on the arch and an irregular pattern of holes drilled in the blade.

21. Brass. 175 mm. Maharastra.
The arch is cusped. An incised Marathi inscription reads *"Shri Ram Haste Sham"* ("From Ram to Sham"). This is a saying like "from here to there" and does not imply that Ram gave anything to Sham.

22. Silver with traces of gold wash. 150 mm. Maharastra.
Another cusped "Mughal" arch. There are holes for attached jingles, now missing.

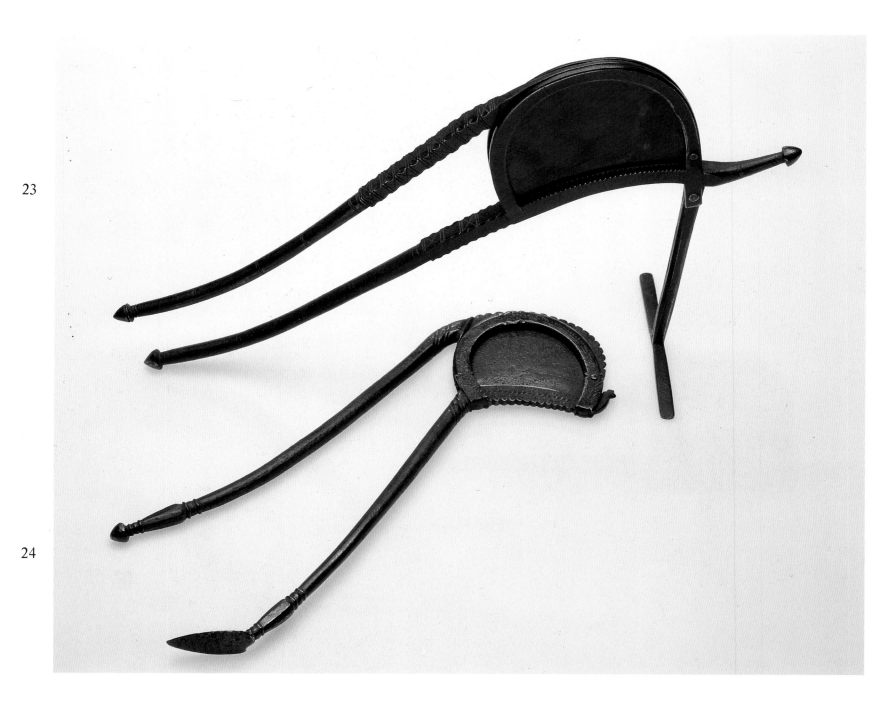

23

24

Two large cutters of the type used by professional areca vendors *(suparivalas)*. Large cutters in Gujarat and Rajasthan are known as *sudo*, smaller ones as *sudi*. The expression *"Sudi veche supari"* (areca caught between the arms of a *sudi*) is used of someone who is caught in a dilemma.

23. Iron. 454 mm. Rajasthan.
Essentially a typical, though outsize, example of the Rajastani iron "guillotine" style. A hinged foot enables it to stand upright when in use; this can then be folded away for transport or storage.

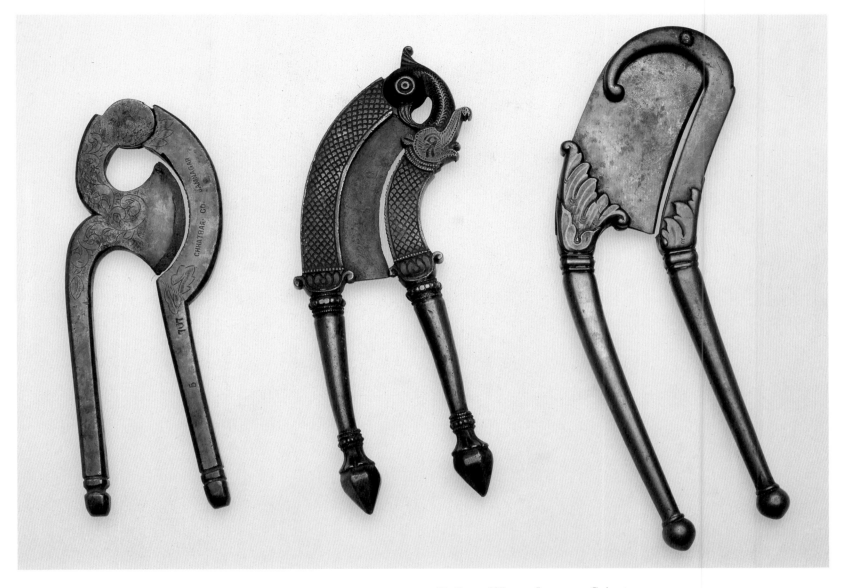

25. Brass. 137 mm. Jamnagar, Gujarat.
An industrially produced cutter inscribed with the manufacturer's name, "CHHATBAR CO. JAMNAGAR". Jamnagar on the southern side of the Gulf of Kutch is a major centre of cutter production, and its cutters are famous all over India. This example has an unusual crescent-shaped blade.

26. Brass. 157 mm. West Bengal.
The brass surface has fish-scale decoration. There is a peacock head at the hinge and a makara head below.

27. Brass. 172 mm. Rajasthan.
Cast brass with European-influenced ornamentation.

24. Iron. 378 mm. West India.
Another large "guillotine". The handles stand at an angle to the arch. The lower handle ends in a flat projection or which the user can place his toe to keep the cutter upright.

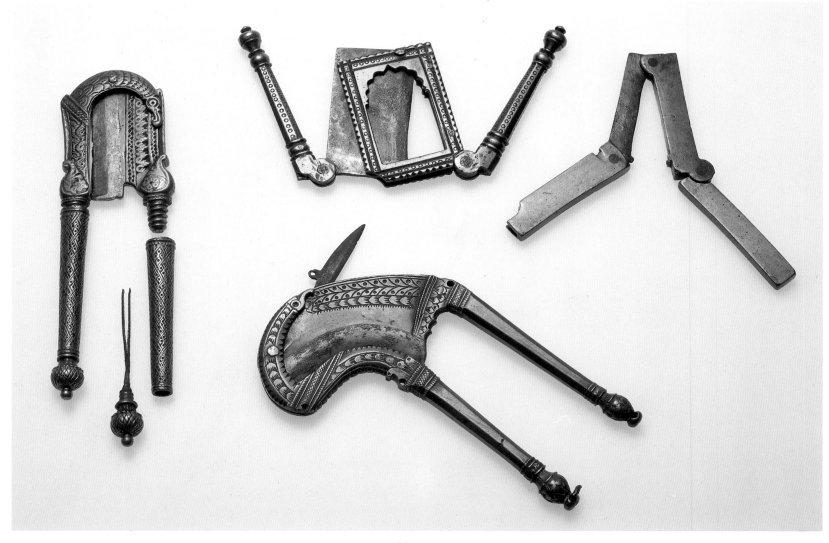

28

30

Folding cutters and cutters which include small additional implements.

28. Brass with lac inlay. 147 mm. Rajasthan (probably Jaiselmer).
The handles are hollow tubes. The finials unscrew to reveal a spatula and a pair of tweezers. Inlaying brass with lac is common in many parts of India including Rajasthan, Uttar Pradesh, Bengal and Orissa.

29. Brass. 82 mm. folded; 136 mm. extended. Rajasthan or Deccan.
A very unusual design. The blade moves within a window in the form of a cusped arch. The handles are hinged so that it can be folded away.

30. Brass. 146 mm. Probably Rajasthan.
A small hinged penknife is concealed in the back.

31. Brass. 61 mm. folded; 204 mm. extended. Probably Maharastra.
An unusual three-jointed folding cutter made out of strip brass.

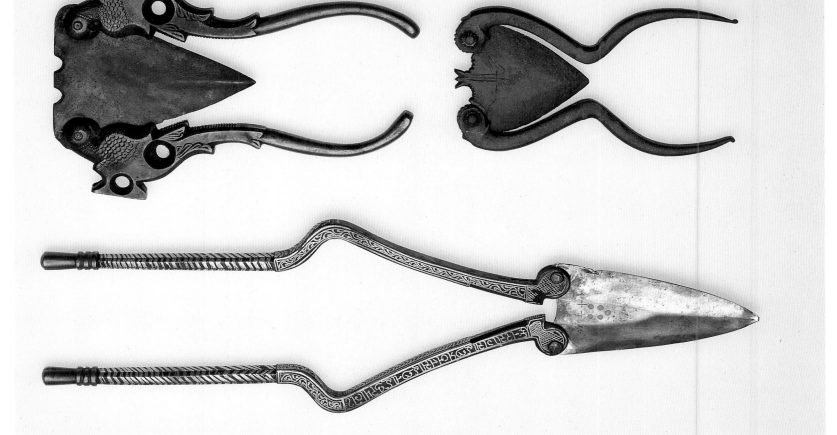

32

33

34

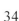

Examples of the *"katar"* style. The *katar*, one of India's most characteristic edged weapons, is a triangular-bladed punch-dagger. These cutters resemble the *katar* in the shape of the blade. When closed it is merely a two-bladed betel cutter. Opened up it becomes a serviceable weapon which is said to be used by women to protect themselves.

32. Iron. and brass. 153 mm. closed; 221 mm. open. Deccan.
Two parrots, their tails extending into curved handles. The large holes in the brass appear functional rather than decorative, and were possibly bound together to hold the cutter in the open position.

33. Iron. 120 mm. closed; 163 mm. open. Deccan.
A simple but attractive implement with a heart-shaped blade.

34. Steel with silver wire inlay. 232 mm. closed; 312 mm. open. Kutch, Gujarat.
The inlay, which is of poor quality, includes a Gujarati inscription: *"Ku(nvar) Narsinghji Prabatsimhji in Hujurma Bhet"* ("This is a present from Narsinghji Prabatsimhji to His Highness"). This may indicate that the maker himself offered examples of his work to his superior on special occasions, a practice also found in Sri Lanka.

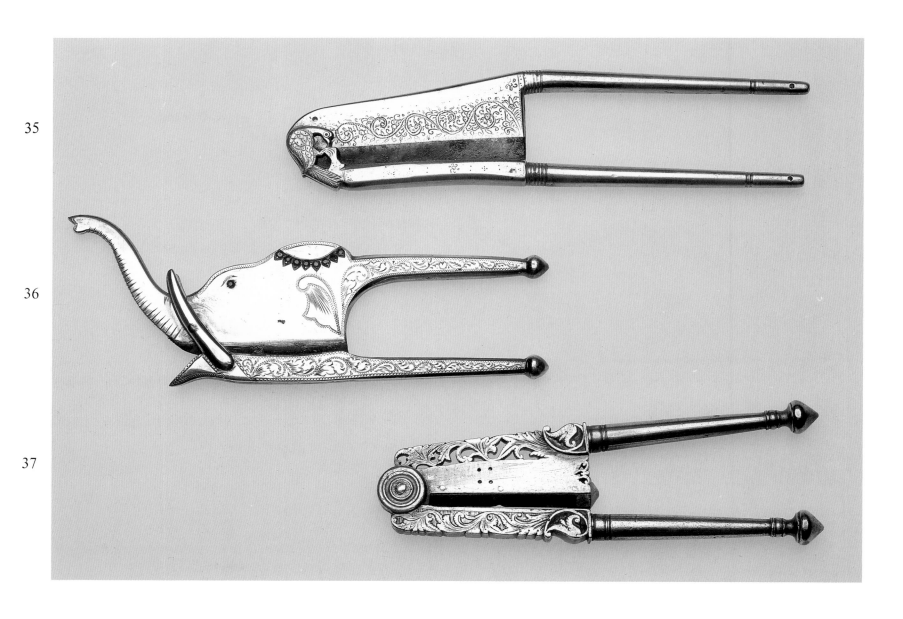

35. Silver. 134 mm. Gujarat (probably Jamnagar).
The silver has a dotted scrolling pattern. The hinge is an unusual bird form.

36. Silver with rubies. 128 mm. Bengal.
A fanciful twentieth century cutter in the form of an elephant, its head adorned by a coronet of Burmese rubies. The cutter was almost certainly intended for use by a lady.

37. Silver. 112 mm. Rajasthan.
The silver has chased and openwork decoration.

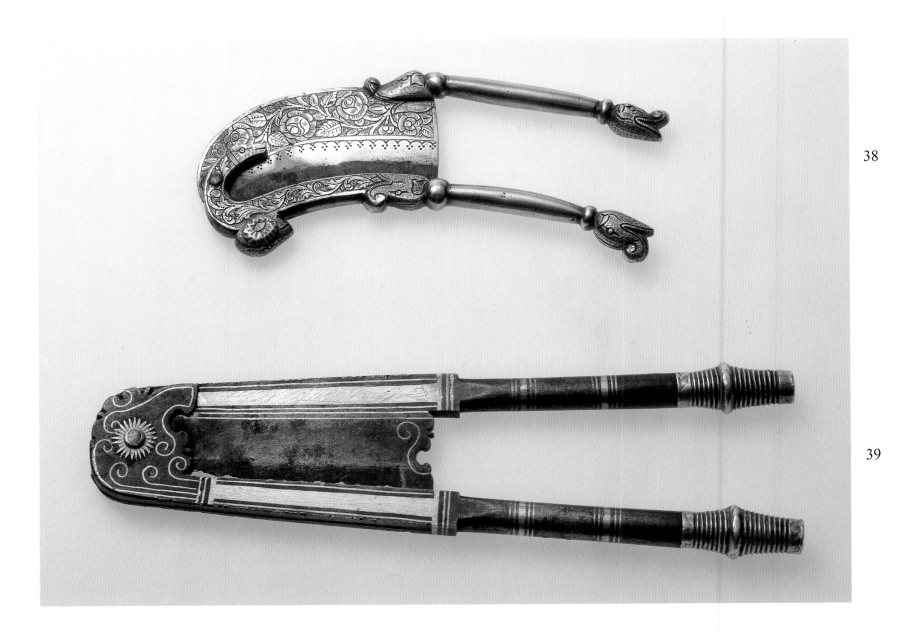

38. Bell-metal, silvered. 126 mm.
There is a chased floral design and no less than six animals' heads including
the ram's head projecting from the lower arm.

39. Steel inlaid with silver. 174 mm. Tamil Nadu.
Unusual cutter of straight tapering form. The inlay gives it a rather austere
neo-classical appearance which is offset by scrolling around the hinge and a
star-shaped washer. The tips of the handles are sheathed in silver.

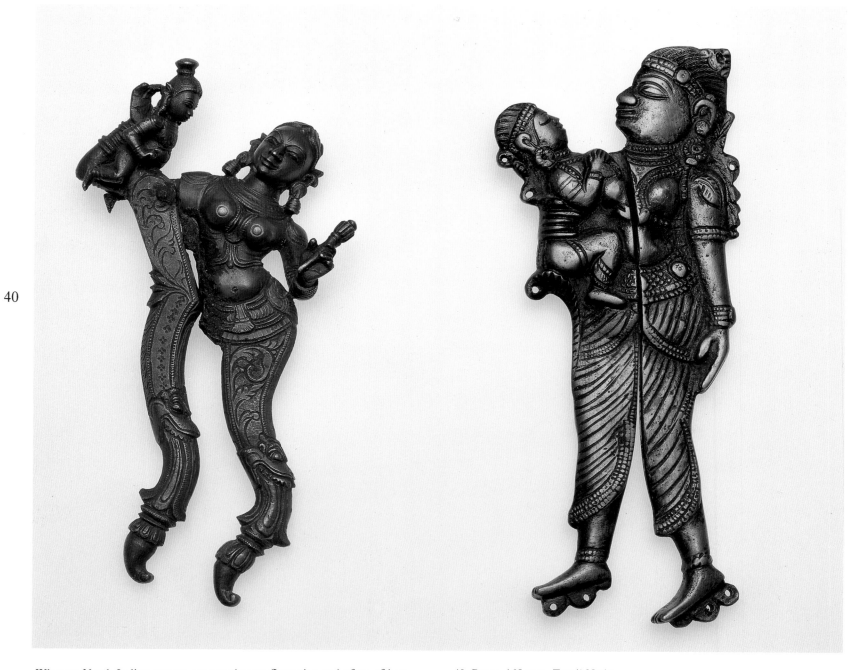

40

41

Whereas North Indian cutters are mostly non-figurative and often of iron, those of the Deccan and South India are usually of brass and exhibit fine sculpture of human and animal forms. The human designs often, as here, involve two figures: embracing lovers or mother and child.

40. Brass. 165 mm. Tamil Nadu.
Mother and child, probably Yashoda and the child Krishna. The child sits on the woman's right arm. Her upper body is naked except for jewels. The curve of her thigh is repeated in the shape of the handles, where liquid gushes from the mouths of *makaras*.

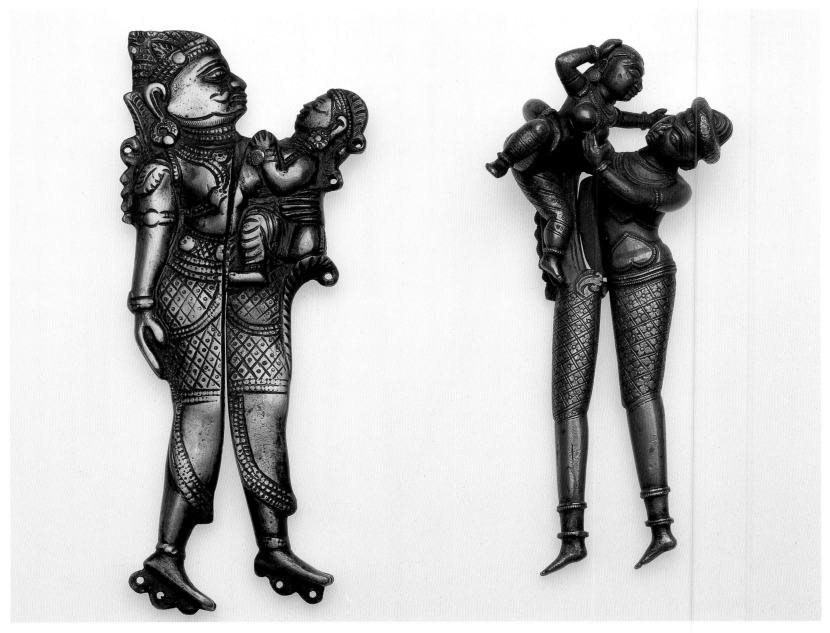

41. Brass. 181 mm. Tamil Nadu.
One side of this cutter depicts a moustachioed warrior, while the other (shown on the opposite page) has a sari-clad woman. Both carry a child clasped to their chest. Images combining both sexes are not uncommon in India: for instance Ardhanarisvara, a form of Shiva, is shown as half-man, half-woman. These figures are more likely to be folk characters than deities. The cutter is impractical as the blade is small and the arms cannot open wider than 40 degrees.

42. Brass. 160 mm. Tamil Nadu (probably Tanjore).
A finely modelled example of the *mithuna* ("embrace") style. Two lovers lie together in an erotic posture, his hand at her breast, and their heads move together as the cutter is opened. Like most *mithuna* figures he makes love wearing a turban.

43 44 45

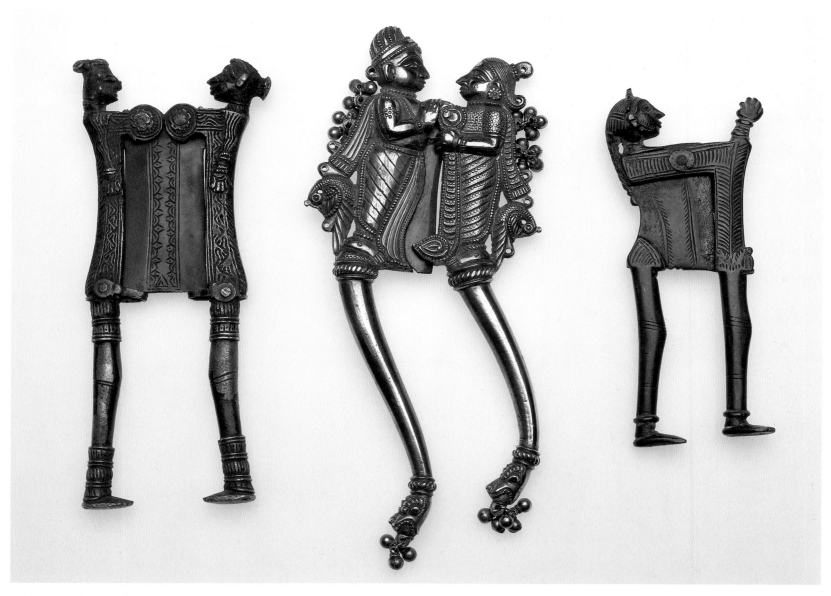

43. Brass. 152 mm. Orissa.
Double cutter showing a man and a woman facing each other. The handles can be secured with catches.

44. Silver gilt. 175 mm. Maharastra.
A romantic piece again illustrating the *mithuna* ("embrace") style, which is emphasized by the presence of parrots, symbolic of Kama the god of love. The man's high turban is typical of Pune, former capital of the Maratha *peshwas*. Brass versions of this style are also found, and some of them have been made recently for the tourist market.

45. Brass with traces of red lac. 122 mm. Orissa.
The hair is braided. The hands are extended rather in the manner of some Sri Lankan cutters (nos. 79–84).

66

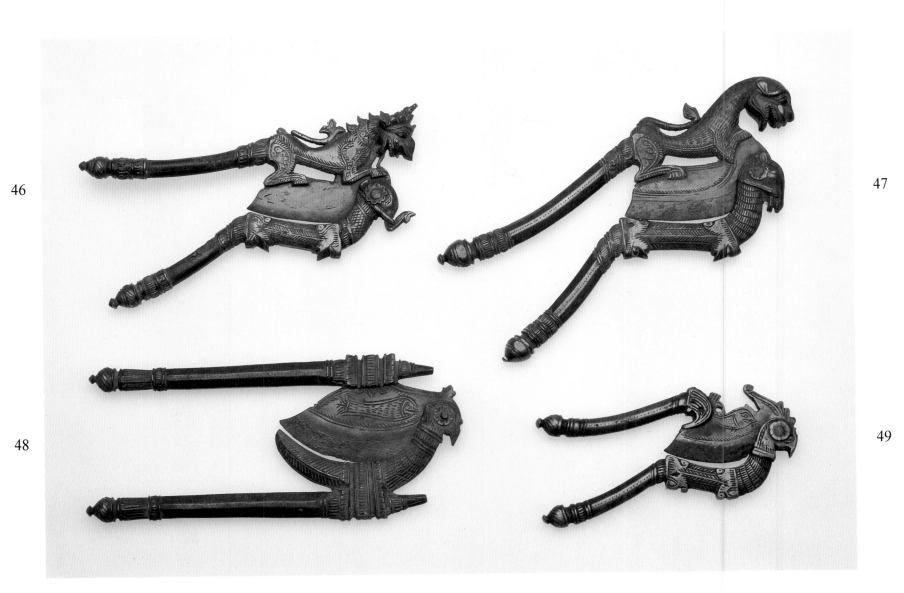

46

47

48

49

Cutters from Orissa in eastern India have certain characteristic forms. Nos. 43 and 45 are rectangular, with heads protruding from the corners. Nos. 46—49 have a distinctive crescent-shaped blade. In all of them the brass has dark patination, and several of them have traces of red lac inlay. T. N. Mukerji ["Art Manufactures of India" (1888)] cites the the town of Chatrapur in Orissa as a centre of betel cutter manufacture.

46. Brass with traces of red lac. 149 mm. Orissa.
Two animals: a crowned mythological lion on top, and an elephant below.

47. Brass with traces of red lac. 167 mm. Orissa.
Similar to no. 46. Two animals, this time a tiger on top and a horse's head below.

48. Brass. 152 mm. Orissa.
Simpler than the others. The blade fits into a sickle-shaped socket in the form of a bird, the hinge acting as its eye.

49. Brass. 108 mm. Orissa.
Cutter in the form of a cockatoo.

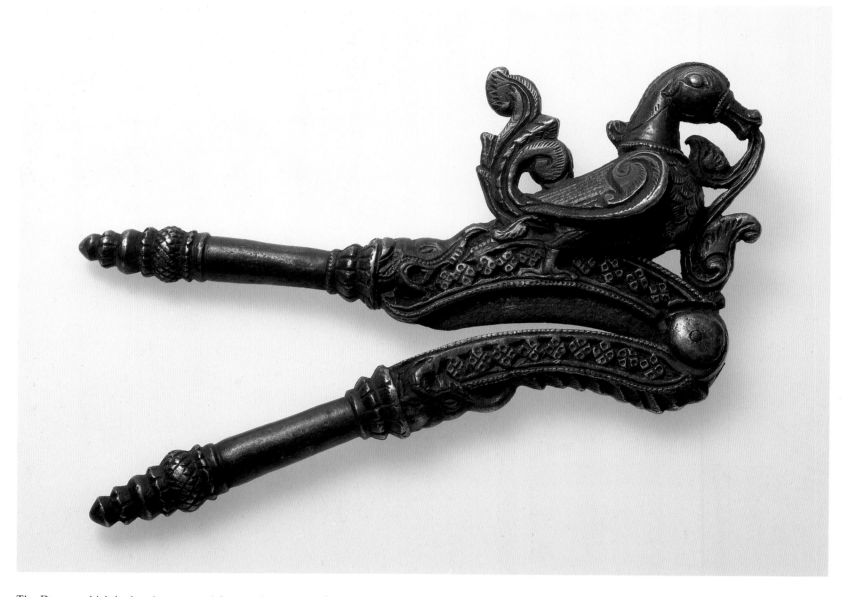

The Deccan which is the plateau area lying south and east of Bombay but north of Madras, produces a variety of styles. In the five examples shown the handles are straight and birds or animals project from the sides. Cutters from Karnataka (formerly Mysore state) are heavy and have cylindrical column-like handles.

50. Brass. 153 mm. Deccan.
A *hamsa*, modelled in the round, perches on the blade arm. The *hamsa*, a mythological goose, is the vehicle of the god Brahma. It is normally shown with lotus shoot foliage hanging from its beak.

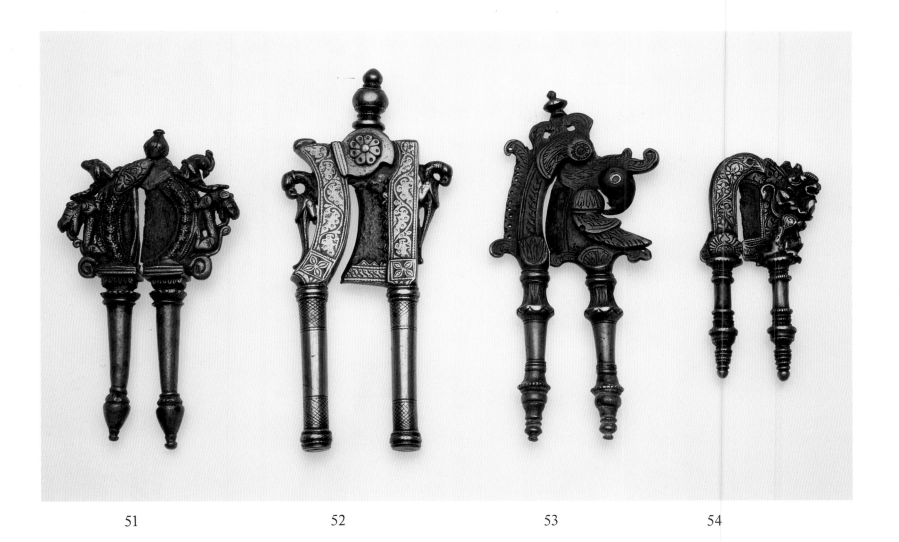

51. Brass. 148 mm. Deccan.
An unusual oval frame is surmounted by lions and parrots. (The parrot on
the left is without its head).

52. Brass. 175 mm. Karnataka.
Typical of the Karnataka style. The blade is framed by a rectangular arch
with parrots on either side. The handles are heavy and cylindrical.

53. Brass. 161 mm. Deccan.
In place of the small parrots in no. 52, here a large parrot composes the
whole of the blade frame.

54. Brass. 105 mm. Deccan.
A stylized lion, standing on a prostrate elephant, faces outwards from the
blade arm.

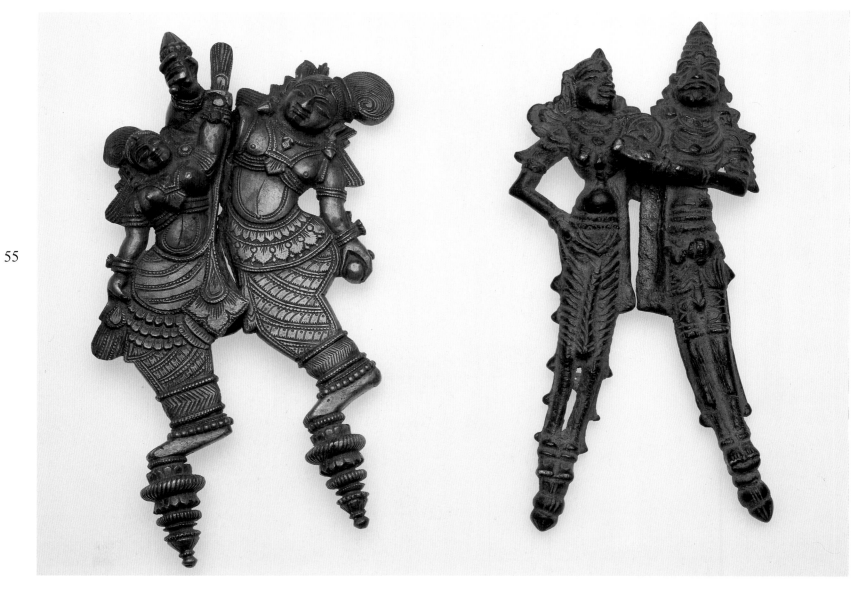

55

56

55. Brass. 162 mm. Tamil Nadu (probably Madurai).
A cutter showing a dancing couple with entwined arms. The scrolling coiffure is found in Nayak art from Madurai. The feet rest on finials composed of rings tapering towards the tip.

56. Brass. 164 mm. Tamil Nadu.
A well-patinated cutter in the *pudukottai* folk style from Tamil Nadu.

57. Iron with brass inlay and mounts. 206 mm. Andhra Pradesh

This early cutter in the form of a saluki is thought to come from the site of Golkonda near Hyderabad, which from 1512 to 1687 was an independent kingdom famous for the wealth of its gemstone mines. The cutter's surface has an incised design. The blade is held in place by iron panels fastened by pins. Salukis are a breed of Arabian gazelle-hound said to be named from the South Arabian town of Saluq. Bred as hunting dogs, they were prized for their intelligence and loyalty. They are referred to in Arabic literature from as early as 750 AD and are frequently depicted in Indian painting.

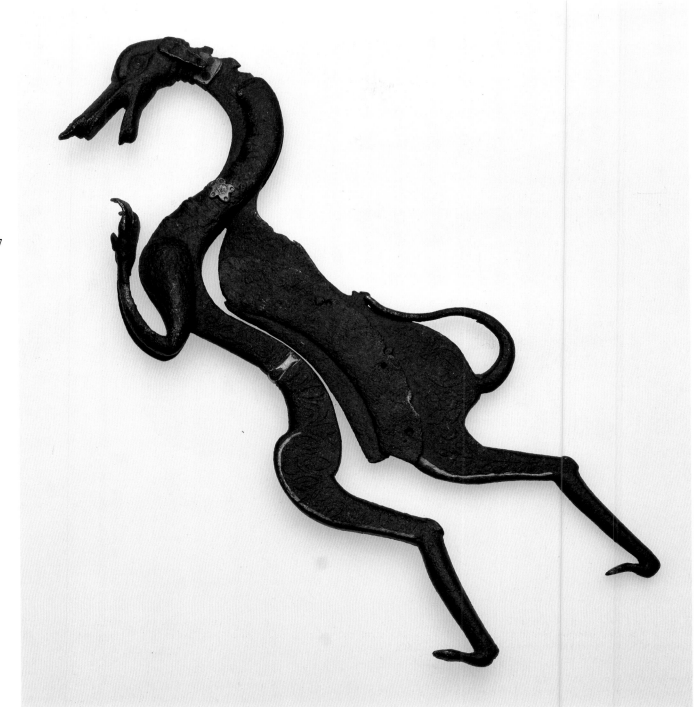

57

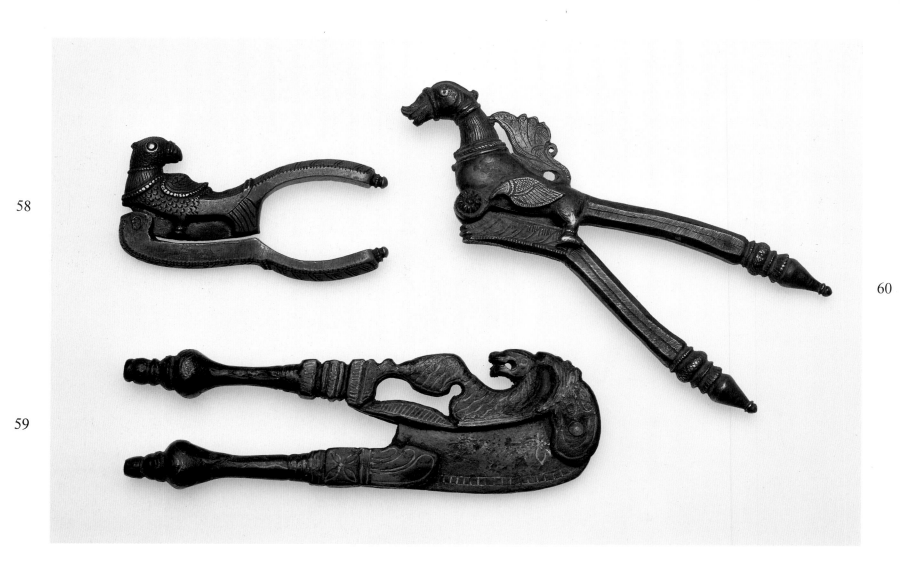

58

59

60

58. Brass. 95 mm. Deccan.
Parrot with reversed head.

59. Iron with brass wire inlay. 166 mm. Tamil Nadu.
An early cutter depicting a leonine beast.

60. Brass. 170 mm. Deccan.
Bird cutter with similarities to no. 50.

These two cutters probably date from the seventeenth or eighteenth century.
The flat-hatted European horseman seems to be wearing seventeenth century
dress. Several related cutters have been found and are believed to come from
Tamil Nadu.

61. Iron. 180 mm. Tamil Nadu.
A European horseman with a board-brimmed hat. There is a leonine beast
beneath the horse and a peacock behind it. The finials are similar to many
Sri Lankan cutters.

62. Iron. 182 mm. Tamil Nadu.
Beaked cutter similar to the Sri Lankan style know as *andu gire* (nos. 87, 89, 92).
A *yali* (mythical bird) provides the main decoration.

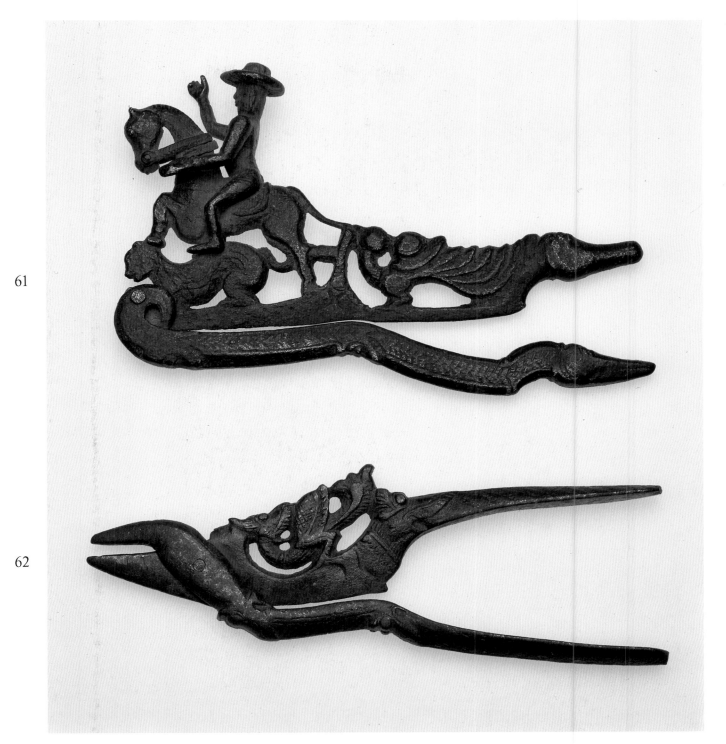

61

62

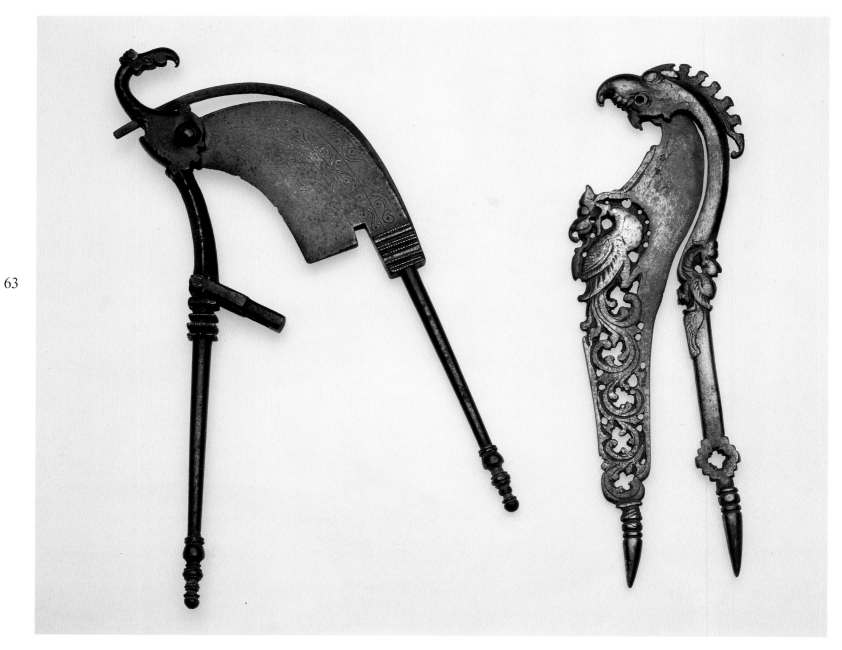

63 64

63. Iron. 260 mm. Tamil Nadu (probably Madurai).
This is a relatively unusual South Indian example of the "spring-catch" style
normally found in the north (nos. 1–4, 14). The *yali* head is typically Tamil.
There is incised decoration on the blade.

64. Iron. 234 mm. Tamil Nadu.
This is again in the form of a *yali*. The cutter's general shape is comparable
to some Sri Lankan examples (nos. 95–96).

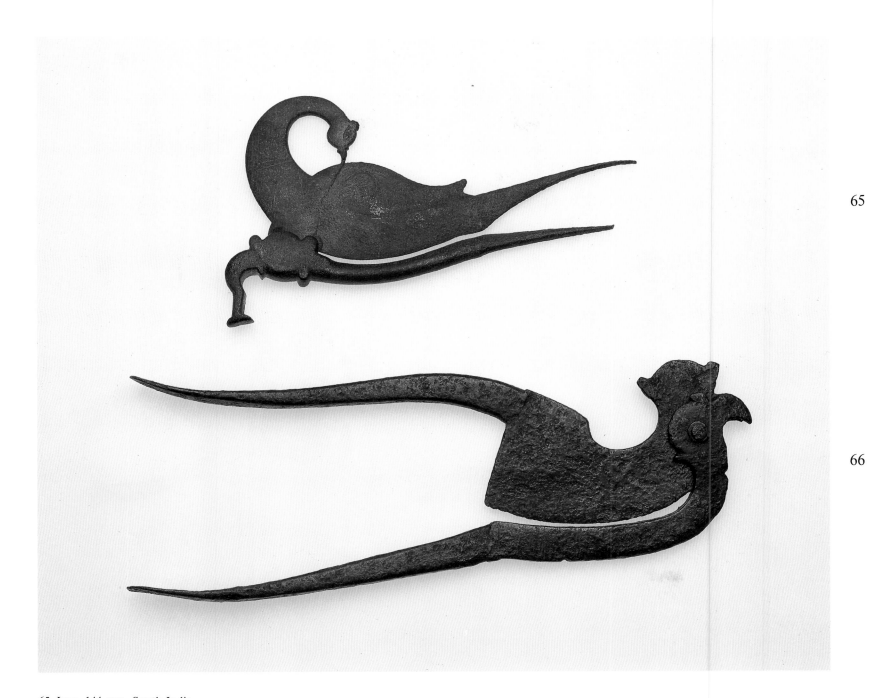

65. Iron. 144 mm. South India.
A simple but elegant cutter in the form of a peacock.

66. Iron. 205 mm. South India (possibly Tamil Nadu).
A cutter in the form of a crested bird.

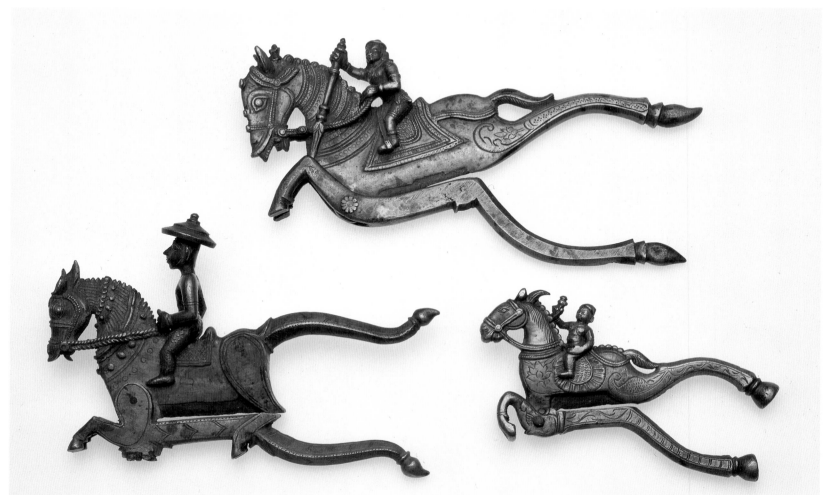

The horse is a common and often delightful betel cutter motif not only in India but also in Indonesia. Indian horse cutters mostly originate from Tamil Nadu.

67. Brass. 173 mm. Tamil Nadu.
Equestrian cutter with typically southern horse trappings. The rider has been cast separately and is fastened to the horse by a pin through his ankles. Although his headgear resembles a solar topee, he is bare-chested and so is clearly not intended to represent a European.

68. Brass. 201 mm. South India.
In contrast to the sedate posture of no. 67, the rider here — though rather out of proportion to his mount — is brandishing a spear and clearly means business.

69. Brass. 129 mm. Tamil Nadu.
In this small cutter the rider carries an unidentified object, possibly a hawk.

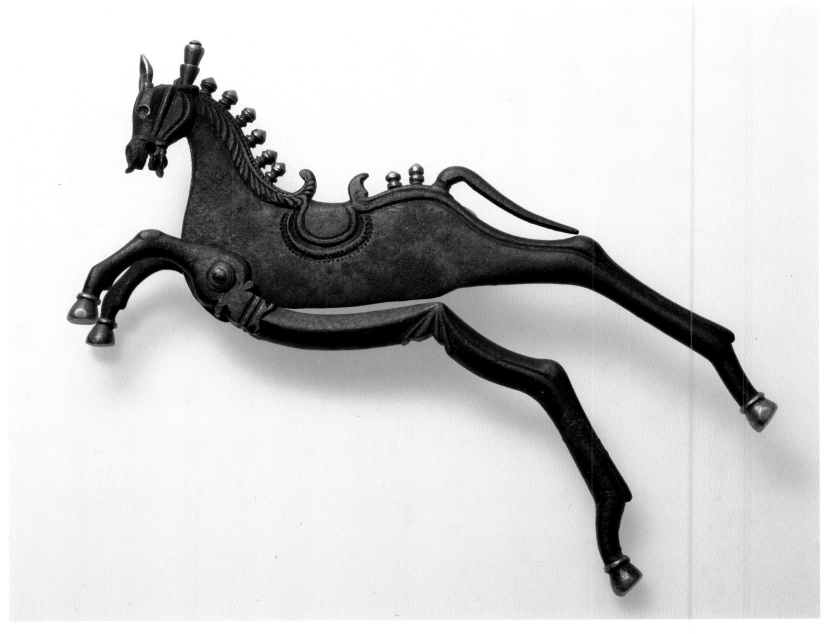

70. Steel with brass attachments. 175 mm. Tamil Nadu.
A rare exception to the general rule that Indian horse cutters are of brass.
This fine cutter is unusual in several ways: the front legs are splayed out; the
head is turned slightly to the left; the hind legs are treated naturistically; and
the eyes were once jewelled. Brass hooves, ears and pompoms along the
mane add an extra touch of extravagance.

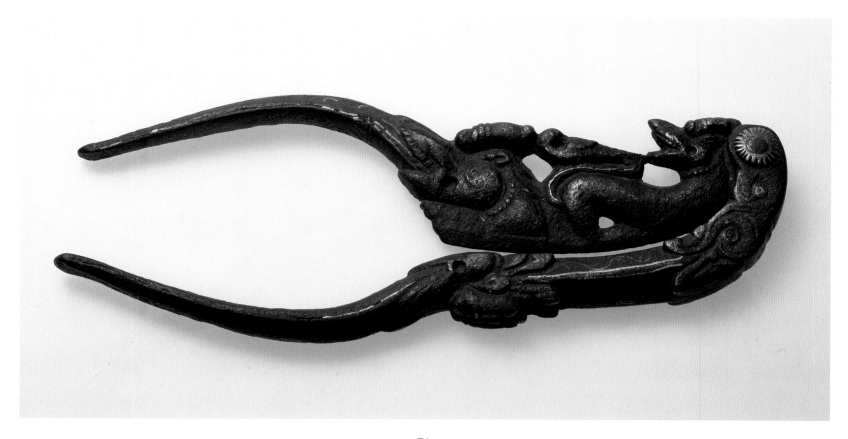

71

71. Iron with brass or gold wire inlay. 189 mm. Probably Tamil Nadu.
An early cutter, replete with mythological beasts and birds.

72. Iron with brass inlay and attachments. 179 mm. South India.
This is unusual in that the arms are hinged separately and swing freely. The brass topknot unscrews.

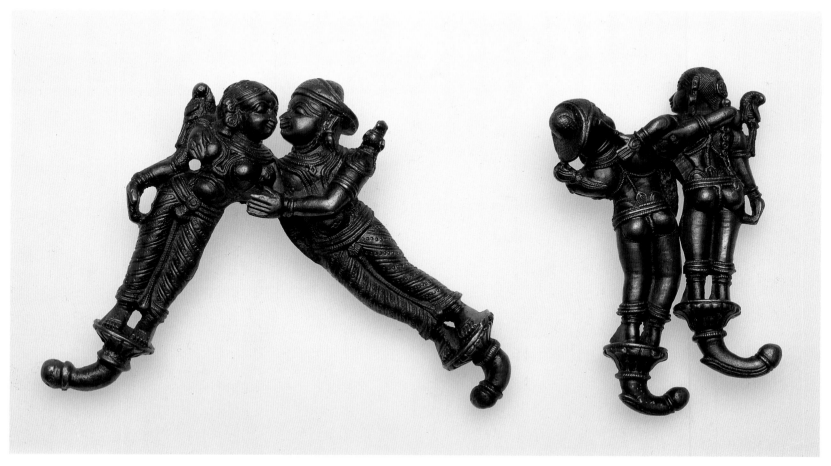

73

74

Two finely cast and almost identical *mithuna* cutters. The boy's hand touches the girl's breast. Parrots, vehicle of Kama the god of love, perch on the young lovers' shoulders. Phallic finials to the handles emphasize the erotic message. The only difference between the two cutters, other than size, is that no. 73 shows the pattern of the lower garments whereas in no. 74 they are left largely to the imagination. Like most *mithuna* lovers the boy nonetheless wear his turban.

73. Brass. 108 mm. Tamil Nadu.

74. Brass. 94 mm. Tamil Nadu.

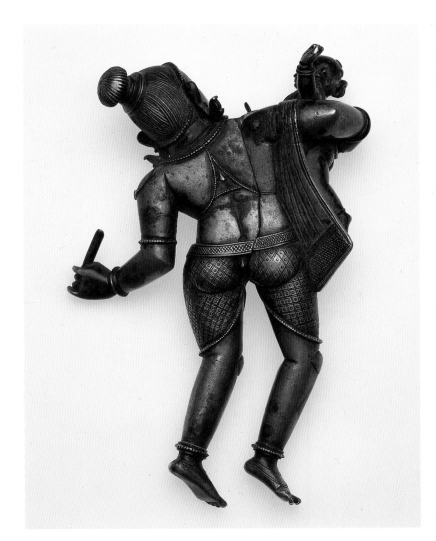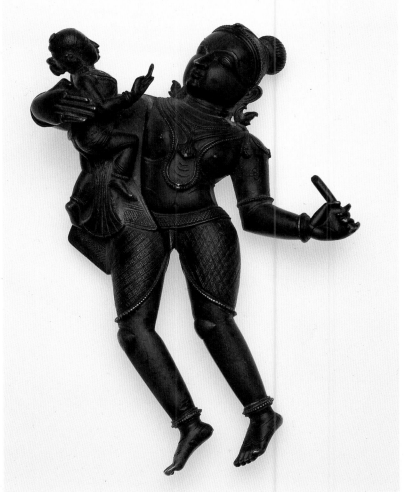

75

75. Bronze. 160 mm. Tamil Nadu.
This cutter, shown front and back, is a fine example of the *mithuna* style and
is in best the tradition of Tamil bronze casting. The figures are shown
naturalistically except that, as in no. 42, the woman is disproportionately
small.

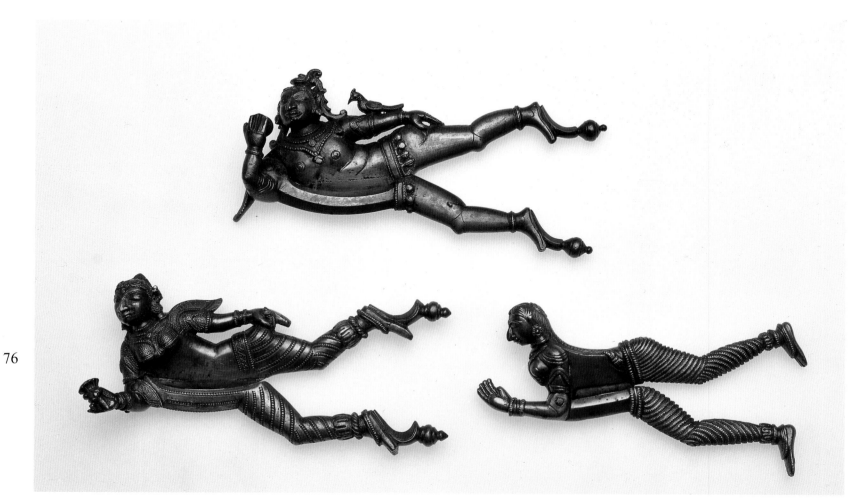

77

76

78

76. Brass. 139 mm. Tamil Nadu.
A girl resting on her right side, her right arm extended. Her feet rest on
curved finials.

77. Brass. 150 mm. Tamil Nadu.
A male figure in a similar pose to no. 76. A parrot rests on his right arm.

78. Brass. 125 mm. Tamil Nadu.
This is similar to the *vandun giraya* ("worship cutter") style popular in Sri
Lanka (nos. 79–84). The hinge here is at the elbow whereas in Sri Lankan
cutters it is at the shoulder. The folds of the lower garment are emphasized.

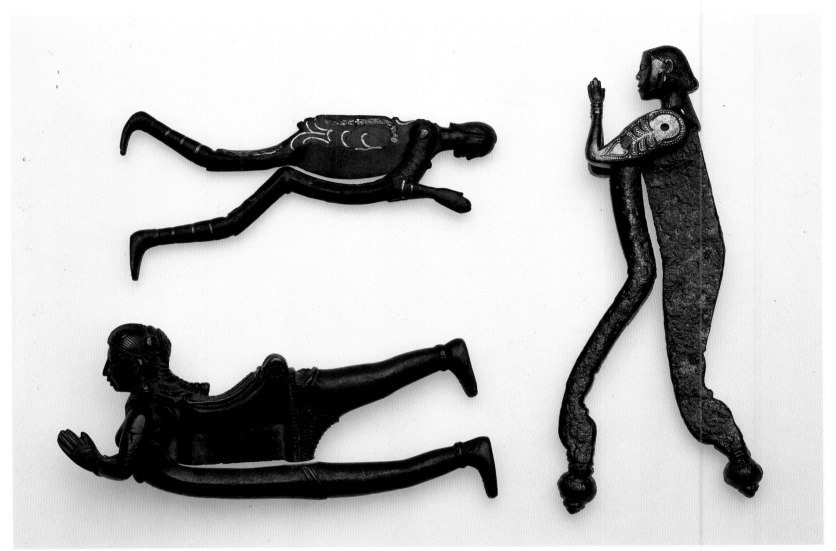

79

80

81

SRI LANKA

Examples of the characteristic *vandun giraya* ("worship cutter") which takes the form of a human figure with extended hands which are brought to the face in a greeting *(anjali)* when the cutters are opened.

79. Iron with silver inlay. 130 mm.
A simple and seemingly early cutter. The legs are shown naturistically and are bent at the knee so that the figure appears to be walking.

80. Copper. 139 mm.
A young girl, her hair braided in Tamil style. The figure is finely cast in the round and is reminiscent of South Indian bronzes.

81. Iron and brass. 168 mm.
This has been made up from an iron cutter similar to nos. 88 or 90 to which a brass face, arms and shoulder cape have been added.

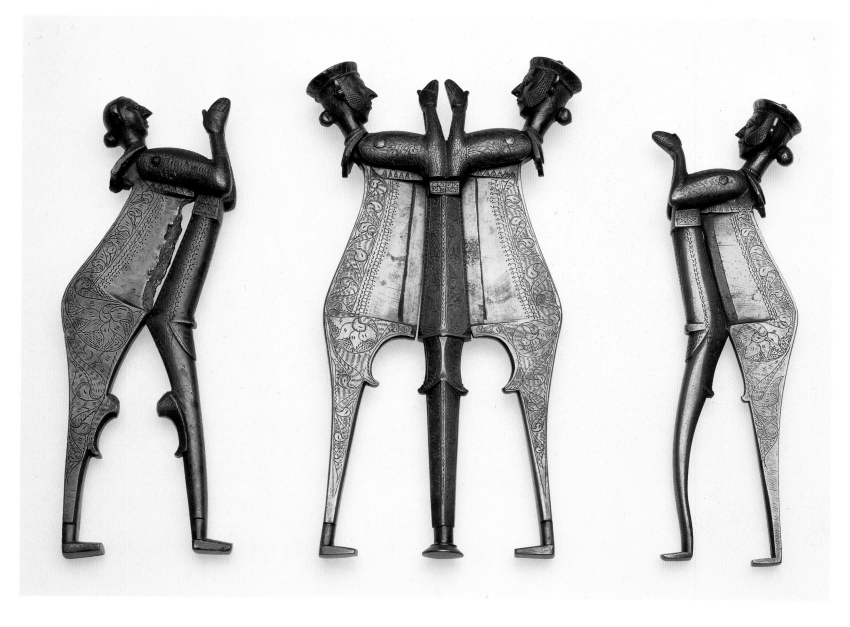

Kandyan variants of the *vandun giraya* style. The figures wear the typically Kandyan round hat, hair bun *(konde)*, and small ruff-like shoulder cape. As with many Sri Lankan cutters, the handle of the blade arm is basically triangular in shape, here forming the figure's thigh and leg.

82. Brass. 218 mm. Kandy.

83. Brass. 230 mm. Kandy.
An amusing double cutter which gives the appearance of two gentlemen greeting each other.

84. Brass. 215 mm. Kandy.

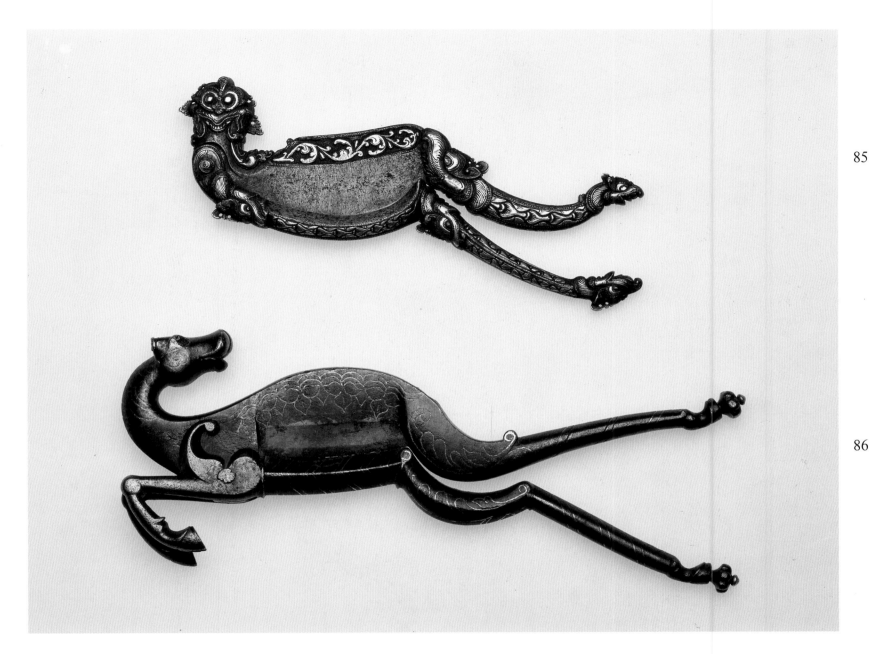

85. Steel with silver overlay. 146 mm.
A unique piece both in terms of workmanship and of subject. The metal is worked in relief, and silver has been overlaid to accentuate the scrolling pattern and details of the face. The latter seems to be derived from the *kibihi-muna* ("face of glory") which is often found as the centrepiece of an arch. Unusually for Sri Lankan cutters, it is shown *en face* rather than in profile. The back of the cutter is a mirror image of the front.

86. Steel with silver wire inlay. 186 mm.
Another very unusual piece. The cutter has the form of a deer bounding away in flight, its head turned backwards towards its pursuer. Originally there would have been golden horns, tail and inlaid eyes.

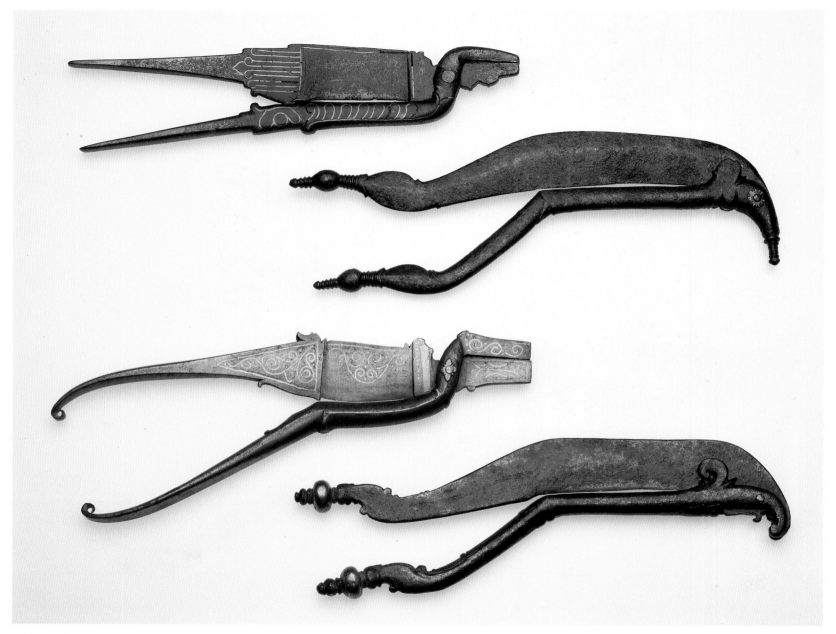

87

88

89

90

87. Iron with brass inlay. 240 mm.
This, together with nos. 89 and 92, typifies the style known as *andu gire* in which the arms extend beyond the hinge to form a mouth or beak (or, seen less imaginatively, a pair of pliers) which opens and shuts when the cutters are used.

88. Iron with brass washer. 265 mm.
Another typical Sri Lankan form in which the arms beyond the hinge extend into a stylised snout. The "dog-leg" shape of the handles gives an impression of walking on tiptoe.

89. Iron with brass inlay. 254 mm.

90. Iron with brass. 258 mm.

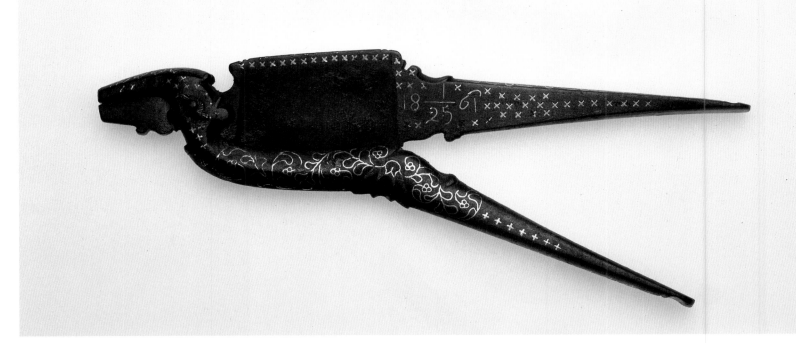

These two iron cutters have been blackened using a process known as *yakada pata ganava*, the object being to highlight the silver inlay and also to protect the cutter against rust. The process was described by Coomaraswamy, writing in 1908, who says that it was by way of being a trade secret. No. 92 is dated 25. 1. 1861, and several other similar cutters have dates around 1860.

91. Iron with silver wire inlay. 153 mm.

92. Iron with silver wire inlay. 191 mm.

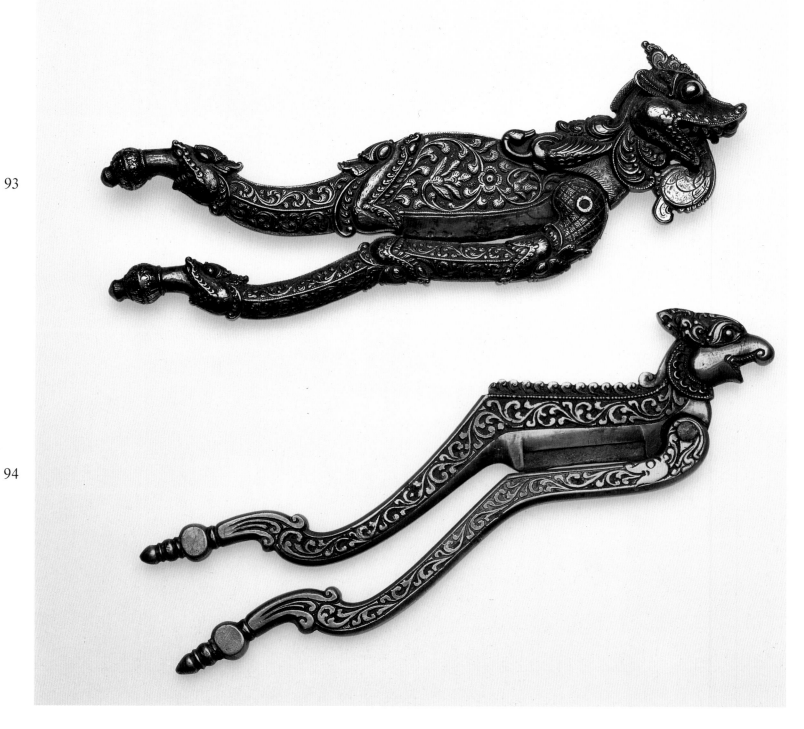

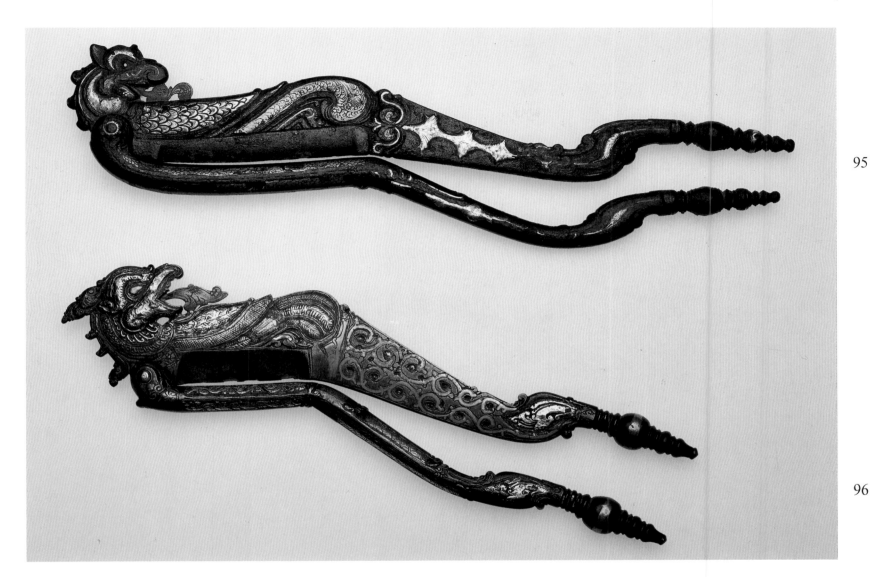

Four mythical creatures.

93. Silvered brass 207 mm. Kandy region
A mysterious animal, the head cast in the round and the rest in low relief. A duck perches at the shoulder.

94. Brass. 209 mm.
A *serependiya* (mythical bird). The cutter is probably of recent make.

95. Iron with brass and silver overlay. 293 mm.
Another *serependiya*. A cutter very similar to this and no. 96 is in the Clive Collection at Powis Castle in Wales and was listed in an inventory dated 1774. The shape is also worth comparing with a cutter from Tamil Nadu, no. 64.

96. Iron with brass and silver overlay. 259 mm.

97. Copper and bellmetal, with silver inlay. 285 mm.
An ambiguous animal in the "snout" style, with wings and a crested head. The lower part of the handles is of a different metal and has a characteristic shape with stupiform finials emerging from the mouths of *makaras*. A similar cutter is illustrated in Coomaraswamy.

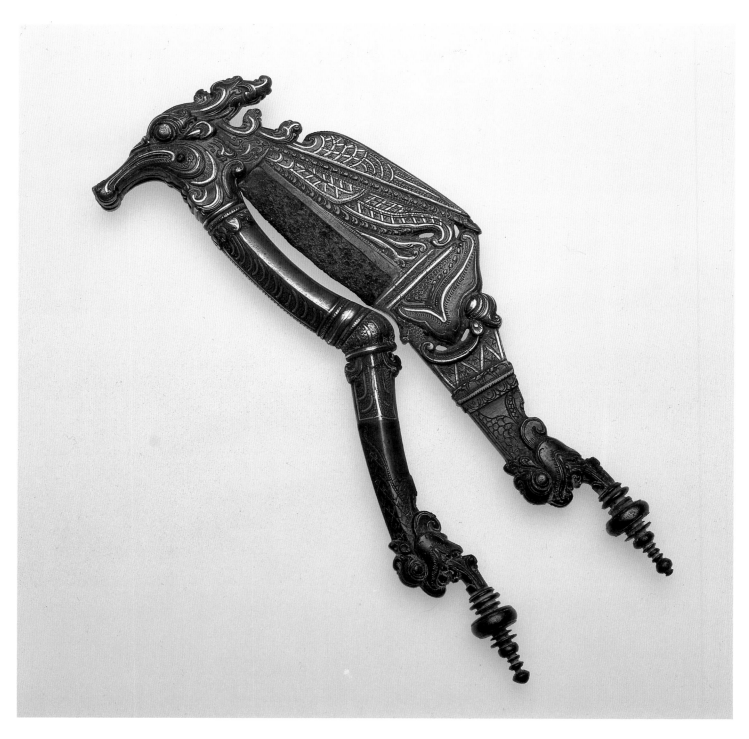

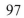

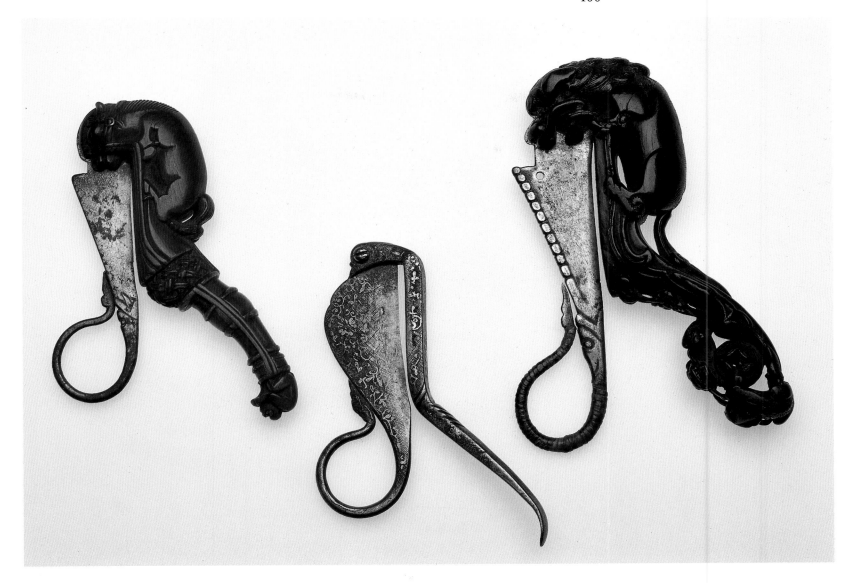

SOUTH CHINA

98. Steel and buffalo horn. 138 mm.
The end of the blade arm, in steel, loops around and terminates in a bird's head. The other arm, carved in buffalo horn, shows a horse crouching at the hinge end and a seated monkey at the other end.

99. Steel. 137 mm.
Both arms are cross-hatched and have decoration in relief. The hinge simulates a bird's head.

100. Steel, buffalo horn and rattan. 157 mm.
The most elaborate of the three. The loop of the blade arm is wrapped in rattan. The other arm is of dark buffalo horn and has a lion crouching at the hinge end and two lion clubs playing with an openwork ball at the other end.

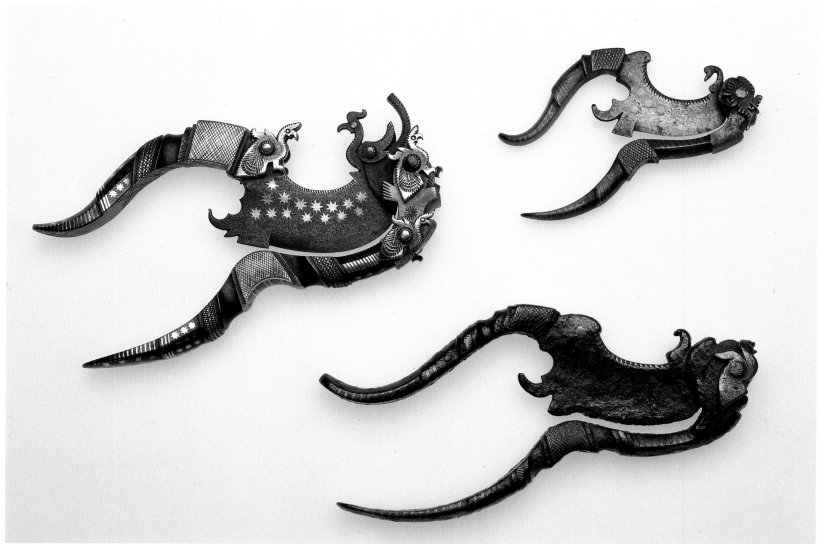

101

BURMA

101. Steel with silver inlay and mounts. 137 mm.
This elaborate cutter is of good steel with a variety of ornamental
embellishments. Silver wire stripes and silver stars are deeply inlaid. In some
areas the striped surface has then been diagonally scored to give a faceted
effect. Three silver peacocks are attached by pins on either side and are
complemented by a steel crested bird projecting from the blade arm. Inlaid
on the underside of the blade arm is a Burmese signature reading "*Saya Kar*".
"*Saya*" means the master of a craft or other accomplishment. Short names
like this were popular in the nimeteenth and early twentieth centuries.

102. Steel with brass inlay. 88 mm.
This is a smaller and rougher version of the 'saddleback' style, with the same
star and stripe inlay as no. 101 but in brass rather than silver. A duck's head
projects at the hinge end of the blade arm. A hook-like projection echoes the
curve of the blade.

103. Iron with brass inlay and mounts. 145 mm.
This cutter, venerable in appearance, closely follows the form of nos. 101 and
102. The bird projection from the blade arm is here vestigial.

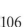

104

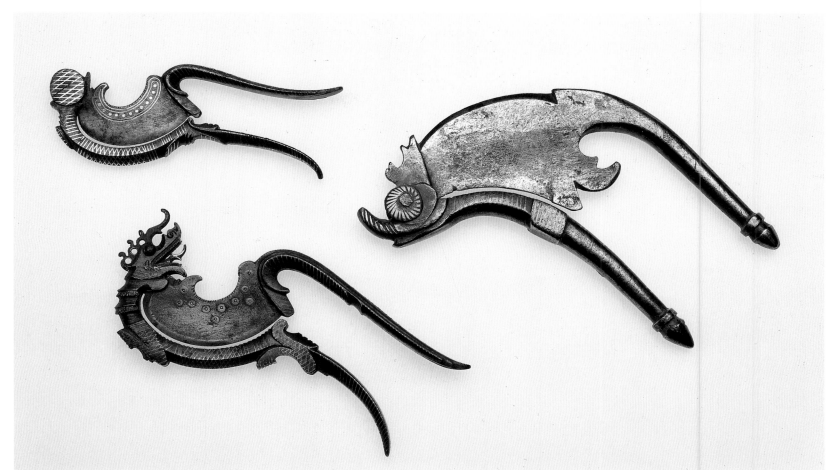

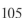

105

106

104. Steel with silver wire inlay. 94 mm.
In form this is similar to the cutters on the previous page, though without their exhuberant embellishments. Silver wire has been inlaid in a weak stripe and diaper pattern. The silver and steel birds have gone, as has the hook-like projection.

105. Steel with brass inlay. 135 mm.
This cutter, resembling a plunging sea-monster, is quite different from saddleback style. The general form, with a concave blade and straight handles ending in bud finials, is similar to Indian cutters from nearby Bengal (no. 26). However, the inlaid brass stripes and our old friend the hook-like projection indicate that this is in fact from the same area as the saddleback cutters.

106. Steel with silver inlay and red paint. 119 mm.
This is typical of the 'saddleback' style except for the impressive crested *naga* head around the hinge. The head forms part of the cutter's lower arm, whereas the crest and tongue are part of the blade arm so that they move when the cutter is opened (a feature which we will meet again in Thai cutters). Crest, jaw and neck have been painted red to enhance the effect. Protrusions from the lower arm, which in no. 101–104 are purely abstract, here represent the *naga's* front and hind legs.

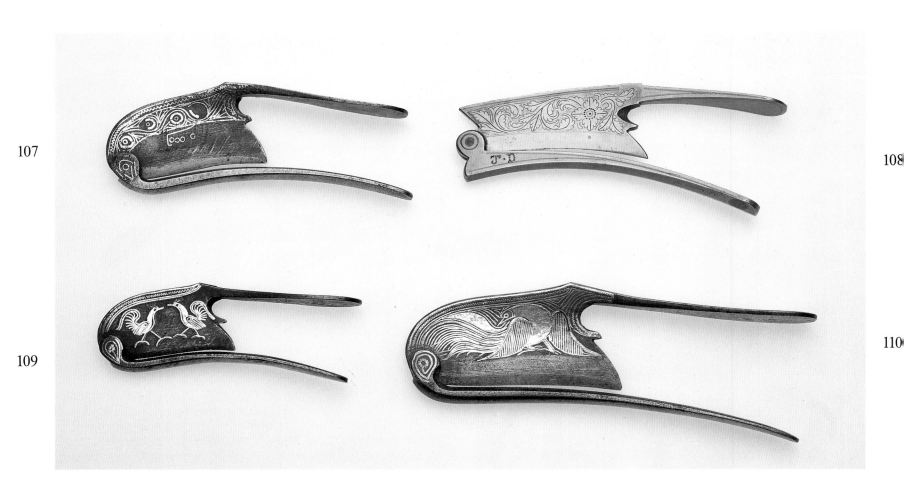

107

108

109

110

107. Steel with silver wire overlay. 122 mm. Upper Burma.
This is the commonest type of decorated Burmese cutter. The top of the blade arm, the upper surface of the top handle and the hinge have all been cross-hatched and richly overlaid with silver wire in a scrolling meander. On each side of the blade arm there is a signature in Burmese script. The one on the side illustrated reads "*Saya Nga*"; that on the reverse side "*Saya Htaing*". As we have seen, *Saya* is the honorific used by a master, i.e. one who is competent in his chosen field.

108. Bellmetal 126 mm.
This is unusual in that the whole implement is of bellmetal including the blade. The angular projections at the hinge end contrast with the other cutters illustrated on this page. The blade arm has foliar chasing, and the lower arm is dot-stamped with the European initials "J.D.".

109. Steel with silver and copper wire overlay. 102 mm. Upper Burma.
A pleasing example of this style with a design of two cockerels.

110. Steel with silver and copper wire overlay. 157 mm. Upper Burma.
A fanciful bird with spread wings and an extending tail. The existence of other almost identical cutters suggests that this design was produced in considerable numbers.

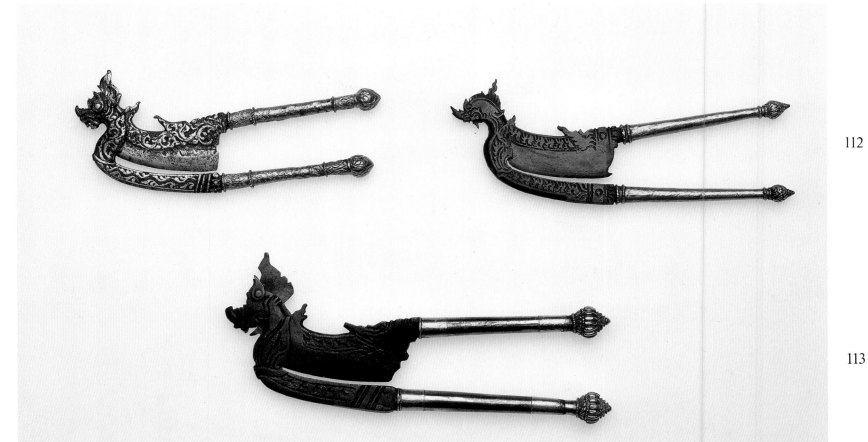

111

112

113

THAILAND and MALAYSIA

111. Iron with gold overlay and gold sheaths. 89 mm. Thailand.
The shape of this cutter is typical of the Thai style, with a crested monster's head at the hinge. Its lower jaw and crest move when the cutter is operated. The handles are encased in gold sheaths terminating in lotus buds. The unusual feature is that the iron is overlaid with gold in a flame meander known as *kranok*. Sumptuary laws, not always fully enforced, restricted the use of gold to those of royal birth and the highest aristocracy, so this may well come from a palace. Its small size suggests that it was intended for use by a lady.

112. Iron with gold sheaths. 103 mm. Thailand.
Similar to no. 111 except that instead of the overlay meander there are bands of incised decoration.

113. Iron with gold and copper sheaths. 115 mm. Thailand or Malaysia.
The sheaths here are of fine gold at both ends but copper or copper-gold alloy in the middle section. This is similar to a pair of cutters in Muzium Negara, Kuala Lumpur. The bud finials are fluted. The engraved decoration on the iron is relatively crude.

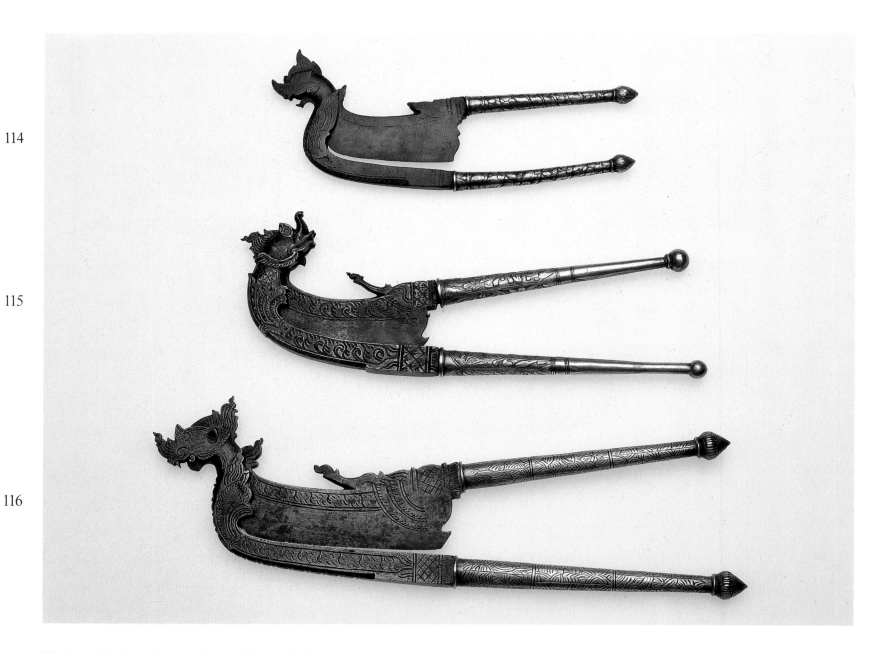

114

115

116

114. Iron with silver-gilt niello sheaths. 143 mm. Thailand.
Similar to the cutters on the previous page, though somewhat larger. The niello sheaths have a spiral pattern and possibly originate from Nakhon Si Thammarat in South Thailand, a town long famous for its nielloware.

115. Iron with silver sheaths. 181 mm. Thailand (sheaths Chinese).
This has the best ironwork of the Thai cutters illustrated. The head of a *kotchasingh* (lion with an elephant's trunk) is shown in low relief looking over its shoulder. The hinge is concealed. Although the decoration on the iron is typically Thai, that of the sheaths is Chinese, with round finials and a pattern of flowers and birds. The sheaths are therefore probably not original. The finial on the lower sheath has been restored.

116. Iron with silver sheaths. 224 mm. Thailand.
The largest of the Thai cutters. Whereas in many figurative cutters the hinge is disguised as the animal's eye, here it is disguised as the ear, which is of brass.

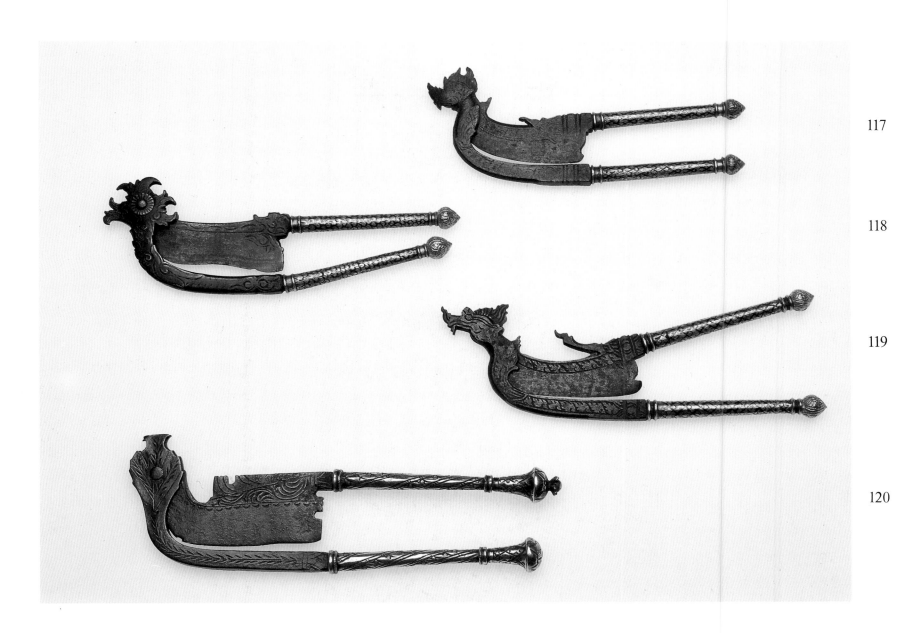

117

118

119

120

117. Iron with silver-gilt niello sheaths. Thailand.
The sheaths are similar to nos. 118 and 119, except that the finials have lost most of their gilding.

118. Iron with silver-gilt niello sheaths. Malaysia.
This conforms to the general shape of Thai cutters except that the head is highly stylised to accord with Islamic teaching. The sheaths appear to be Thai, with lotus bud finials. However, a very similar cutter in Muzium Negara, Kuala Lumpur has granulated goldwork which is clearly Malay.

119. Iron with silver-gilt niello sheaths. Thailand.
This cutter, with its upturned head, is entirely Thai in feeling.

120. Iron with silver sheaths. 174 mm. Maylasia.
In this example the figurative Thai style has been entirely replaced by Islamic abstract form. The sheaths too are of Malay work, with a spiral design and parasol finials. A very similar cutter, though without sheaths, is in the Musée de l'Homme collection (Thierry, fig. 211).

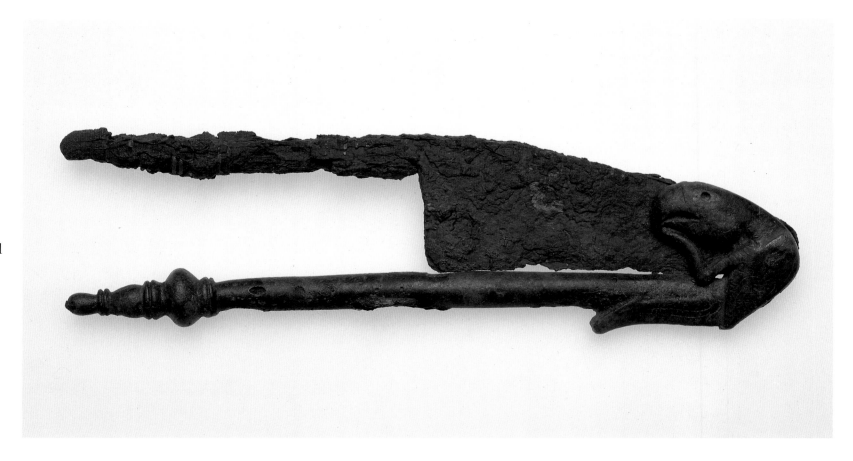

121

121. Iron with copper sheathing and silver inlay. 182 mm. Sukhodaya period (ca. 1400 AD). Excavated in Central Thailand.
The lower arm, which is of iron sheathed in bronze, incorporates a parrot which is bent over at the hinge end. The hinge is at the base of the parrot's wings. Whereas the lower arm is in good condition, the upper (blade) arm is of unsheathed iron and is heavily coroded. Remnants of several narrow silver rings are visible. Stylistically the cutter is closer to nos. 50 and 60 from the Deccan than to later Thai cutters.

SUMATRA

Three cutters from the Batak peoples of northern Sumatra. Of these, nos. 122 and 124 are the two most common shapes; no. 123 is quite exceptional.

122. Iron with silver sheaths. 200 mm. Karo-Batak.
This "snout" shape is reminiscent of one of the characteristic Sri Lankan forms (nos. 88, 90), although the similarity is probably coincidental. The iron has modest but elegant decoration. The sheaths are of low-grade silver with round finials.

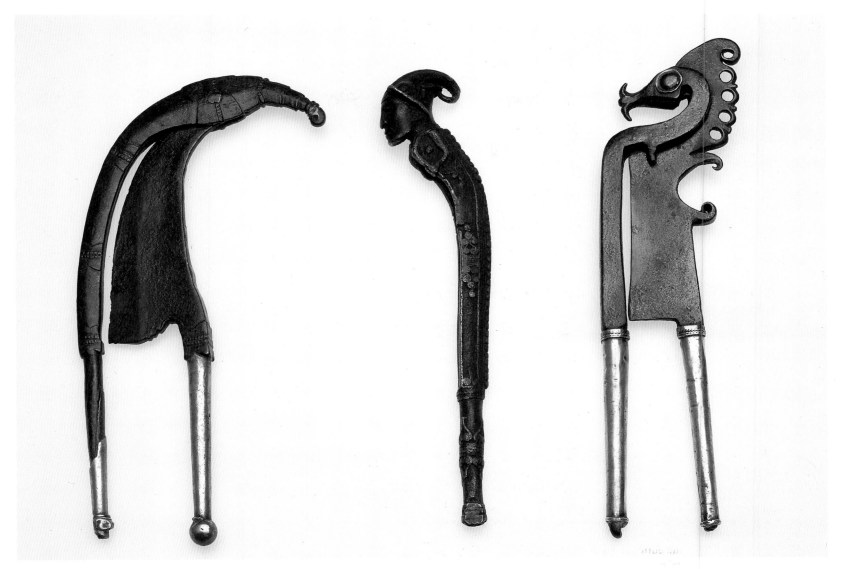

123. Brass. 189 mm. Toba-Batak.
Lower arm only. It carries a typical Batak geometric decoration and
terminates at the hinge end in a head modelled in the Batak manner with a
long face and a strong square jaw. The head is wearing a Phrygian cap which,
on closer inspection, appears to be the head of an elephant the ears of which
form the cap's rim. Beneath the head a pair of arms are folded in front of the
body — another typically Batak pose. This exceptional piece has only one
parallel example known, which is in the Linden Museum, Stuttgart.

124. Iron with silver sheaths and copper eye. 122 mm. Karo-Batak.
Horse-shaped cutters, which we have already encountered in South India, are
common in many parts of Indonesia. Thsi is of typically Batak design, with
flared mouth, arched neck and openwork mane. The hinge takes the form of
an eye with a copper rim.

125

126

127

Three cutters from the Palembang area in southern Sumatra. All three have a curious quadrilateral shape. The inner edge between the handles vaguely resembles a human face in profile. The handles are parallel and at an angle to the rest of the cutter.

125. Iron with gold sheaths. 147 mm. Palembang.
The upper edge of the blade arm originally had gold sheathing. This has now gone, revealing an engraved design on the iron underneath. The handle sheaths are in two shades of low-grade gold.

126. Iron with brass overlay and silver sheaths. 172 mm. Palembang.
Parts of the iron surface are decorated with brass overlay. The sheaths are of silver with round finials.

127. Iron with gold overlay and silver sheaths. 186 mm. Palembang.
The upper part of the blade arm has elaborate gold overlay. Silver sheaths terminate in florette finials.

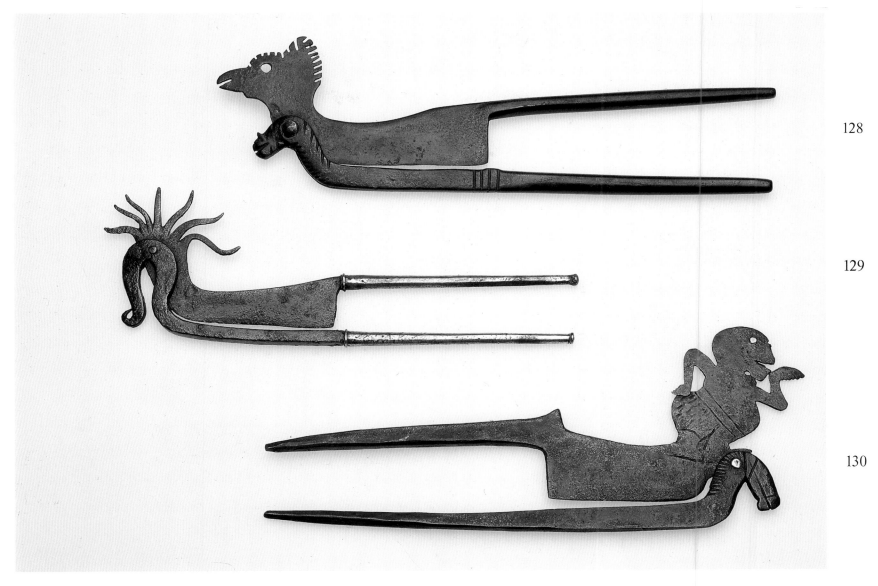

128

129

130

These three cutters come from the Lampung district in the far south of Sumatra. The iron, though of modest workmanship, is designed with whimsical humour.

128. Iron. 245 mm. Lampung region.
The blade arm has a silhouette in the form of a stylised bird's head. An unusual feature is the horse's head at the hinge end of the lower arm. For a parallel to this one would have to look to Orissa (nos. 46, 47).

129. Iron with white metal sheaths. 207 mm. Lampung region.
An unusual and comical design, with seven strands of untidy hair and, below, what is perhaps the trunk of an elephant. The sheaths are of silvered white metal.

130. Iron and brass. 236 mm. Lampung region.
The blade arm has the silhouette figure of a dwarf, possibly Semar or one of the other *punakawan* (clown-servants from the Javanese shadow play). The lower arm once again forms a horse's head. Both the dwarf and the horse have brass inlaid eyes, the latter also doubling as the hinge. The handles are square and seem never to have been sheathed.

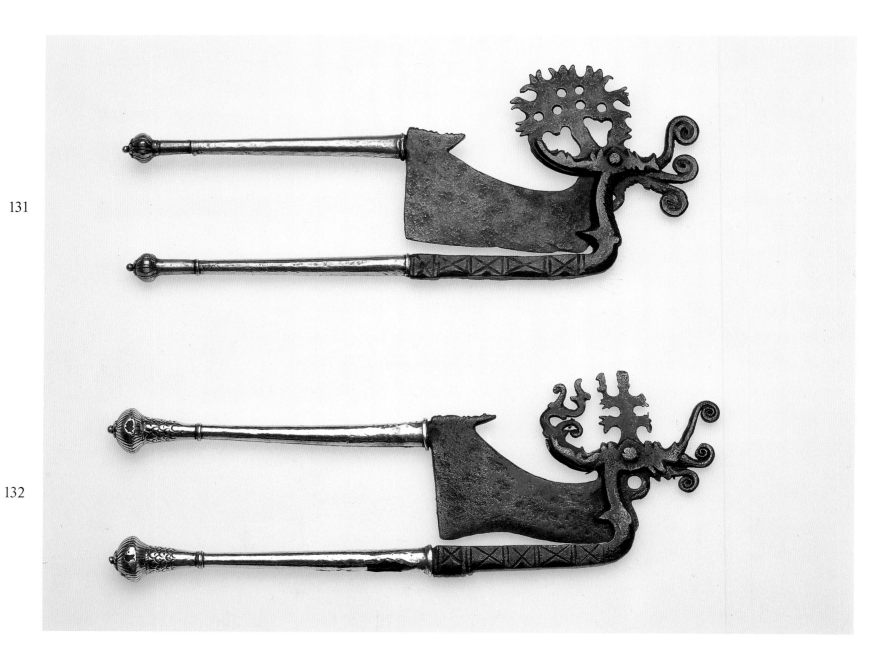

MADURA

Cutters from Madura, a small island off the north-east coast of Java, are often characterised by elaborate openwork in wrought iron.

131. Iron with silver sheaths. 230 mm.
Mythical monster with scrolling projections from the mouth and a tree-like crest. Silver sheaths.

132. Iron with silver sheaths. 228 mm.
Another example of the same type.

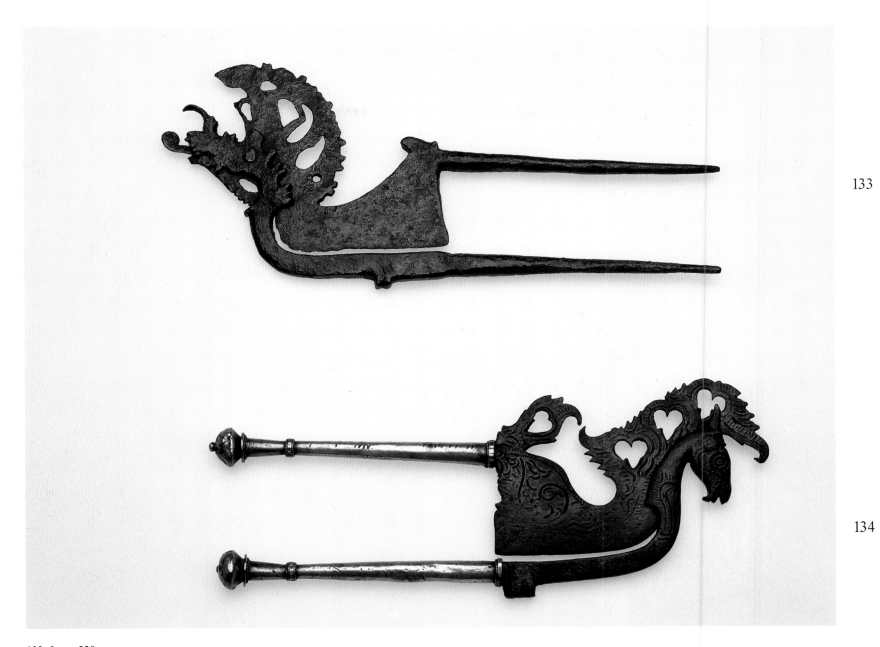

133. Iron. 228 mm.
Another mythical monster. At the front of the crest one can see a
wayang-type figure with his hands resting on his hips. The sheaths are
missing.

134. Iron with silver sheathing. 218 mm.
This horse with an openwork mane is a common form of Madura cutter.
The surface has engraved decoration. Silver sheaths.

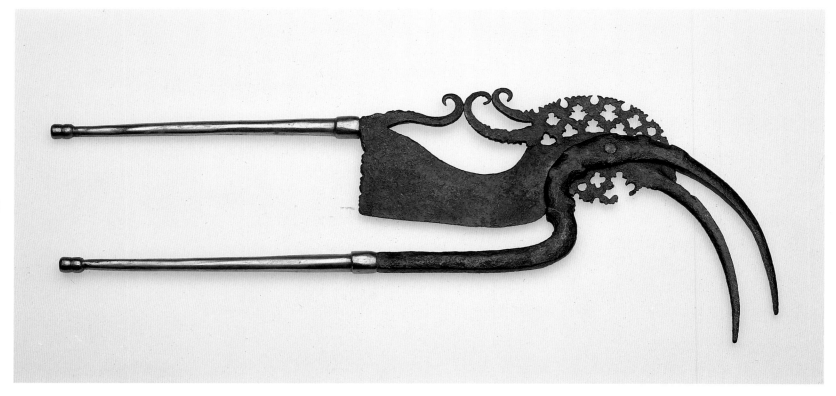

135

135. Iron with steel sheathing. 428 mm.
This large and spectacular cutter is in the form of a bird with a very
elongated beak. Possibly it depicts a hornbill, a bird which is venerated in
many parts of Indonesia and is mythologically associated with the afterlife.
The bird is shown with an elaborate openwork crest. The steel sheaths are a
recent addition.

JAVA

Four cutters in the *"naga"* style from central Java. *Naga* is the Sanskrit word
for "snake", and *nagas*, often shown crowned, are a favourite Javanese
decorative theme. Here the snake-like appearance is virtually lost due to the
crown and to the absence of a sinuous body.

136. Iron with gold overlay. 137 mm. Central Java (possible Surakarta).
This cutter is unusual in being made of *pamor sanak*, a type of brittle iron
with a pearly appearance which is normaly used for *keris*, the characteristic
Indonesian serpentine dagger. The cutter is almost certainly the work of a
keris smith *(empu)*, and is illustrated in Solyom — "The World of the
Javanese Keris" (fig 63). A Balinese *pamor* cutter is shown as no. 175 in this
collection. Gold sheet has been applied to part of the surface. The sheaths
are missing.

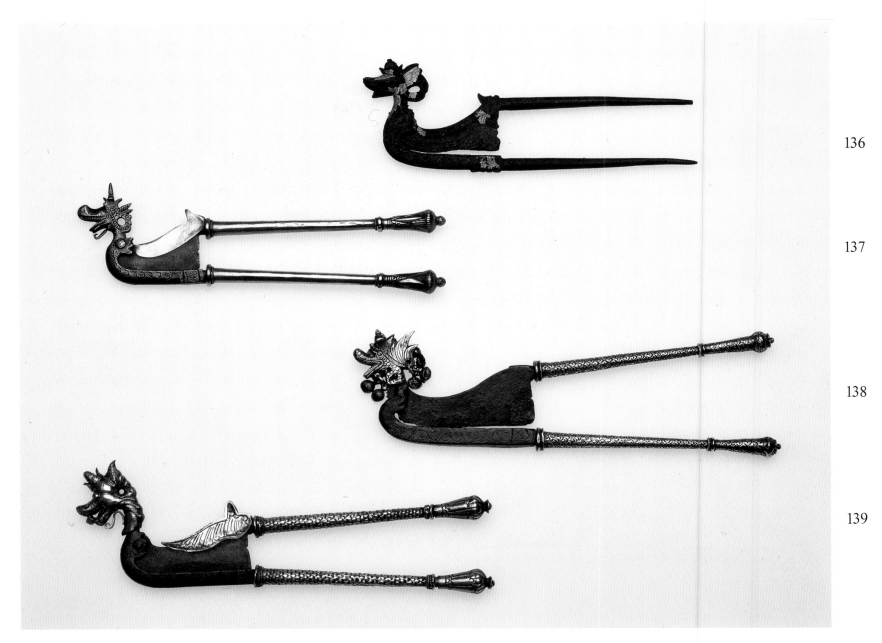

137. Iron with silver sheathing. 153 mm. Central Java.
The iron head of the *naga* is forged and then engraved. The back of the blade-arm is sheathed in silver, as are the handles.

138. Iron with silver sheaths and embellishments. 170 mm. Central Java.
The head is of engraved silver which is attached by pins to the iron. Seven small silver jingles hang from the head. The sheaths are of silver with characteristic club-shaped finials.

139. Iron with cast and repousse silver. 168 mm. Central Java.
The head of the naga is cast in silver and attached by a socket to the iron of the cutter. The back of the blade-arm and the handles are sheathed in silver.

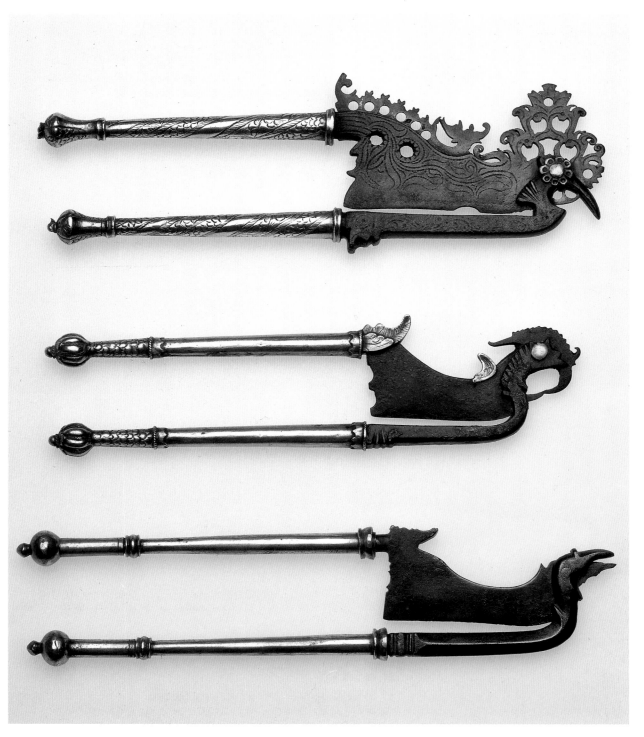

140

141

142

Three cutters featuring birds, another favourite motif for Javanese cutters.

140. Iron with silver sheaths. 171 mm. Central Java. Possibly intended to represent the head of a stylised cockerel. The bird has an elaborate crown-like headdress in openwork, and there is more openwork along the back of the blade-arm. The surface of the iron has an engraved design. Silver sheaths with club finials.

141. Iron with silver sheathing. 160 mm. Central Java. Another cockerel. Two areas of the back are sheathed in silver. The handles have silver sheaths with lobed finials.

142. Iron with white metal sheaths. 172 mm. Central Java. A modest but beautifully executed bird-headed cutter. The beak opens and closes as the cutter is used. The long handles have silvered white metal sheaths with round finials.

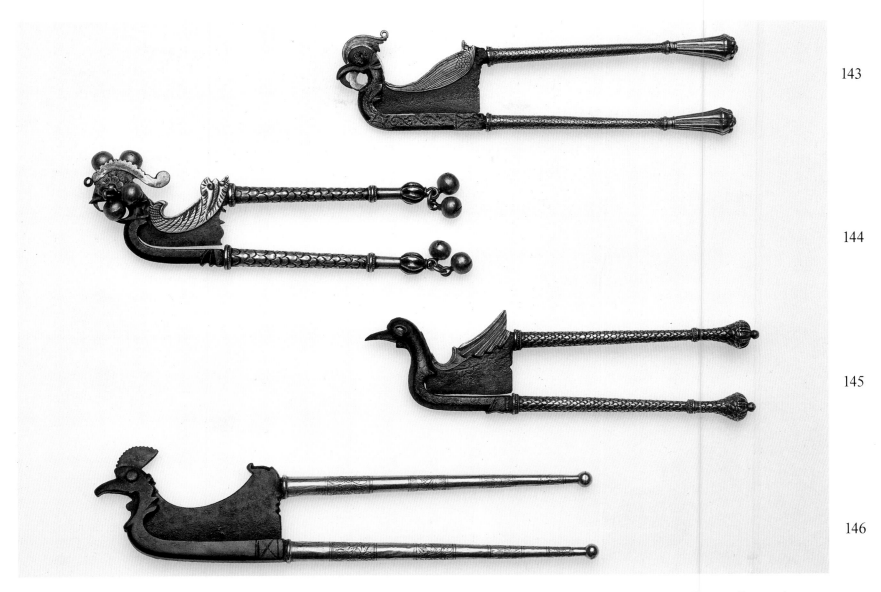

Another four bird-headed cutters from Central Java. Their small size and elaborate detail may indicate that they were intended for use by ladies. The handles of Central Javanese cutters are generally long in relation to the size of the blade.

143. Iron with and silver and gold sheaths. 134 mm. Central Java.
The eyes, which act as the hinge, have inset diamonds. The crest is of silver and there is silver sheathing on the back. The handles are of silver with gold finials.

144. Iron with silver sheathing, partly gilt. 114 mm. Central Java.
The bird's head is finely modelled in iron, with a silver crest. Silver sheathing on the back has been decorated to indicate wings. The handles are also sheathed in silver, and silver jingles are attached by small chains to the finials and to the hinge.

145. Iron with and silver sheathing. 128 mm. Central Java.
Again the eyes are inset with diamonds and there is silver sheathing to indicate wings. The handles are also silver sheathed, with a fish-scale pattern and club-shaped finials.

146. Iron with gold sheaths. 164 mm. Central Java.
A cockerel of unadorned iron. The gold sheaths are particularly long and have engraved decoration and small round finials.

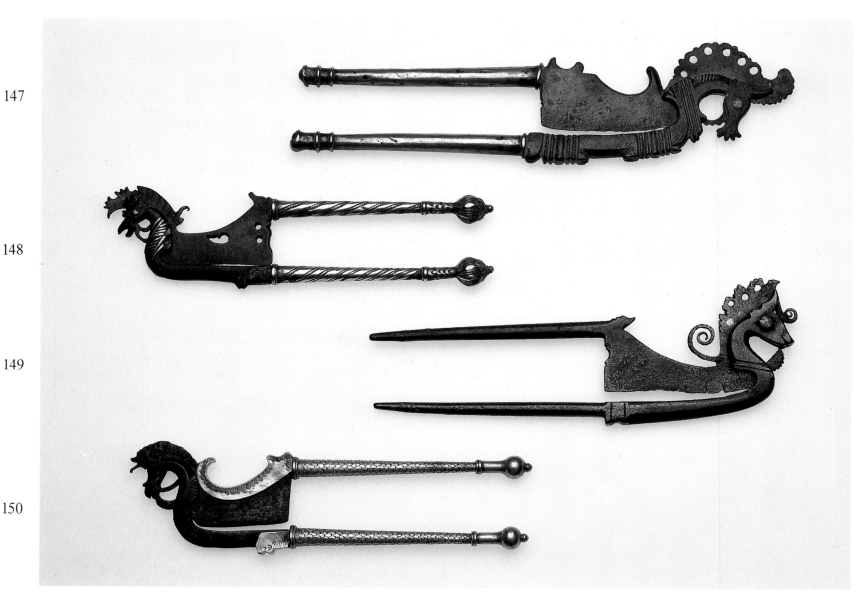

Four cutters in the form of horses. Horse-shaped cutters are popular in Sumatra, Madura and Bali, as well as in Java. These examples, which are mainly from East Java, have relatively small heads and elaborate manes.

147. Iron with white metal sheaths. 222 mm. East Java.
The iron is unadorned except for perforated decoration to the mane and striations on the lower arm. White metal sheaths.

148. Iron with brass inlay, and silver sheaths. 170 mm. East Java.
The small and somewhat unequine head has eyes-cum-hinge with tiny diamonds set in brass. There is brass inlay on the neck. The sheaths have an elaborate spiral pattern and round finials.

149. Iron with brass inlay. 183 mm. East Java or South Sulawesi.
A simple design, with four brass roundels inset below the mane. The scrolling curls projecting from the forehead and the base of the neck are an unusual feature and may indicate a Sulawesi origin. The sheaths are missing.

150. Iron with silver sheathing. 170 mm. East Java.
The head is similar in form to no. 148. the body is partially sheathed in silver. The handle sheaths have a fish-scale pattern and round finials.

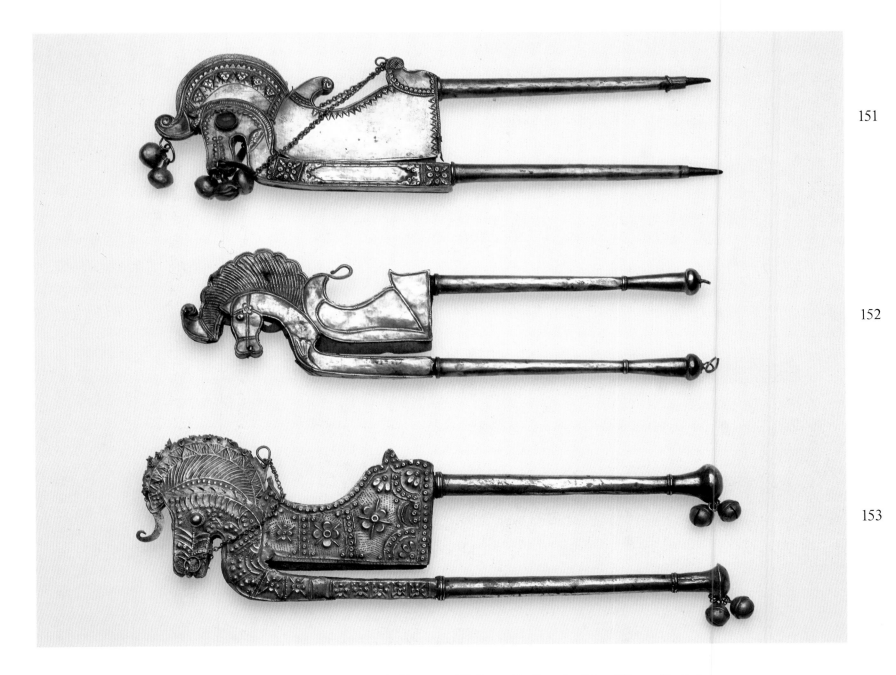

151

152

153

Another three cutters in the form of horses. These are entirely sheathed in silver, a style which is popular on the north coast of Java.

151. Iron with silver sheathing and inset cornelian. 257 mm. North Java. The eyes are of cornelian. Silver jingles are attached, and a silver chain simulates the reins. The tips of the handle sheaths are missing.

152. Iron with silver sheathing. 237 mm. North Java. An elegant and less encumbered version of no. 151.

153. Iron with silver sheathing. 259 mm. North Java. The silver sheathing covering the body has ornate repoussé decoration. Silver jingles are attached to the tips of the handles.

154

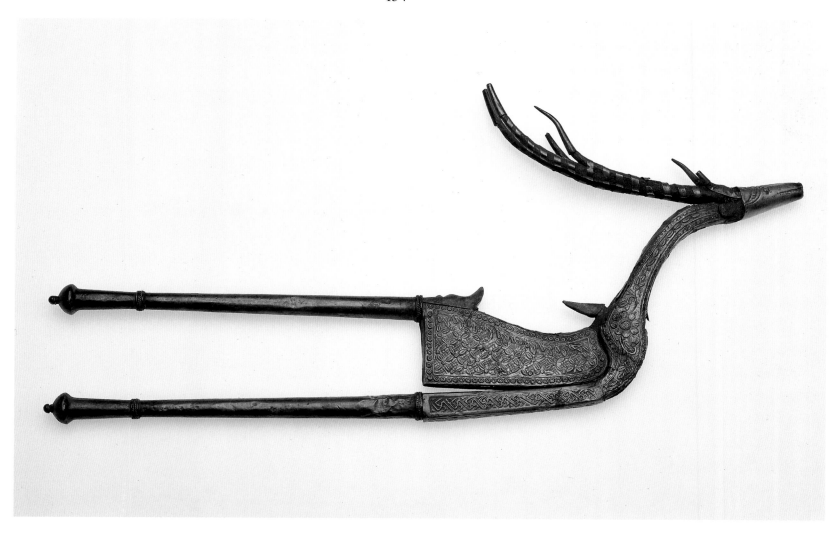

154. Iron with silver sheathing. 373 mm. North Java.
This large and majestic stag is almost completely sheathed in silver which has
repoussé decoration similar to no. 153. The impressive three-pointed antlers
are spiral bound with a silver strip and the tips have silver sheaths. The
handles have plain silver sheaths.

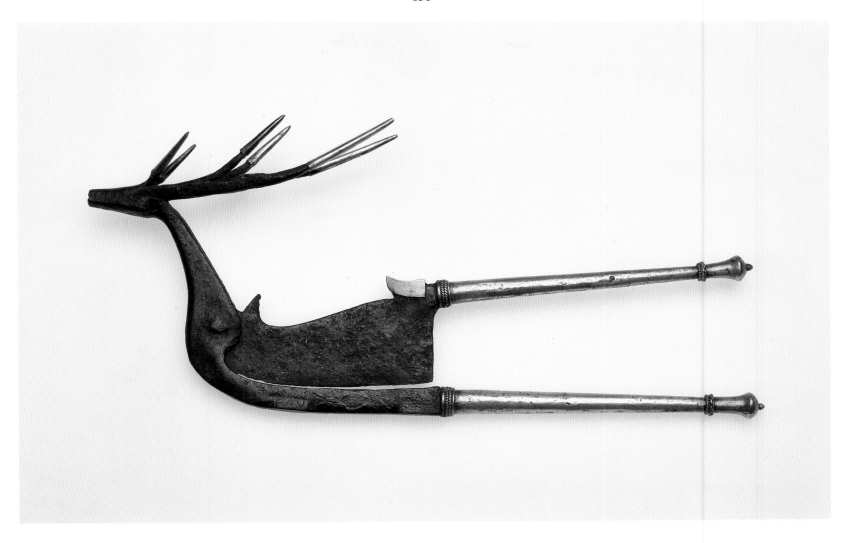

155. Iron with silver sheathing. 273 mm. North Java.
Another large stag with two three-pointed antlers. It is very similar to no. 154
except that the sheathing is limited to the handles, the tips of the horns and
a small part of the back. Possibly the cutter was at one time totally sheathed
like no. 154. If so, it has benefitted aesthetically from the loss, since good
ironwork is preferable to poor silver.

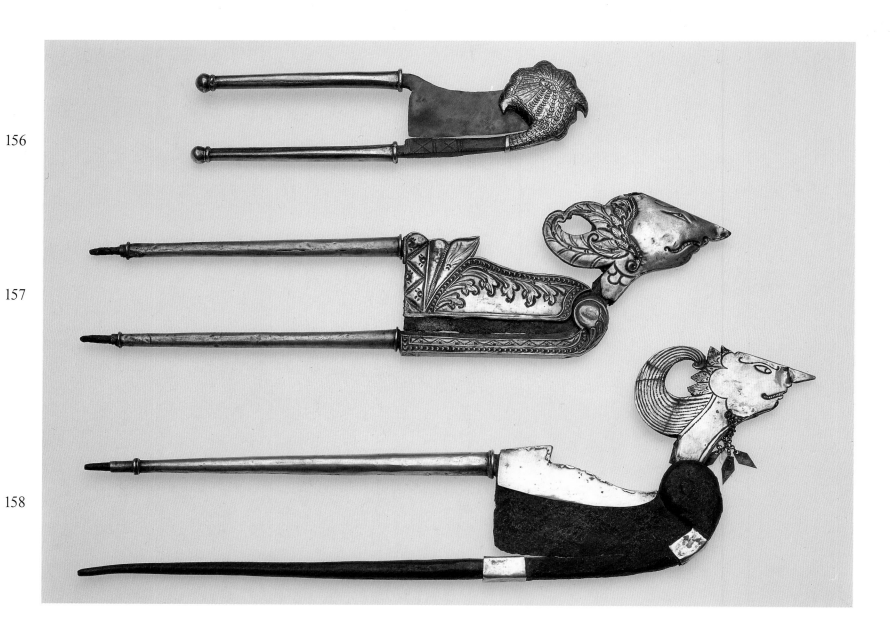

156

157

158

A further three silver-sheathed cutters from the north coast of Java

156. Iron with silver and white metal sheathing. 182 mm. North Java.
The cutter is decorated with a stylised parrot's head of incised silver
sheathing which is attached to the cutter's lower arm and conceals the hinge.
The handle sheaths are of white metal.

157. Iron with silver sheathing. 286 mm. North Java. The cutter is in the
form of a character from *wayang kulit*, the Javanese shadow play. Probably he
is Arjuna, one of the heroes of the Mahabharata, who wears his hair in this
style known as *supit urang* ("lobster's claw"). The sheathing is decorated with
elaborate and well executed repoussé work. The tips of the handle sheaths
are missing.

158. Iron with silver sheathing. 317 mm. North Java.
Similar to no. 157 and again probably depicting the *wayang* hero Arjuna. The
head is of folded silver sheet which is slid over the iron neck. Small silver
pendants hang as earrings. The incised decoration is much less elaborate than
in no. 157. One of the handle sheaths is missing.

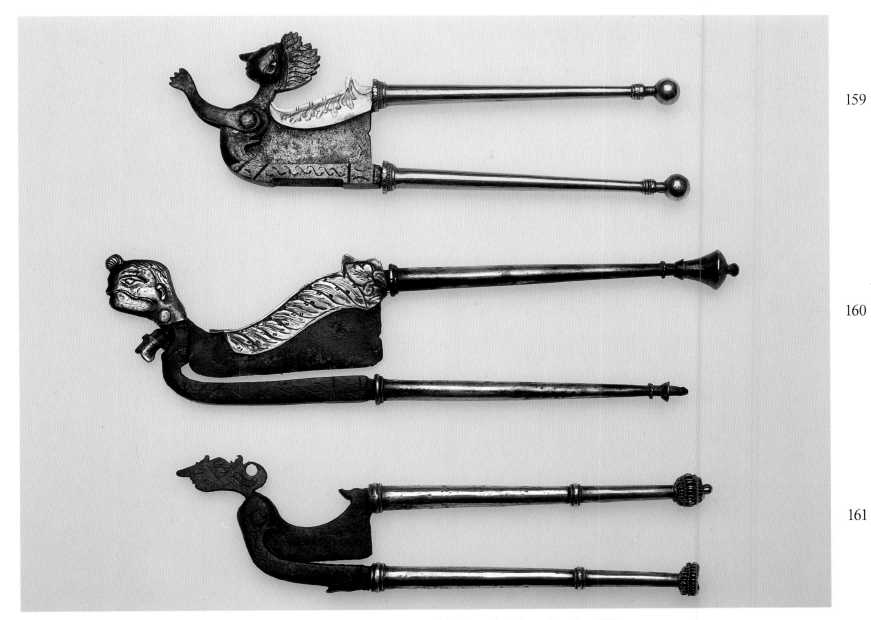

159

160

161

Three unusual cutters with human subjects.

159. Iron with gold sheathing. 148 mm.
The cutter depicts a man with a sharp protruding nose and flamboyant hair. The outstretched arms, which make a greeting gesture when the cutter is used, are reminiscent of the *vandun giraya* style of Sri Lanka (nos. 79–84) except that here the arms have been forged separately and are joined to the cutter at the hinge. The gold sheathing has an engraved design. The handle sheaths are of gold with silver finials.

160. Iron with silver sheathing. 180 mm.
The silver head, held by a rivet, depicts a figure with a wide open mouth. The bun on top of the head is a traditional feature from Central Java. Silver sheathed handles with one finial missing.

161. Iron with silver sheathing. 149 mm.
One of the most charming pieces in the collection. It shows a *wayang* head, probably Arjuna, with decoration engraved in the iron. Long silver sheaths with part of one finial missing.

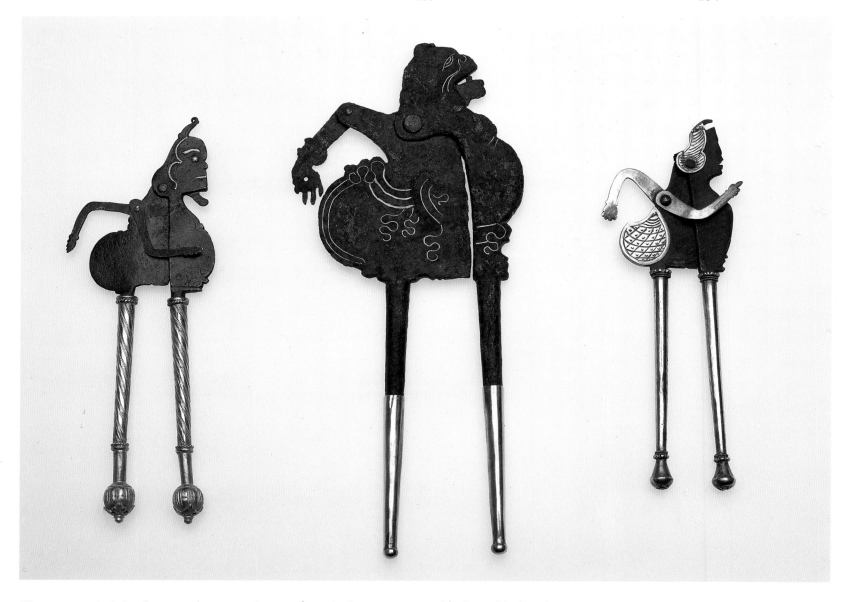

Three cutters depicting Semar, an important character from the Javanese shadow play *(wayang kulit)*. Semar and his sons are clown-servants working for the hero Arjuna. They not only amuse the audience by their antics but also interpret the action in the vernacular language of the ordinary people. The central cutter (no. 163) shows Semar in his commonest form; the flat-faced examples (nos. 162, 164) are unusual variants. In all three cutters the arms are articulated, as in the hide puppets on which they are based.

162. Iron with silver inlay and sheathing and an inset diamond. 178 mm.
The face has silver inlay and a tiny silver-mounted diamond for the eye. The elaborate sheaths have spiral decoration and round finials.

163. Iron with silver inlay and steel sheaths. 222 mm.
An early cutter with well-executed silver inlay on the face and body. The short steel handle sheaths are recent.

164. Iron and silver. 155m.
In this cutter the articulated arms are of silver, and silver sheathing is used for Semar's hair and his ample posterior, as well as for the handles.

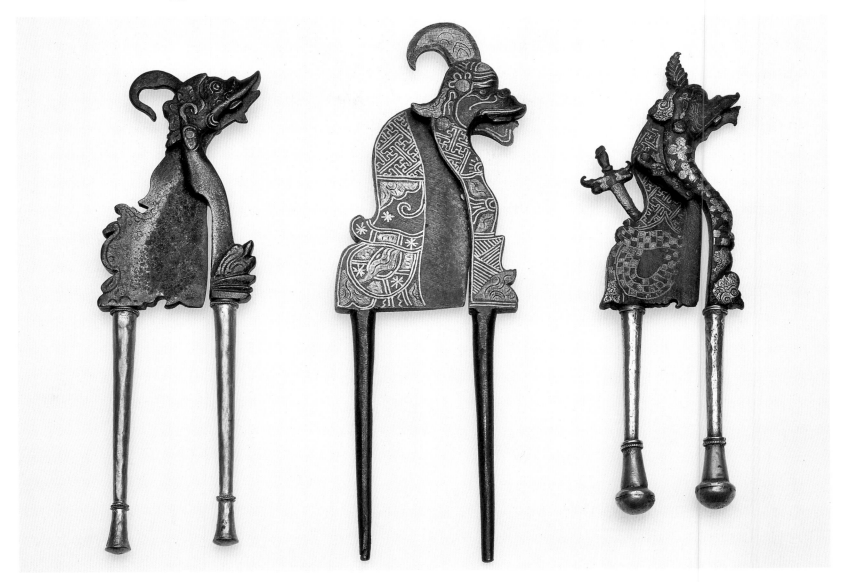

BALI and LOMBOK

Three clown-servants (Balinese: *penasar*) from the Balinese version of the shadow-play *(wayang bali).* As in Java, the clowns have an important role as servants to the noble characters. Twalen, the Balinese equivalent of Semar, and his son Merdah serve the heroic Pandawa brothers; Delem and Sangut their evil cousins the Korawa.

165. Iron with white metal sheaths. 185 mm.
The clown-servant Sangut. Together with his doltish elder brother Delem, Sangut serves the Korawas. He is intelligent and imaginative and has sympathies with the heroic side though it is his fate to remain loyal to his

masters. This cutter with its sensitive caricature is a good example of the Balinese sculptural style.

166. Iron with silver overlay. 210 mm.
Twalen, chief of the clowns and the Balinese equivalent of Semar (nos. 162–164). Despite elaborate silver decoration this cutter does not have the same impact as no. 165. Sheaths missing.

167. Iron with silver overlay and silver sheaths. 183 mm.
A clown-servant, probably the stupid Delem. The arms are articulated like Javanese clown cutters, though the lower arms are missing. He wears a *keris* strapped to his belt, though, seen in profile, it seems impaled in his hind-quarters.

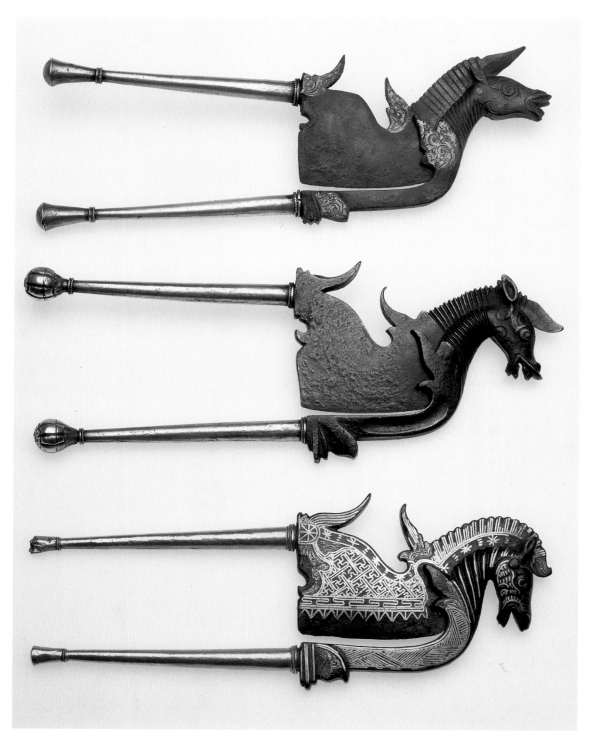

Balinese cutters are more solidly made than the slender long-handled cutters from central Java, and are often decorated with wire inlay. Winged horses are a favourite subject, and nine examples are shown. The wings are indicated by a single stylized projection near the neck. Another projection near the handle represents the tail.

168. Iron with gold overlay and silver sheaths. 201 mm. Bali.
The cutter is almost identical to no. 171 except that the goldwork is only locally applied leaving most of the iron unadorned. This restraint serves to highlight the quality of the ironwork which, like most of the Balinese cutters in the collection, is quite able to stand in its own right without the aid of surface embellishment. Silver sheaths.

169. Iron with silver sheaths. 201 mm. Bali.
Another example of the strength of Balinese ironwork. This is the best of the nine Balinese horse cutters in terms of sculptural quality although it is the only one to be totally undecorated. Silver sheaths.

170. Iron with silver inlay and gold sheaths. 196 mm. Bali.
Very similar to no. 173 except that the inlay is in silver rather than gold and the sheaths are of gold rather than silver. The latter fact merely serves to show that these sheaths are often replacements and not original to the cutter.

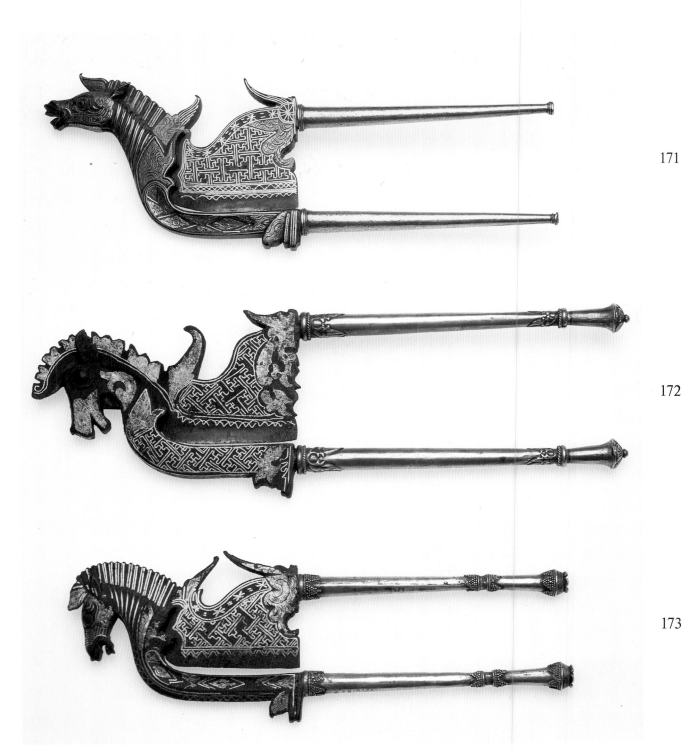

171

172

173

171. Iron with gold inlay, overlay
and sheaths. 205 mm. Bali.
Lavish gold inlay and overlay
decoration and plain gold
sheaths.

172. Iron with gold inlay and
overlay and silver sheaths.
227 mm. Bali.
The body has a conventional
banji motif. The head has
contrasting areas of gold overlay
and unadorned iron. Compared
with nos. 171 and 173 it is flat
and stylised. Good-quality silver
sheaths.

173. Iron with gold inlay and
overlay and silver sheaths.
187 mm. Bali.
Good silver sheaths with
granulated decoration.

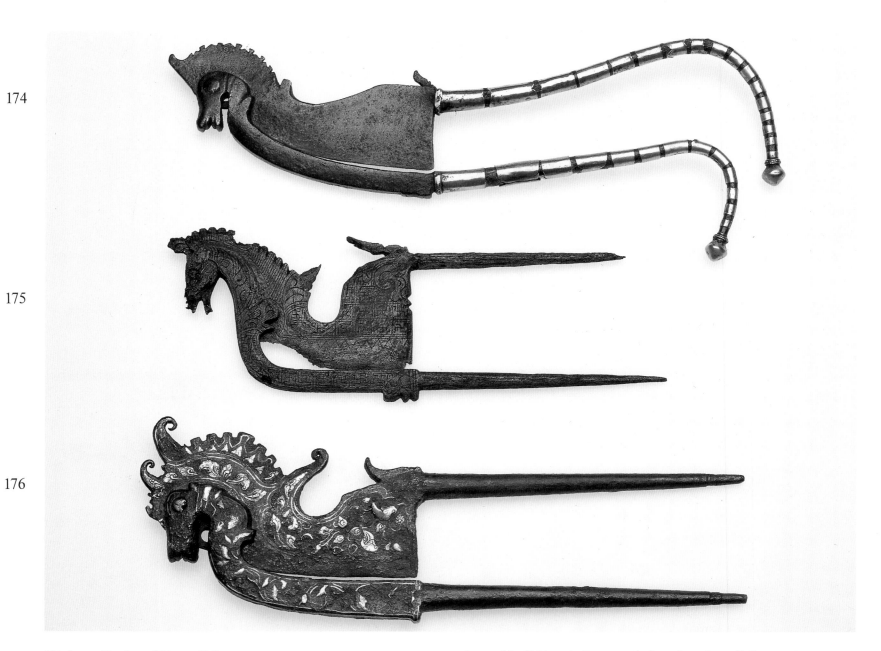

174

175

176

174. Iron with silver. 257 mm. Bali.
In contrast to the sculptural examples on the previous page, the head here is small and rather primitive in the Javanese style. The unique handles are long and curved and are partially covered in sections of silver sheath.

175. Iron. 195 mm. Bali.
This cutter is made with *pamor,* the mixture of wrought iron and nickel-containing 'meteoric' iron used for *keris,* the characteristic Indonesian dagger. No. 136 is a similar example from Java. Some Balinese cutters were made by communities of *keris* smiths based at the towns of Klunkung and Kusamba, but it is unusual for cutters to be made of the same metal. The surface has an incised design probably intended to receive wire inlay. No sheaths.

176. Iron with silver overlay. 232 mm. Bali.
Unusual patches of overlay, much of which is now missing. No sheaths.

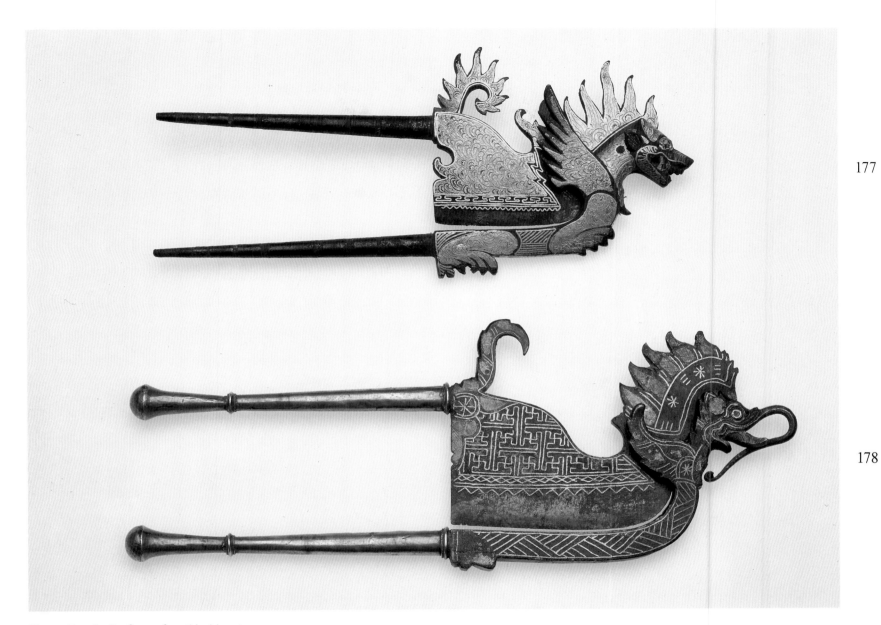

177

178

Two cutters in the form of mythical beasts.

177. Iron with gold overlay and inlay and inset diamonds. 204 mm. Bali.
This cutter depicts a winged lion (singha bersajap). In Bali the winged lion with flame-like mane and tail is a common artistic motif. The animal is protective rather than threatening, and is incorporated in the architecture of traditional buildings to guard them against supernatural enemies. The cutter, which is unusual in showing the animal's legs, is lavishly decorated in gold with restrained engraving. The eyes are of inset diamonds. The handles at one time had six narrow flat gold washers, now missing.

178. Iron with brass inlay. 252 mm. Bali.
The winged elephant with flaming mane is again a fairly common subject for Balinese cutters. The decoration is in the usual banji pattern with a solar symbol near the tail. Silver sheaths.

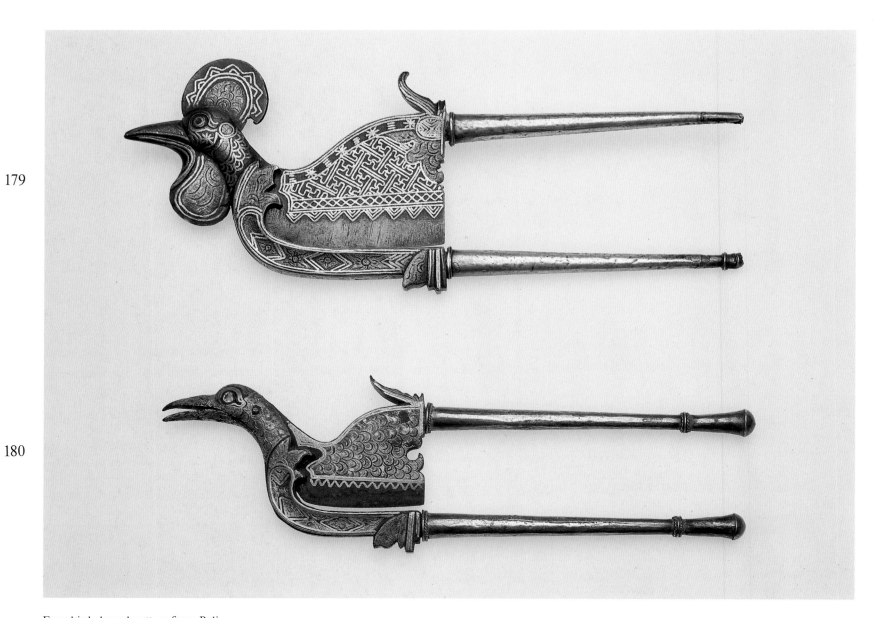

Four bird shaped cutters from Bali.

179. Iron with silver inlay. overlay and sheaths. 207 mm. Bali.
A cock, the head similar in shape to no. 181 except for the addition of comb
and wattle. Both of these are decorated with silver overlay on a cross-hatched
and engraved surface. The cutting arm is inlaid with silver wire in the
conventional *banji* pattern. Silver sheaths, the finials missing.

180. Iron with gold overlay and silver sheaths. 211 mm. Bali.
A bird, similar to no. 181, decorated with rich gold overlay. with an engraved
pattern of feathers. Silver sheaths.

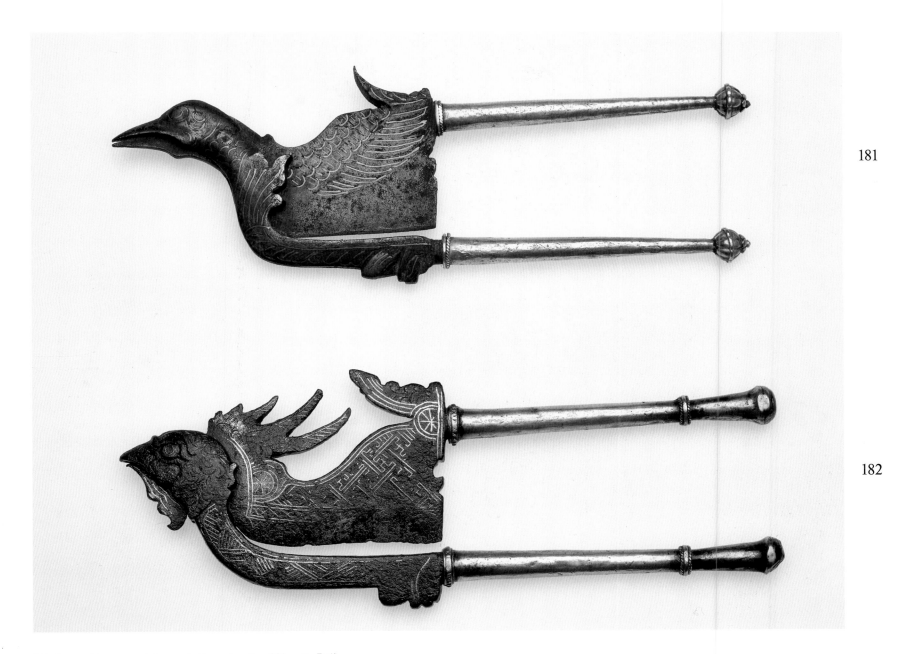

181. Iron with copper inlay and silver sheaths. 201 mm. Bali.
The inlay is here in the form of wings rather than the more common *banji*
swastika design. Silver sheaths.

182. Iron with silver inlay and sheaths. 201 mm. Bali.
A crested bird with an expressive modelled face. The inlay decoration is in a
banji pattern with sun symbols at the neck and near the tail. Silver sheaths
with club-shaped finials.

183

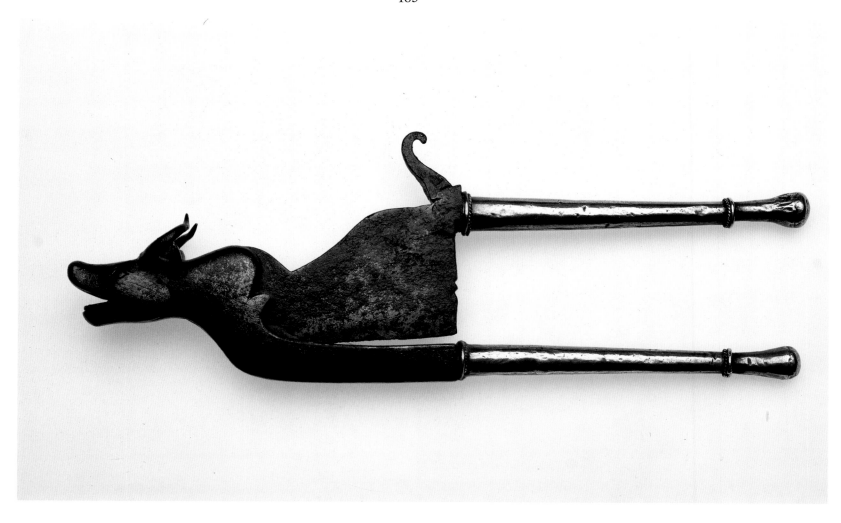

183. Iron with silver sheaths. 231 mm. Bali or Lombok.
This massive cutter in the form of a buffalo is one of the most spectacular
pieces in the collection. It is of unadorned iron, with plain silver sheaths. The
head is made in the round, and the horns have a spread of 42 mm. Possibly
from Lombok.

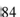

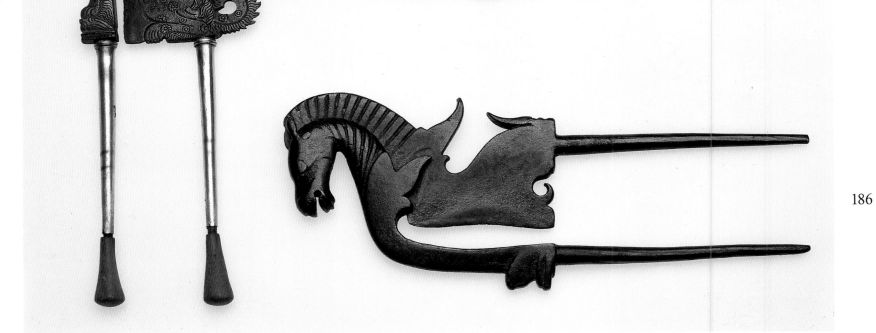

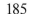

Three animal cutters from Lombok. Lombok, the island to the east of Bali, has a population partly composed of Balinese immigrants, and the two cultures are therefore closely related.

184. Iron with sheaths of silver and wood. 220 mm. Lombok.
A mythical lion (singha) seated on its hind legs. The mane and tail are similar to no. 177, but there are no wings. Good quality engraving. The sheaths are of silver but the finials have been replaced with wooden ones.

185. Iron with silver sheaths. 208 mm. Lombok.
Another singha, this time winged and similar to no 177. The sheaths have a fish-scale pattern and club-like finials.

186. Iron. 223 mm. Lombok.
A well-shaped horse in unadorned iron. No sheaths.

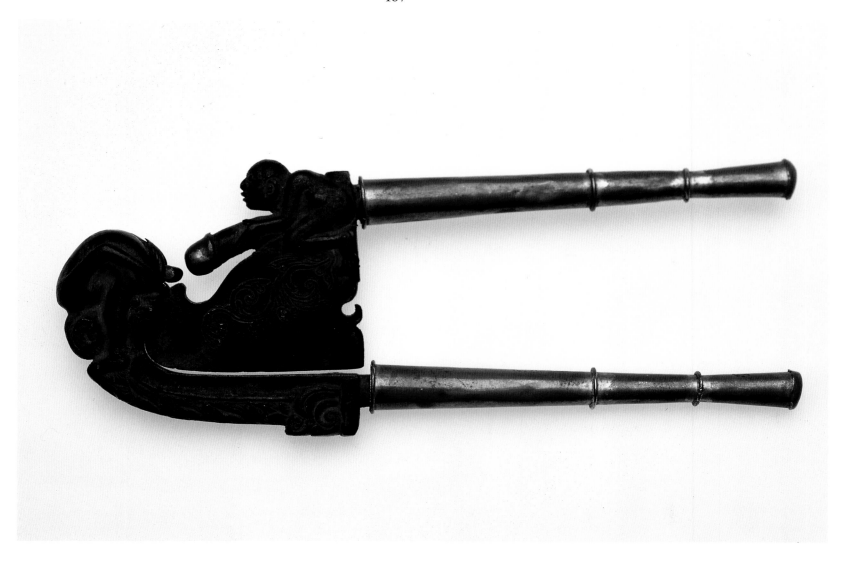

187. Iron with silver overlay and white metal sheaths. 170 mm. Lombok.
A very explicit if rather optimistic erotic scene. Explicit scenes of intercourse
are common in Balinese and Lombok art, even as bas reliefs on the walls of
temples. Here the figures are forged in iron, highlighted by silver overlay.
The dull sheaths are replacements.

MINIATURES

Twelve miniature cutters from India, Sri Lanka and Java.

These cutters are not intended for use. Traditionally it was the practice for cutters to be given as wedding gifts and for the bride to bring one into the household as part of her dowry. Today many young people do not chew betel, and so it has become the practice for miniature substitutes to be commissioned from silversmiths and given in lieu.

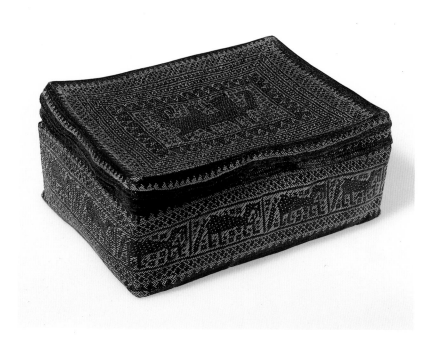

A box for betel leaves woven from extremely fine rattan. A mythical winged animal is shown on the top of the lid, and horses around the sides. It comes from the Lampung district in the south of Sumatra. The box has an inner tray made of the same material.

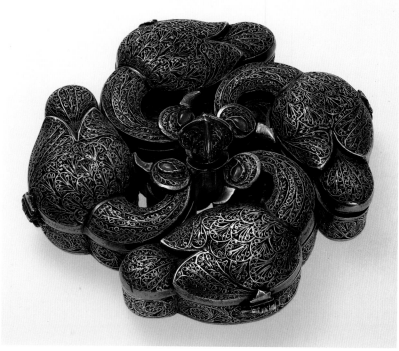

Four interlocking boxes made of fine silver filigree with rubies. The compartments are held closed by a single central screw. Each compartment has the form of a duck, with ruby eyes. Boxes of this type were used for a variety of purposes including serving betel *masalas*. Probably Deccani.

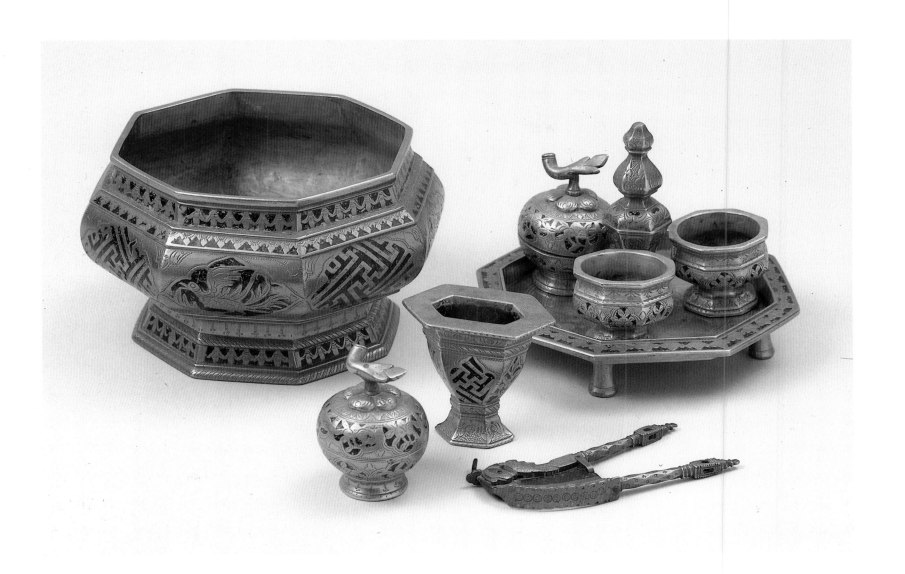

A complete betel set in brass with inlaid niello decoration. It comes from the Palembang region of Sumatra. The cutter is Indian. The tray can be lifted by the tall projection in the middle and fits into the top of the box.

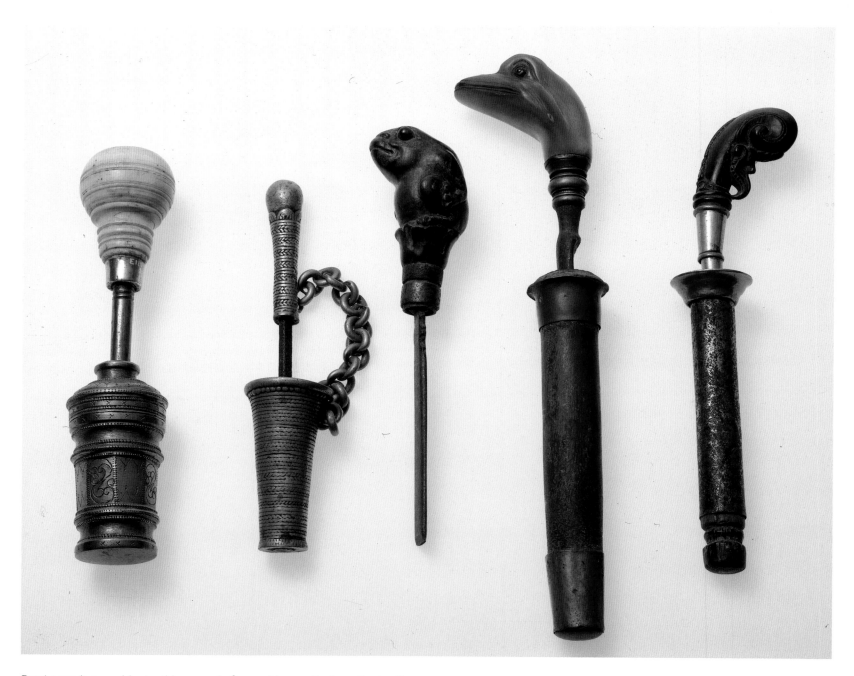

Betel pounders used by toothless people for mashing up the ingredients of
the quid. An iron spatula with a handle acts as the pestle, and a metal or
wood tube as the mortar. The example on the left is typical of Sri Lanka.
Next to it is a brass Batak pounder from Sumatra. The three on the right are
from Lombok which produces many imaginatively carved handles.

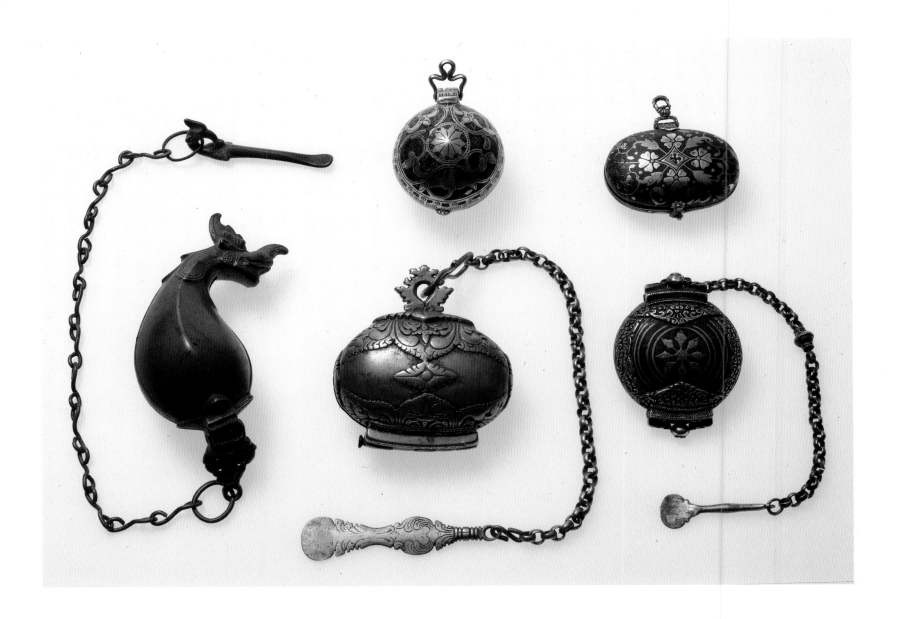

Lime boxes. The example on the left is from Kerala. The inside has a domed compartment to keep the lime moist, and the narrow spatula is inserted through a hole in the top of the dome. The narrow spatula is attached by a chain fastened near the hinge. The two containers at the top are from Tanjore in Tamil Nadu. The two at the bottom right are from Sri Lanka. Here there is no domed compartment, the spatula is shaped like a flattened spoon, and the chain is attached to the clasp rather than the hinge.

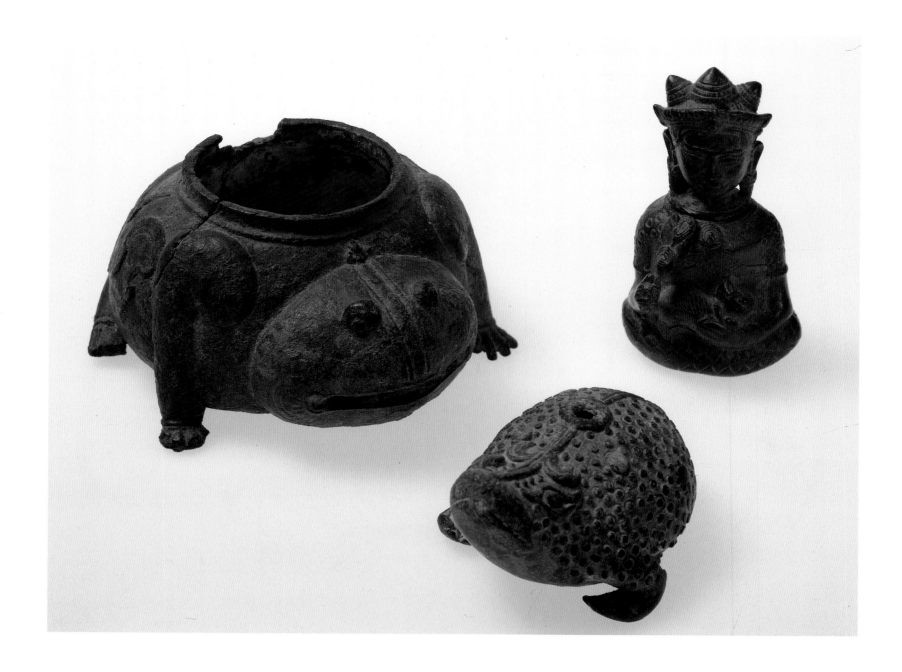

Early examples of lime-pots. Two, shaped as frogs, are from East Java and date from around the 13th century AD. The third, which is in the form of a seated figure holding a pet cat, is from Cambodia and dates from the 13th—14th centuries AD. The head is removable and is joined to a spatula.

The box in the foreground is a Batak tobacco box and has a sliding cover. The three lime containers at the back are (from left to right) a miniature drum-shaped box from Java; a stupa-shaped lime-pot also from Java (though the style is also found in Thailand); and a Batak container from Sumatra.

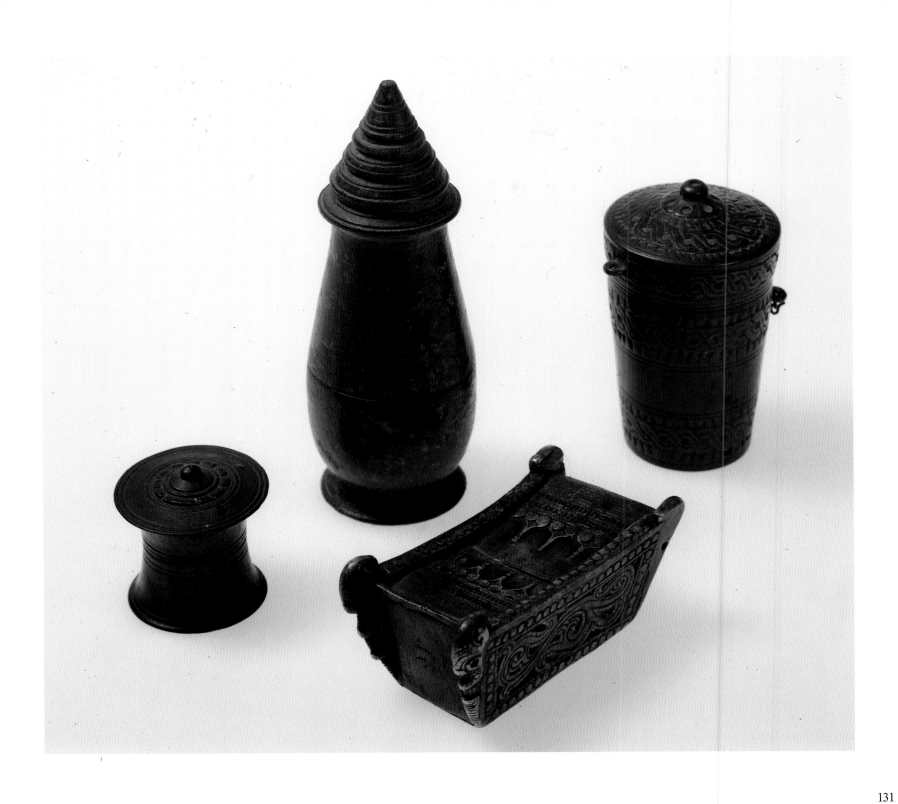

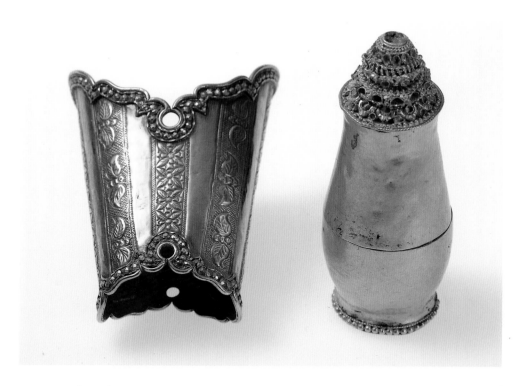

On the left is a silver-gilt Malaysian sleeve for holding betel leaves. The stupa-shaped limepot on the right is of gold and is from Thailand, dating from the 15/16th century AD.

Two knives for cutting areca nut. The smaller one is of rock crystal, steel and gold. It is Thai and dates from the 18th century. The larger is from Bali (or Lombok) and is of iron and wood with silver strips.

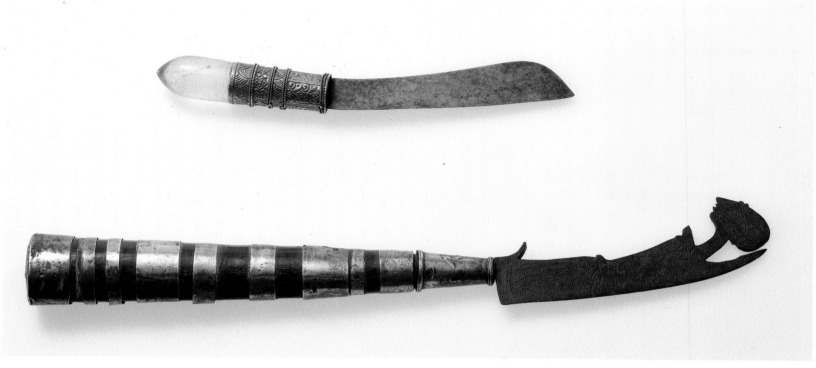

Photo credits:

All studio photography by Heini Schneebeli.
Field photographs by the author except
page 23 by Michael Freeman and
page 18 bottom left by Léon Busy

Bibliography

Brownrigg, Henry – "Betel Paraphernalia in Sri Lanka" (*Orientations*, Hong Kong, June 1985).

Buddle, Anne – "Cutting Betel in Style" (*Arts of Asia*, Hong Kong, July–Aug. 1976).

Burton-Bradley, Burton G., MD – "Arecadinism: Betel Chewing in Transcultural Perspective" (*Canadian Journal of Psychiatry*, vol. 24. no. 5, Aug. 1979).

Charpentier C-J., – "The Use of Betel in Ceylon" (*Anthropos*, 72 (1–2), 1972).

Conklin, Harold – "Betel Chewing among the Hanunoo" (National Council of the Philippines, 1958).

Coomaraswamy A. K. –"Medieval Sinhalese Art" (Broad Campden, 1908).

Dhamija, Jasleen (ed.) – "Crafts of Gujarat" (Mapin International Inc., New York 1985).

Fox, Robert B. – "The Tabon Caves: Archaeological Explorations and Excavations on Palawan Island" (Manila, 1970).

Fraser-Lu, Sylvia –"Silverware of South-East Asia" (Oxford University Press, Singapore, 1989).

Gode P. K. – "Some Words for the Nut-cracker - Vak" (*Journal of the Deccan College Research Insitute*, Poona, No. 1. Dec. 1951.

Gode P. K. – "The Indian Nut-cracker, AD 1300–1800" (*Bombai Itihasa Samshodana Mandal Quarterly*, 1948).

Gode P. K. – "Studies in Indian Cultural History", vol. 1, (Hoshiarpur, 1961). (This includes reprints of the above two articles, along with others on betel-related subjects).

Goris R. – "The Position of the Blacksmiths" (in "Bali, Studies in Life, Thought and Ritual", The Hague and Bandung, 1960).

Grewel, Royina – "Tambula, Ritual of the Green Leaf" (*Namaskar*, Bombay).

Ho Wing Meng – "Straits Chinese Silver: a Collector's Guide" (Times Books International, Singapore, 1984).

Klebert, Beowulf K. – "The Lerche Collection, Chewing Betel through the Ages" (*Arts of Asia*, Hong Kong, Jan.–Feb. 1983).

Krenger W. – "Kulturgeschichtliches zum Betelkauen" (*Ciba Zeitschrift*, No. 84: 2922–35, 1942).

Lewin, Louis – "Phantastica: Narcotic and Stimulating Drugs, their Use and Abuse" (London, 1931, 1964).

Linschoten, Jan van – "The Voyage of John Huyghen van Linschoten to the East Indies" (The Hakluyt Society, London, 1885).

Locke, Carol Jean – "Betel Nut Sets" (*Arts of Asia*, Hong Kong, Jan.–Feb. 1976).

Marg Publications – "Treasures of Everyday Art: Raja Dinkar Museum" (*Marg*, vol. XXXI, no. 3, June 1978).

Millot, Jacques – "Inde et Bétel" (*Objets et Mondes, la Revue du Musée de l'Homme*, Paris: Tome V - Fasc. 2, Summer 1965; Tome VI - Fasc. 1. Spring 1966).

Morarjee, Sumati – "Tambula: Tradition and Art" (published privately, Bombay, 1974).

Penzer N. M. – "The Romance of Betel Chewing" (in Penzer – "Poison-Damsels and other Essays in Folklore and Anthropology", London, 1952).

Ramseyer, Urs – "Art and Culture of Bali" (Oxford University Press, 1977).

Rumphius G. E. – "Het Amboinsch Kruydboek" (Amsterdam, Den Haag, 1741).

Sharar, Abdul Halim – "Lucknow: Last Phase of an Oriental Culture" (Translated and edited by E. S. Harcourt and Fakhir Hussain. Paul Elek, London, 1975).

Sheppard, Mubin – "Taman Indera: Malay Decorative Arts and Pastimes" (Oxford University Press, 1972).

Shway Yoe (Sir George Scott) - "The Burman, his Life and Notions" (Macmillan and Co., London, 1910).

Solyom, Garrett and Bronwen – "The World of the Javanese Keris" (East-West Center, Honolulu, 1978).

Thierry, Solange – "Le Bétel: I. Inde et Asie du Sud-Est" (Catalogues du Musée de l'Homme, Paris, 1969).

Thurston, Edgar – "Castes and Tribes of Southern India" vols. I-VII (Madras, 1909).

Umemoto, Diane L. – "The World's Most Civilised Chew" (*Asia*, New York, vol. 6, no. 2, July/Aug. 1983).

Zebrowski, Mark – "Ornamental Pandans of the Mughal Age" ("Symbols and Manifestations of Indian Art", Marg Publications, Bombay, 1984).